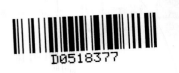

PRAHA - KARLŮV MOST A ŘEKU VLTAVU

Kriegsgefangenenpost

Postkarte

An

Miss Alma Peregrine.

Plenty "lusus naturae" Empfangsort *The Children's Home*
here - hard to keep
up. 8/10. 2 Elusive, Straße *Llangarsydd,*
Next stop Jerusalem. (pagne) Land: *Cairnholm Is.*
Landesteil (Provinz usw.) *Wales.*

21. Brasília - DF.
Palácio do Itamaratí
Itamaraty Palace

CARTÃO POSTAL
UNIÃO POSTAL UNIVERS.

MISSION
ACCOMPLISHED!

EDIÇÃO ESPECIAL DE SOUVENIR BRASILIA LTDA.

Miss Alma P.
The U
Fairnar
loro Day
Cairn

RIO DE JANEIRO

A close call this time
t everyone is safe.

A.

Miss A. Peregrine
The Children's Home
Faenar Uchel,
Cors Dafud, Llangorozdd
Cairnholm, Wales
United Kingdom.

lm Circle,
ssuater, Florida,
United States FL
16th January

Dear Miss Peregrine,

I don't wish to alarm you, bu
my informants sent me this.
appear that some of Mr Bar
are in Blackpool, England

Does Miss Avocet s
there? Without my Maj
I cannot tell.

In any case, please warn her, an
take the greatest care yourself.

With love, Abe.

A. Bostrom, 2016 Pa

JAN 19 201
FLORIDA USPS

JAN 19 2016
FLORIDA USPS

THE ART OF

— A TIM BURTON FILM —

MISS PEREGRINE'S

HOME FOR

PECULIAR CHILDREN

WRITTEN BY **LEAH GALLO**

DESIGNED BY **HOLLY C. KEMPF**

QUIRK BOOKS

PHILADELPHIA

Library of Congress Cataloging in Publication Number: 2016934610
ISBN: 978-1-59474-943-8

Printed in the United States of America
Typeset in Baskerville Handcut
Designed by Holly C. Kempf
Edited by Leah Gallo, Holly C. Kempf

Production management by John J. McGurk

Photo Credits:

Leah Gallo Pages 5-6, 12 left, 14-15, 17, 18, 32-33, 35-36 left, 38-42, 45, 47, 50-59, 61 bottom left, 63, 67, 69-70, 75 top & bottom, 84-87, 89, 92, 94-95 bottom right, 101 top, 108 top, 109 left, 110, 111, 114 bottom, 115, 117, 118 bottom, 119, 120 bottom left, 121, 123, 125-133, 144, 146, 147 bottom, 154, 156, 162-163 top right, 173 top right, 174 left, 178, 181 right, 185, 186 Left top and third, middle top, right middle, middle bottom, 187 top right, middle right, bottom left, 188 left top & middle, middle top, second & bottom, right middle, 189 top row, center, right middle

Jay Maidment Pages 16, 31, 34, 36 right, 37, 43-44, 46, 48-49, 61 bottom right & top, 62, 64-66, 68, 75 left & middle, 76, 80, 81 top, 83 bottom, 95 top, 96, 98, 100, 112 right, 113 left, 114 top, 134, 136-137, 138 bottom, 141-142 bottom, 143, 145, 147 top, 148, 150-153, 158-159, 163 top left & bottom right, 166, 170 bottom left, 176 top, 179-180, 181 left, 186 left second and bottom, 187 top left & middle, middle left, bottom middle & right, 189 bottom

Derek Frey Pages 72-74, 81 bottom, 90 top & bottom, 91, 104, 107, 109 right, 116, 139, 186 right top & bottom, 188 top right, middle third, bottom left

Richard Selway Pages 78, 88, 90 middle, 95 bottom left, 97, 163 bottom left

Phoebe Rudomino Pages 168, 169 top, 170 bottom right

David White Pages 101 bottom, 138 top

Christine Cantella Pages 186 center, 189 bottom left

Paul Gooch Pages 120 bottom right

Quirk Books Pages 8-11, 13

Ransom Riggs collection Page 12 right

Quirk Books
215 Church Street
Philadelphia, PA 19106
quirkbooks.com

10 9 8 7 6 5 4 3 2 1

Acknowledgments

I would like to thank the entire cast and crew of *Miss Peregrine's Home for Peculiar Children*, who worked so hard to create a beautiful and unique new world—without you there would be no book. I'm especially grateful to those who contributed photos or allowed me to pick their brains about the process, often over the course of several interviews. In particular, Derek Frey provided photos *and* answered hundreds of questions tossed his way, acting as a sounding board and unofficial editor. Plus, he's a wonderful husband and father. My appreciation to Jason Rekulak at Quirk Books for guiding us through this process and to Mary Ellen Wilson for being an insightful copy editor. Sam Hurwitz deserves a medal for providing us with tidy transcriptions of the electronic photo kit interviews. My gratitude as well to Valery Nuttall, who painstakingly combed through the entire book. I am indebted to the editors, especially Keith Mason, Tom Kemplen and George Mitchell, all who made themselves available whenever we needed to spin through the film; also Julia Hewitt, for always so kindly feeding me. I would like to recognize my zany graphic design contact, Carol Kupisz, for always making me smile; Christine Cantella, for sending me Colleen Atwood's drawings; Alexandra Kemp for bringing us the props we requested; Sophie Worley for providing the art department files; and Helene Tackács for being such a gracious VFX liaison. There's a list of people who worked on the film that contributed to what ended up on the page: Sarah Clark for her assistance setting up the vintage photoshoots (and many others); Katterli Frauenfelder, who was both an invaluable source of information *and* an amazing first AD; Jay Maidment who taught me tips of the trade; Josh Roth and Gregor Telfer, for offering me a home for my kit; Des Whelan for consistently bringing good will to the set, for always helping me find a place, and because you have the best name; and Richard Selway, whose reference photos are more striking than some of my stills. I want to offer a special acknowledgment to Ransom Riggs, who was available whenever I had a question or request, and who is an all-around great guy. Finally, always last but never least, Tim Burton, for your guidance, your insight, your kindness, and your general, all around brilliance. Working with you is truly like being part of a family, and for that, I am forever grateful.

Dedication from Leah

To Desmond - my own peculiar child whose greatest talent is
force of personality and the joy that he brings me every day.

Dedication from Holly

To my boys, Eli & Finn but especially Gary for all his support.
Thank you for staying on the right side of sane for our family.

Table of Contents

3rd September 2014

POST CAR

My Dearest Abe,
 I hope this card finds you well. The children and I yearn to hear your news.
 Little on the island has changed, but orderly and uneventful is the way we prefer things.
 I do hope you will visit us again soon, we should so love to see you.
 with Admiration,
 Alma Peregrine.

Mr.
2

CAIRNHOLM.

Foreword

I finished writing *Miss Peregrine's Home for Peculiar Children* in 2011 with a lot of pride and modest expectations. I had worked hard on the book—poured my heart into it—but I was young, it was my first novel, and having spent the prior few years as a struggling, fresh-out-of-film-school screenwriter, I was accustomed to pouring my heart into projects that few people ever saw. Besides, I knew *Miss Peregrine* was an odd little book, not the sort of thing that was likely to climb best-seller lists. Part fantasy, part mystery, part contemporary coming-of-age drama, it was a bizarre genre mishmash—with a dash of gothic horror and time travel just to make certain no two bookstores would shelve it in the same section. My publisher thought teenagers might like it, and Young Adult is a category that can encompass many genres, so we pushed for its inclusion there—but that wasn't an easy fit either, at first, because *Miss Peregrine* looked nothing like the splashy, colorful books that populated the YA section back then. It was illustrated with old black and white photographs and had an old black and white photo as its cover, and I worried it would be the last book a browsing teen would reach for. (A major bookstore chain agreed and declined to carry the book, which seemed to seal its fate.) Needless to say, I expected *Miss Peregrine* to sell about fourteen copies.

Luckily, I was wrong—stunningly, drastically so. The book did not fail. It wasn't an overnight sensation, either, but gradually, over the course of a year or so, it found a surprisingly wide readership. Even more surprising: Tim Burton was one of those readers. Just a few months after *Miss Peregrine* was published, I heard that he was interested in adapting it for the screen.

It's difficult to overstate how uncanny this was for me. Tim Burton has been one of my film heroes since I was old enough to know what a film director was. His influence on *Miss Peregrine* is clear enough to anyone who reads it closely; his aesthetic is part of its DNA, spliced alongside that of Edward Gorey, C.S. Lewis, and Arthur Conan Doyle. If you had asked me to choose a dream director for *Miss Peregrine*, living or dead, I would have chosen Tim Burton. So the fact that he found my book at all—a little book from a little publisher and a first-time author—was amazing enough. That he wanted to *make a film of it* seemed too perfect to be true. So I decided it wasn't.

More precisely, in order to armor myself against crushing disappointment, I decided there was no way the project would actually happen. Nothing so right ever came to pass in Hollywood. It would fall apart somehow. The studio would get cold feet. Nuclear war would break out. Tim would decide to direct *Beetlejuice Goes Hawaiian* instead. I remained stubbornly in denial through four long years of development, even as a script was written, the movie got a release date, and the lead roles were cast. Even when the production was only weeks from its start date, I forced myself not to get excited. It could still fall apart, I thought. Remember what happened to *Superman Lives!* Then one day it was no longer possible to convince myself it wasn't happening because I was standing on the set, surrounded by lights and equipment and crew, ecstatic and dizzy, watching Tim direct a scene I'd dreamed up at my writing desk four years earlier. Only after that hallucinatory day did it begin to sink in: *holy mother of God, Tim Burton is making* Miss Peregrine.

I visited the set a number of times, and it's almost impossible to describe how it felt—but I'm a writer, so I'll try. As a longtime fan of Tim's, it was surreal to talk with him and inspiring to watch him work. He bops around the set like a mad scientist in his laboratory, overflowing with energy and enthusiasm that's just infectious. The crew—Oscar-winning artisans and tech wizards at the top of their craft—have incredible respect for him and work in quiet harmony with one another, performing a behind-the-scenes ballet of mind-boggling complexity. I fell in love with the cast—the kids especially, who were sweet and humble and so talented. I learned more creeping around that set than I did in three years of film school! But for the work that all those talented people were engaged in—on the sets, the props, the costumes, the scene-work and dialogue—for all that to have been inspired by something I wrote was like an out-of-body experience. It was very emotional at times, and I often felt like I was dreaming. To see a world I invented filtered through the capacious imagination of one of the world's great film artists has been one of the great thrills of my life, and to remember where it all began—with a novel that didn't seem to fit anywhere, that I worried no one would read—well, I'm humbled, I'm grateful, and I'm still pinching myself.

Ransom Riggs

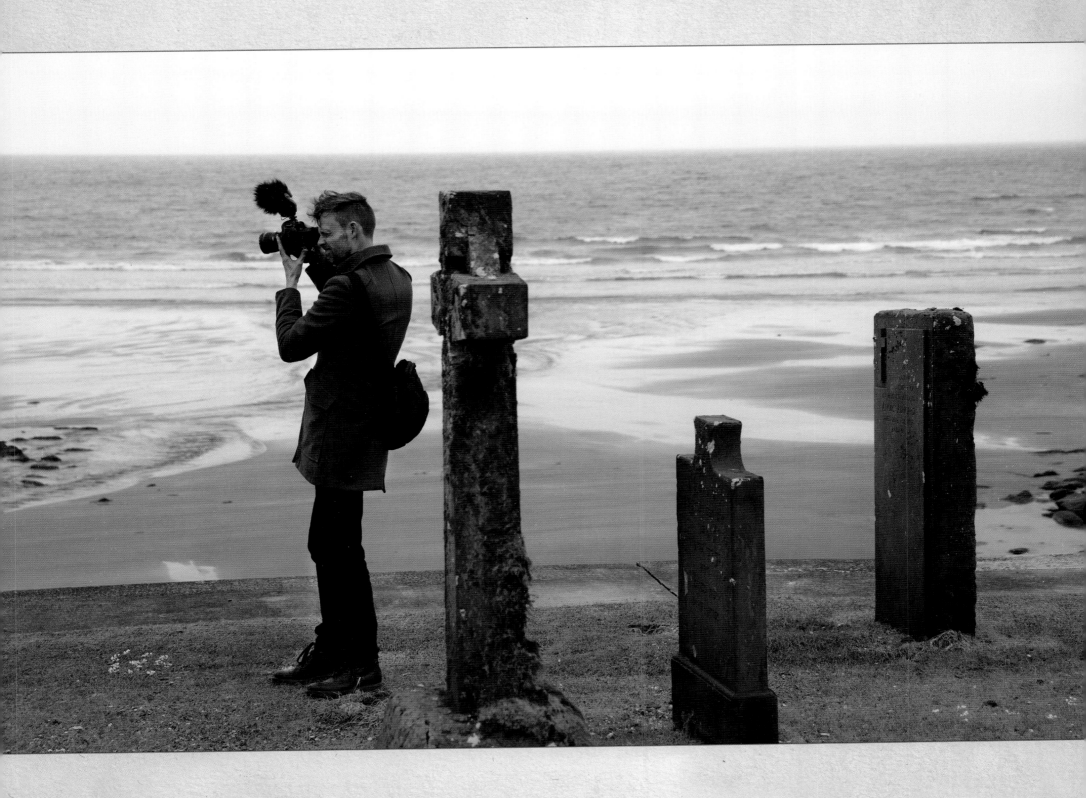

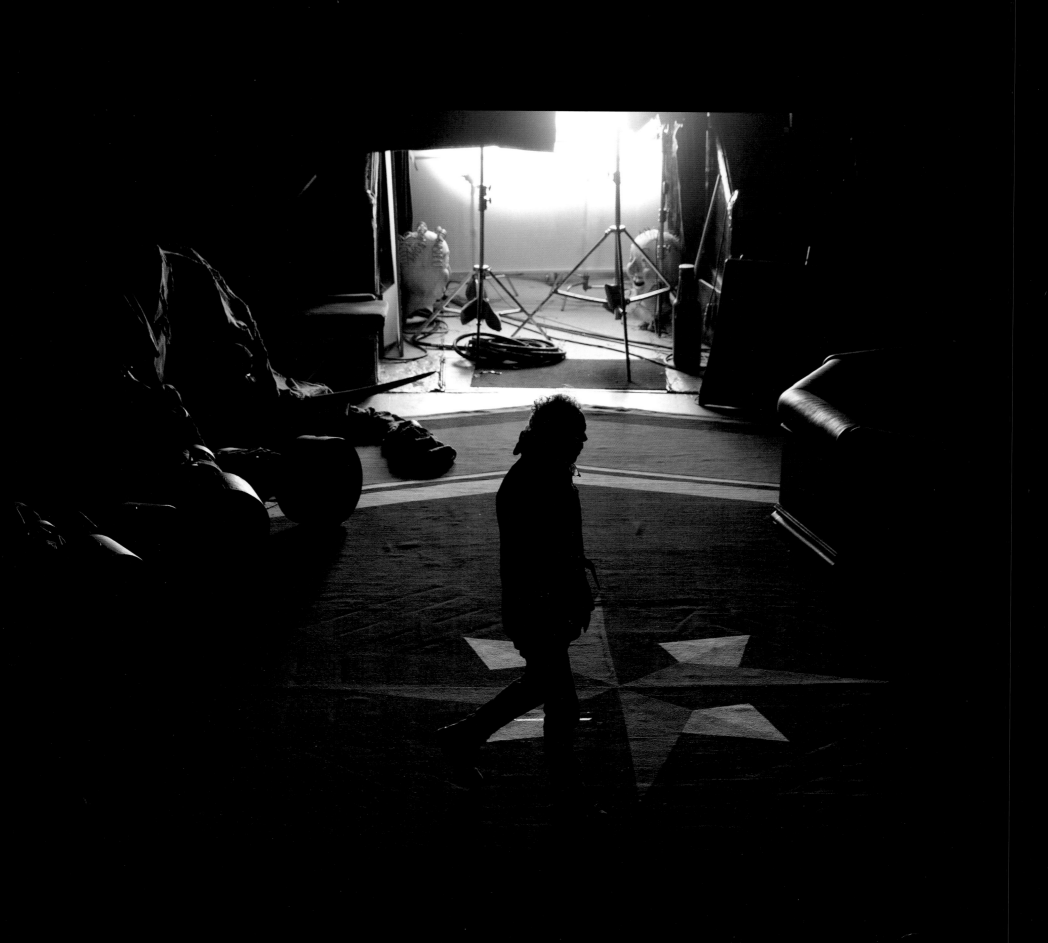

Introduction

Before *Miss Peregrine's Home for Peculiar Children* became a film, it was a novel by Ransom Riggs. There were so many facets that drew me to Ransom's book. The photographs spoke to me on an emotional level; there was a sense of mystery, power, and creepiness. I liked that they provoked my imagination, and that I didn't immediately know everything about the images. The narrative was reminiscent of a fairy tale or a fable. It mixed up the past and present, and centered on kids who have strange abilities, afflictions even, that they manage to live with and incorporate into their lives. They aren't superhuman, but they are unusual. And like any good fantasy, the story was rooted in reality and drew on real feelings. Every step the novel took was unexpected and didn't follow a traditional path. I liked that the book is not so easily categorized. It has been classified as young adult, dark fantasy, but as is often the case with categorizations, this seems unnecessarily limiting. I think it's for all ages, and I never understood the classification of what is considered dark. I often find what is considered normal—such as going to school or having my aunt visit—as some of the most terrifying ordeals I have endured. On the other hand, I find watching a monster movie comforting. I think those kinds of films are an outlet, that they give people a way to cope with psychological sentiments in their lives they are trying to understand. I found Ransom's novel compelling in a similar way to old horror movies, and I was drawn to the material enough to make a movie about it because I wanted to further explore Miss Peregrine's world.

I'm always asked why I'm so attracted to the outsider, and I think it's because many people have felt that way at one point in their lives. Once they have, no matter how popular people become, or successful, those feelings of not fitting in are still there—it's written into their DNA. I can certainly relate. Jane Goldman, who really understands peculiar people, has done a fantastic job of translating the vibe of the novel into a script. Basing a film on a book is sometimes one of the hardest transitions, because they are such different scenarios. But the most important aspect, which I feel she's done, is to capture the vibe that attracted us both to the book in the first place. It's a balance of many different elements—it's a little scary, a little funny, a little mysterious. Like the book, there's also a simplicity to it. It's very human based, which I think is important to retain, so that people can identify with the emotions of the characters.

This film was shot in several locations, with many challenges. I wanted it to be a more practical approach, trying to do the effects live when possible—though calling it practical is a bit questionable since it wasn't so practical for the cast, who were put through the ringer on a daily basis. I was lucky that they supported this approach, despite the difficulties of trying to do as much as possible on-camera, in real locations and sets. We navigated uncooperative weather, different climates, three countries, a real boat, a fake boat, and an underwater tank. We created rain showers, snow showers, snowballs, pelted people with candy, set Sam Jackson on fire, reversed time, made people eat eyeballs, flew the cast around on wires, had them sliding off roofs, buffeted them with super-powered fans, covered them in bee stings, turned people to stone, created about fifty versions of the same house, battled ticks and time, and generally had a blast. It was everything I love about filmmaking: the surreal situations and opportunities it offers the cast and crew, the strange places you find yourself in, and the unexpected and creative moments that happen every day. Filming is often a series of unexpected outcomes. That's the joy and beauty of it—that it is constantly new and unpredictable. Most importantly, filmmaking is about the people you meet and work and bond with. I feel so fortunate that my job allows me to work with such a group of amazing and creative people that can take an idea to the next level.

So much hard work has gone into this movie and this book is a celebration of that. It offers the reader a taste of the filmmaking experience. Any movie requires an intense collaborative effort to achieve what appears on screen, and so much of that extends beyond the period of actual filming. This film has been five years in the making. A lot of imagination and skill went into creating Miss Peregrine's world. I'd like to thank everyone for their dedication, attention to detail, and for caring so much. I'd also like to thank anyone who sees *Miss Peregrine's Home for Peculiar Children* and enjoys it. Your enthusiasm is one of the reasons I keep making films.

Tim Burton

1

A Peculiar History

FROM NOVEL TO FILM

A photograph documents a fraction of a second gone by, becoming a piece of the past the instant it is snapped. Though a camera records imagery, it does not store memory. A print becomes a slice of history disembodied from the events that surround it. These pictures are often lost once their owners pass, dissociated from the people and places they represented. If they aren't saved in a family album or tossed in the trash, they are sold at estate sales, flea markets, swap meets, and auctions. A select few stand out, provoking dicussion and wonder among the collectors and photography enthusiasts that find them. Their subjects are reinvented by their new owners. Life is once again breathed into them, even if it is not their own.

These kinds of haunting vintage photographs—abandoned and rediscovered—form the spine of Ransom Riggs's best-selling novel *Miss Peregrine's Home for Peculiar Children*. In fact, the forty-six orphaned images captivated the author so much, he created an entire world for the subjects to live in. Riggs belongs to a small group of enthusiasts whose passion is collecting obscure old photos that strike them as unique. "I thought, here's a way for me to find pieces of art that might otherwise be lost," Riggs explains. "To nominate myself as a curator and say, 'I think that's beautiful. I think that's interesting. I want to save those and show them to someone else.'"

Originally, collecting these photos was just a hobby. Then Riggs was introduced to Jason Rekulak, the publisher of Quirk Books. They began collaborating on a series of small projects and quickly hit it off. "I could tell right away that Ransom was a smart, creative, imaginative guy, and I was itching to do something with him," Rekulak says. "One day, he approached me with some photographs he'd encountered, pictures of children dating back to the early twentieth century. Kids in top hats, kids in monocles, kids in clown suits, and kids holding weird, homemade stuffed animals. They were all very eerie and surreal; Ransom kept referring to them as 'nightmare fuel,' and I thought that was a pretty apt description. His first idea was to assemble these photos into some kind of art book. Our working title was *Creepy Kids*, and Ransom's initial plan was to accompany the photos with a series of rhyming couplets."

MISS PEREGRINE'S
HOME FOR
PECULIAR CHILDREN
— BY RANSOM RIGGS —

PREVIOUS SPREAD: *Photographs from Ransom Riggs's novel* Miss Peregrine's Home for Peculiar Children. OPPOSITE: *A photograph from the novel: "Miss Finch's Loop."* ABOVE: *The cover of Riggs's book, which has sold more than three million copies.*

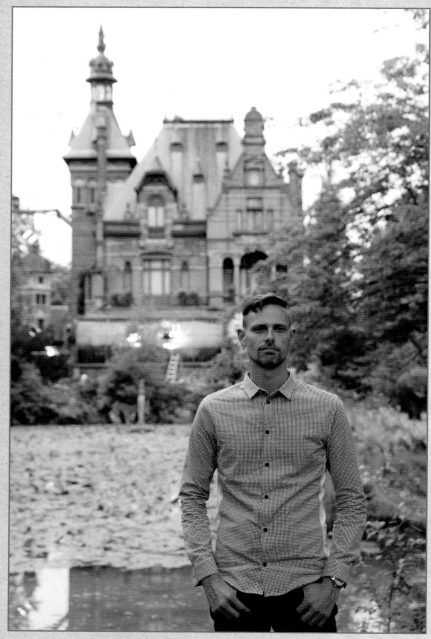

Riggs on location in Belgium.

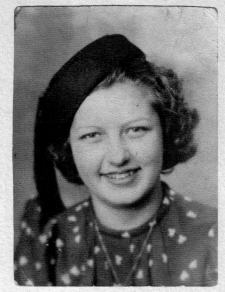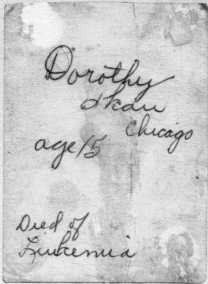

The first vintage photo a ten-year-old Riggs bought at a flea market. It sparked his fascination with old pictures that culminated years later in a collection of several thousand images.

Strikingly, one of the titles they both referenced for inspiration was *The Melancholy Death of Oyster Boy* by Tim Burton, a 1997 book of illustrated poems about a group of misfits. "We thought the book should have a similar tone: little creepy profiles or stories of 'unfortunate' children," Rekulak remarks. "But as Ransom delivered more photos and more poems, we kept asking more questions of the material. Who are these kids? Do they know one another? Is it possible they all live in the same place? Is there any way to connect the poems? After a few weeks, I remember feeling certain the book needed a bigger, more substantial editorial component—the poems would not be enough." So Rekulak did something that rarely happens in publishing. He went to Riggs (who had never published a word of fiction) and offered him a contract to write a full-length novel.

Riggs, who calls himself an "author-slash-human-slash-short-filmmaker-slash citizen," dreamed of making a living through his creative efforts. He attended film school and fell into writing to pay the bills. His passion for collecting photography started as a child when he bought and framed an image of a girl who reminded him of someone he liked. A few months later, he removed the photo

from its frame and flipped it over to discover the portrait was of a girl who had died of leukemia. "It convinced me that pictures have this life beyond themselves that was really fascinating," Riggs marvels. "That bug in my head stayed with me for a long time."

Years later, his interest in vintage photography was revived by a collector selling photos at a swap meet in Pasadena. "He had clearly made himself into a curator of beautiful old pictures, had gone through tens of thousands of them, to pick out those he thought were gems—images that seemed like lost folk art," Riggs remembers. "I bought a whole bunch and got really obsessed. At the start I only had a few dozen photos, but even that small batch—mostly of strange, troubling faces—was enough to plant the seed of an idea."

With Rekulak's encouragement, Riggs began to thread together images of children into a single overarching story. "I knew these kids would be different from normal ones and inhabit a world of their own, and I had an idea about sending a boy from our world to go and find them," he says. "Why he had to find them, who they were, what precisely their 'world' was—those were all things I discovered as I went along."

Riggs realized he would need more photos to properly tell the story. He searched online, attended photo shows, scoured flea markets and secondhand shops, and even unearthed a few in abandoned houses. But his most reliable source was other collectors. "I probably sifted through a half million images while putting together the first book," he recalls. "Many of my favorites I discovered in the archives of other snapshot collectors. I traveled around the country to visit them. I'd spend hours looking through their huge collections. I know some people whose houses are stacked to the rafters with boxes and albums of old pictures. And they really love it when I say, 'Hey, can you find that one picture of the kid in the jacket on the pedestal?' The reply is always, 'Sure. That'll take me a week.'"

The process of constructing the novel was, by necessity, organic. Riggs had the core of the narrative, and the pictures became the basis for many of his characters. When struck by a photo of a boy covered in bees, he decided that the insects would live in the boy's stomach and the boy could control them. But as the text developed further, the process flipped. "I had to find pictures to fit the story because it grew huge muscles and said, 'I

A vintage photo titled "A Boy and His Bees" included in Riggs's novel.

need to go over here. So I'm not going to get shoved around by your dumb photo collection. Go and find me a whatever.'" Overall, it was a give and take in which the pictures served the story but also shaped it. "The story would affect the kind of pictures I looked for, and then the picture I found, which was never quite what I was imagining when writing, would change the story just a little bit," Riggs continues. "So the product is something I never could have predicted, which I kind of like. It's like giving away some of my own control to the god of randomness, to inject some chaos into this and let it go wherever it's going to go."

For Riggs, the pictures also grounded the fantasy. "I thought it would be really interesting if I got this super-fake, fantastical story, and then it's anchored by pictures of real things and real places and historical events," he says. "I kind of like that tension between fiction and documentary." Above all, he had to love the photos he was including. "Each picture that made it into the book was interesting to me for one reason or another," Riggs continues. "And it's not always the same reason. Maybe the character had an interesting object in his or her hand, maybe it was just a beauti-

ful-looking picture—the light was really nice or it just appealed to me photographically. I also tried to look for photographs that did things my words couldn't do to add another layer to the story."

Riggs's novel, rich in layers and memorable visuals, was optioned to be turned into a film before it was even released. Staff members at Chernin Entertainment (run by the company's founder and industry veteran Peter Chernin, along with his president of film, Jenno Topping) often search up-and-coming manuscripts for stories that could be adapted to film. "I obtained a secret, very early manuscript from our book scout spies in New York before it was even public," Topping confides. "Because its presentation already has a strong visual component, it lends itself to cinematic material the second you look at it." So certain was she of the manuscript's potential that she passed it straight on to Chernin. "It's so visually arresting," she adds. "I read the book on a Friday night and called Peter, and he read it on Saturday night, and by Monday we had bought it." Chernin and Topping, who became producers on the film, knew immediately which director they wanted. "The second you look at the book, you couldn't not think of Tim," she continues. "It seemed to fit so perfectly within his oeuvre. The story just seemed to be written for him."

In June 2011, Chernin Entertainment sent Burton a packet about the novel, including a short synopsis and copies of the photos. The imagery drew him in immediately, elevating the project above the numerous pitches continuously sent his way. "The pictures Ransom chose really had the right balance of mystery, poetry, and creepiness," notes Burton. "I found them compelling—much like old horror films. And like all peculiar things it's not simple to categorize."

Initially, Riggs had trouble grasping the idea that Burton would be directing a book he had written. "A fair number of books get optioned, but not very many end up being made into films," he reckons. "So I tried to keep my optimism under a heavy, wet blanket, lest I be terribly disappointed down the road. When I heard that Tim was interested, I became even surer a movie was never going to happen. I've loved Tim's work since I was a kid, and I figured there was no chance that something as crazy as him directing the movie version of my book would ever come to pass. You only have so much luck, right?"

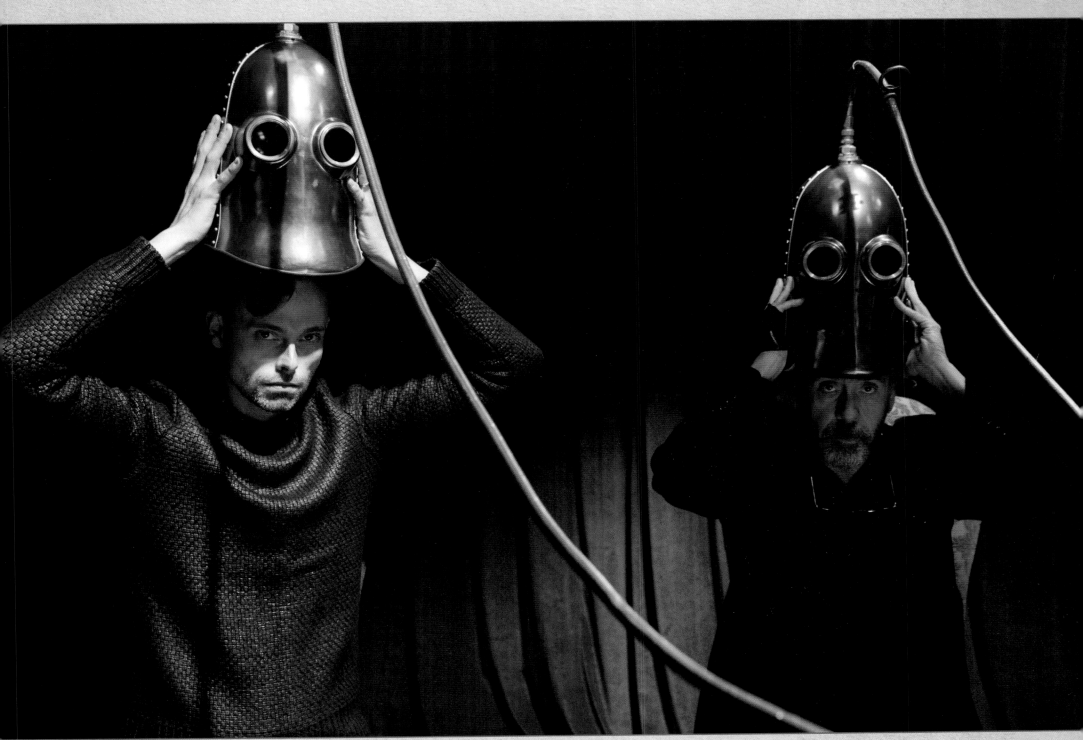

OPPOSITE: *Film producers Peter Chernin (right) and Jenno Topping on the stairs of the lobby set.* ABOVE: *Masterminds of the* Miss Peregrine *universe, author Ransom Riggs (left) and director of the film adaptation, Tim Burton.*

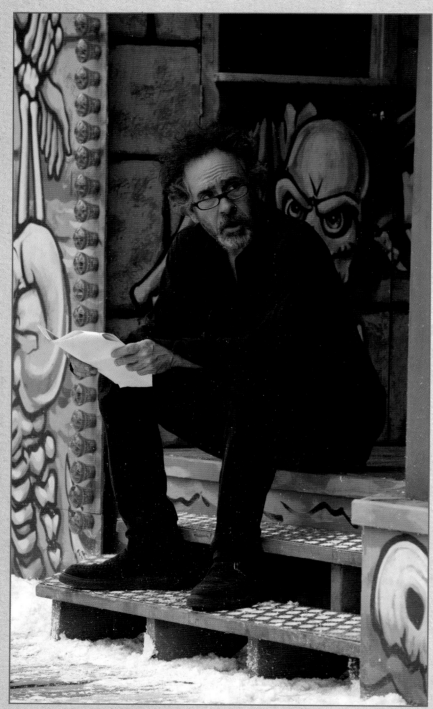

Burton takes a break during filming to review the day's script pages.

When the reality finally set in that Burton was indeed about to direct an adaptation of his novel, Riggs says the process became that much easier. "Selling your book to Hollywood is all about trust, because the minute you sign it over, your control evaporates. To best serve the material, they need to make it their own. It's much easier to let go and trust when Tim Burton is the surgeon performing the operation. I love the way he balances the joyful and playful with the dark and disturbing; the way there's always this duality of happy and sad. It's silly and somber and all of these things at once. I think he has a similar approach to his material as I do to mine, so it seemed like a good marriage of styles."

The narrative follows a teenager, Jacob Portman (Jake), whose journey to understand his grandfather's death leads him to a remote island where kids with strange abilities are kept hidden from the rest of the world. Derek Frey, head of Tim Burton Productions and executive producer of the film, has worked with

> ## "It's much easier to let go and trust when Tim Burton is the surgeon performing the operation."

Burton since 1996 and has keen insight into Burton's choices. "It's easy to see why Tim would be attracted to this story," Frey offers. "Our characters are more misfits than superheroes. Their abilities aren't limitless. Their peculiarities are traits that some people would see as bad. But they've learned to live with them over many, many decades, and now they're in a situation where their lives are threatened and they have to devise creative ways out of these situations by using their peculiarities."

"I sometimes see my job as a translator ... you're taking something and translating it into the language of cinema."

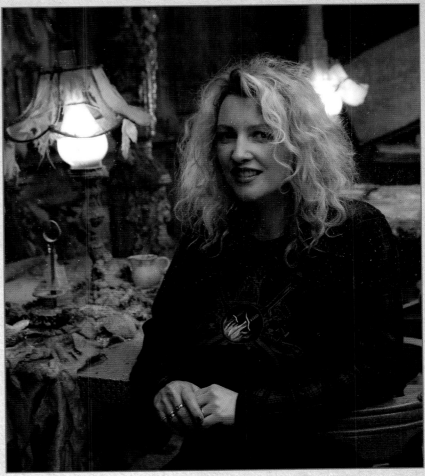

Screenwriter Jane Goldman visits the cocktail lounge set during filming.

Burton views the peculiar childen as anti-superheroes. "They're not using their abilities to save the world. If they can use them to deal with an issue, great, but it's on a much more human level. It's more personalized—this is just who I am, it can be used for good or for bad or for making honey or for nothing. It's more grounded."

Once Burton committed to the project, he needed to find someone capable of the delicate and difficult process of adapting the book into a script. Chernin Entertainment had been courting screenwriter Jane Goldman for other projects, with no luck. Goldman is known in the industry as a go-to person for comic book adaptations, with such successes as *X-Men: First Class* and *Kick-Ass*. She also skillfully adapted Neil Gaiman's fantasy *Stardust*, as well as Susan Hill's horror novella *The Woman in Black*. At their first face-to-face meeting, Topping mentioned Goldman to Burton, who was immediately interested. "I'd met Jane a few times," Burton says. "I always felt a connection with her, and it was in the back of my mind that I'd like to work with her sometime. This was the perfect project—she understands peculiar people."

After securing Burton's approval, Topping met with Goldman for coffee. "I mentioned the book, and her ears kind of perked up, and we just knew," Topping recalls. "Jane called me the next morning. She'd already read the book and was dying to meet with Tim. It was, again, one of those fortuitous moments that never happen, where everything just so gracefully falls into place. And Tim and Jane loved each other so much from the beginning. How

amazing and unusual to go through the entire experience with just one writer. There was never a thought that we would work with anyone else."

Goldman's philosophy for creating an effective adaptation is simple. "As long as you're true to the spirit of the original material, which you love and you know the readers love, then everything else is in service of making it work as a movie. Movies have a different pace than books have, a different structure. So the important thing is to make the source material shine in its new form. I sometimes see my job as a translator—translating a written work into the language of cinema." For this project, Goldman pinpointed the key element she needed to translate: the vibe. "The story has a creepiness and a romance and a humor and a beauty and a

Burton walks through a scene in the bombed-out lobby set.

darkness, and it's important not to betray all of that," she continues. "I think you could do a film version that brought out any one of those elements, but it's about keeping the balance and the tone."

Once the screenplay was completed, Riggs was given a copy to read. "Even though Tim Burton was directing it and Jane Goldman was writing it, I was still nervous," he admits. "I have read a lot of bad screenplays in my time. But this one was really good and funny, and it made me genuinely laugh and feel emotion. That's not easy to do. Screenplays aren't usually documents that produce a big emotional reaction. The words feel a little cold on the page, and what's there is only fifty percent of the final product. The screenplay is a blueprint, and then the director and all of these artisans come together to make it a whole thing. So, to be able to read the screenplay and vividly see the images playing out in my head was exciting. I felt like I was watching the movie."

"We made a real effort to keep what's so special about the book," Frey adds. "The book is quite intimate. It's not a huge tale, and that's what's so wonderful about it. There's a personal nature to the project. The connection between Abe, the grandfather, and Jake, his grandson, is at its core, and we strived to keep the heart of the story intact."

The book is a mystery that takes its time to unwind. In the beginning, Jake believes that the tales his grandfather told him are nothing but an elaborate fantasy. As the story unfolds, the reader, along with Jake, gradually learns the truths held within the grandfather's stories, the why and how of it all. Goldman and Burton were adamant that this mystery translate to the screen. "There had been some thoughts early in the process about whether the story should show its hand earlier," Goldman remembers. "Some people felt that the audience needed to know exactly what Jake is trying to achieve when he goes to the island, that he should have a task and a goal. I think Tim and I were both always united in feeling that the story should be driven in a quiet way by mystery, rather than be goal-oriented, not a 'the hero must achieve this' kind of thing."

As with any adaptation, hurdles sprang up during the process, which necessitated departures from the source material. "The book is complicated from a rules standpoint, and in a couple drafts of the script we found that there was a lot of exposition," Topping reflects. "To Tim's credit, halfway through that process, he said, 'Guys, you know, this is dull enough. Nobody cares about the gobbledy-gook. I want this to be a much more visceral, emotional experience.' So he took [the exposition] way down and assumed that people would be able to fill in the gaps on their own. And that's when the script really gelled."

Another challenge was handling the story's large number of characters. "You have to give each character a moment showing their peculiarity," Frey notes. "Yet there's so many children in this film. To find that balance was a real undertaking." One of the changes that helped showcase each character was something that everyone agreed would be good for the film: extending the ending and creating a grander finale. "That's unusual for an adaptation," Goldman says. "Often you're having to cut things out, but this story was so beautifully and succinctly told that we felt it could continue for a little. So the final third of the movie is extended with new ideas, adding and building onto what's in the book."

"The third act is quite different from the book, in terms of how it plays out," Topping adds. "It's something we discussed extensively with Ransom. He's been our partner completely, and we want fans to understand that the changes are something we had to do for the film. It's not in any way a defiling of the book."

"It's very strange, having a book adapted into a movie," Riggs confesses. "The process is not straightforward. I feel like the *Miss*

Peregrine fans have a conception that the best movie adaptation is just like the book. Maybe because I've been in film a bit myself, I have a different point of view. For me, the best adaptation is not always the most faithful. The movie should be as interesting as it can be; not just a filmed *Cliffs Notes*. If you read the four-hundred-page book out loud, it would take seven hours, so you have to condense and do all this magic and alchemy to shrink that story into a smaller thing. You will have to change parts, and sometimes you have to make improvements. You have to make it cinematic. Even though we sometimes say, 'Oh, your book is very cinematic,' still so much happens in the head of the character that inherently it is not really so. That little bit of magic I don't fully understand. I think the process looks a lot easier than it is."

One of the bigger changes fans will surely notice is that the main female character, Emma Bloom, has traded her peculiarity with that of Olive, so that Emma is now lighter than air and Olive controls fire. The change arose through early conversations between Goldman and Burton, before the script was even written. Though Goldman notes that they loved both abilities, they felt as if air had more untapped potential. "The fire ability just felt a little similar to things we'd already seen onscreen. Floating was such a beautiful visual; it was something that both Tim and I loved the idea of seeing more of. Also the peculiarity of being lighter than air could bring other facets to the story. It was partly to expand what Emma was about and being able to use that visual imagery in a fresh way." In particular, Goldman envisioned an underwater boat scene with Jake and Emma that significantly expanded the one described in the book. "Bringing in the underwater element seemed to tie in so organically with the air element," she continues. "That was a decision we wrapped up fairly early."

Riggs believes that although the peculiarities have swapped, the souls of the character remain the same. "Emma is still Emma," he says. "In the book, Emma starts off as this fiery, intimidating, frightening character. The first time we see her, she's holding a knife to Jacob's throat, but then she softens. Throughout the series, she becomes a more nuanced character who's still fierce and self-determined and fearless. Being someone who can control air—having this lightness about her, this sort of flowing character—jives pretty well with the series arc of Emma."

While Goldman was working on the script, Burton was finishing his previous commitments, namely the films *Dark Shadows* and *Frankenweenie*, both of which were released in 2012. In January 2013, Burton turned to his frequent collaborator Dermot Power, a concept artist, to begin working on the first visual exploration of *Miss Peregrine's Home for Peculiar Children*. "Dermot is a great artist," Burton volunteers. "He can adapt to different styles without me

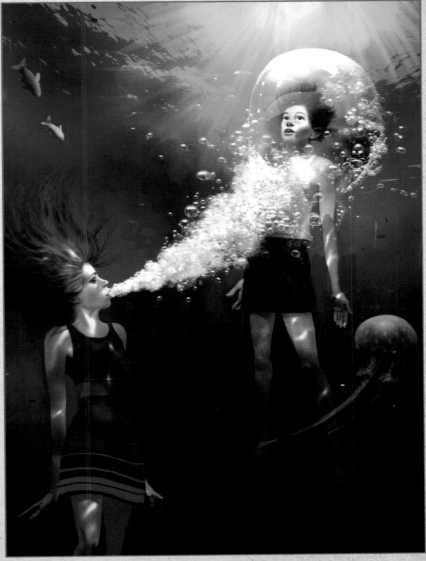

Early artwork by Dermot Power illustrating an underwater scene with Emma and Jake.

having to say much, but he also brings his own style to every project. He's good at getting into the spirit of the material."

Burton was busy promoting *Frankenweenie* on the 2013 awards circuit, but he took a quick break to speak with Power about the project, so the concept artist could begin work. Their communication occurred as much in a visual language as with words. "Tim draws and understands drawing, so he doesn't need artwork to be highly finished or realistic," Power explains. "I think he likes looser sketches, as they give him room to interpret and expand on the ideas presented. I see my role as raising questions, not answering them—particularly at the earlier stages of a project. Also, you have

> "Dermot is a great artist ... he's good at getting into the spirit of the material."

to make sure your ideas are in the illustrations, because Tim doesn't usually enter into protracted conversations about a design. He's much more likely to communicate with a quick sketch, which is useful because his drawings are economical and direct. Every line means something. I'll usually answer him with another illustration."

Burton's first instructions to Power were to think about the house. "I did a bunch of quick sketches very early on in the process," Power remembers. "Again, just to help Tim think about what the house might be like. I think the most useful images were the kids in the garden surrounded by giant trees. I was trying to show that they were hidden and protected. The architecture didn't matter so much as the atmosphere of the scenes."

OPPOSITE AND ABOVE: *A few of Power's many early concepts for the children's home.*

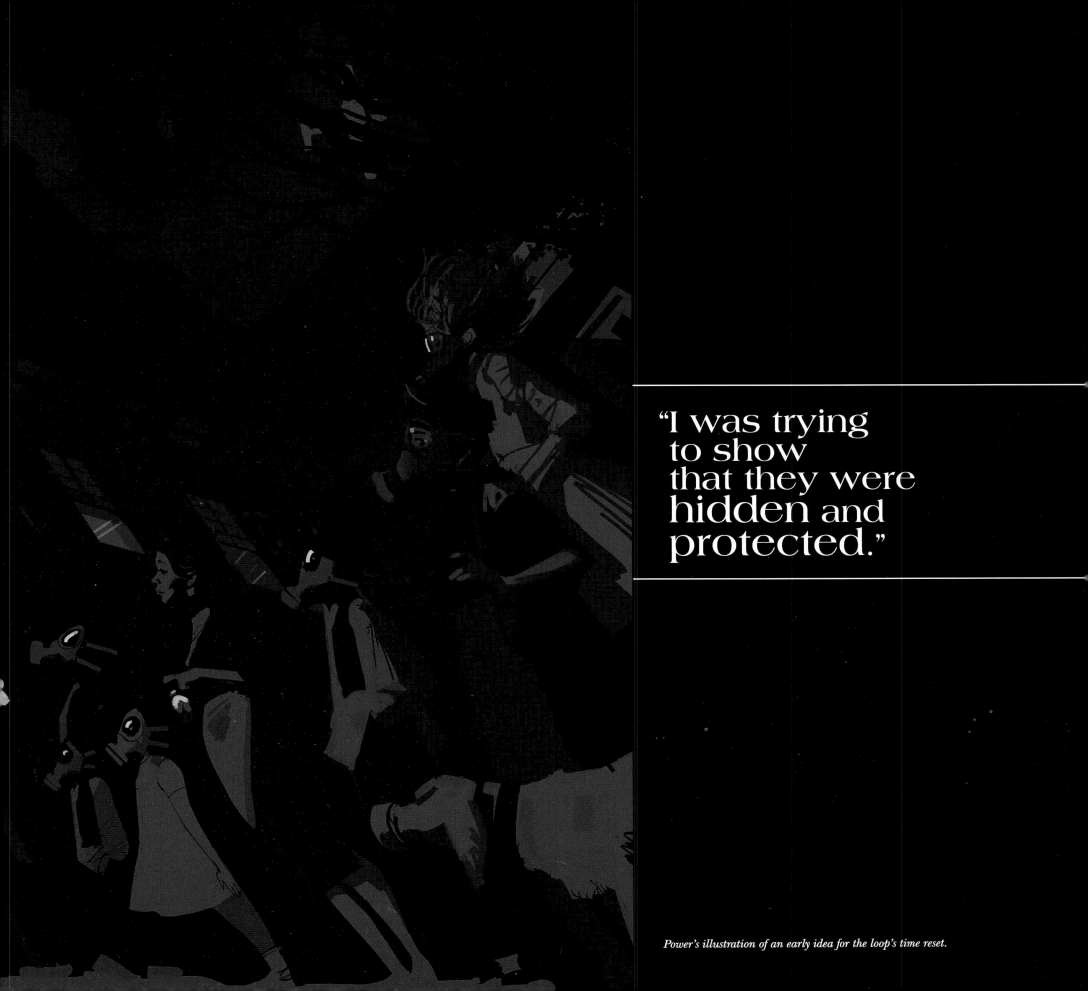

"I was trying
to show
that they were
hidden and
protected."

Power's illustration of an early idea for the loop's time reset.

Burton also directed Power to draw concepts for how the kids might look. "Tim mentioned that their 'peculiarities' were more like afflictions than superpowers, something they have to suffer but then learn to put to good use," Power reports. "So they look a little care-worn and weathered, which suited the war-torn Britain we were seeing in the research. The photographs from the original novel were very evocative and inspiring."

Power created his artwork digitally, using a catalog of research to which he constantly adds. He remembers the process of drawing Emma's boots, in particular, a feature that Burton emphasized was of great importance. "My main objective when I first drew the shoes was to make them an easy read—that is, I wanted big,

> ## "Tim mentioned that their 'peculiarities' were more like afflictions than superpowers."

clumpy, heavy boots that would anchor Emma to the ground," Power comments. With that in mind, he drew boots that resemble what a twentieth-century diver might wear. "Tim wanted them to be much fancier, and he did a beautiful sketch of an Edwardian-style woman's ankle boot—the complete opposite of what I'd envisioned. They still needed to read as 'weighty,' so that was a challenge. For inspiration, I looked at ornate metal nineteenth-century colt revolvers. The resulting boots read as metal and solid but still delicate and refined. A world away from the clumpy footwear I first drew."

"Emma's boots were a starting point for the character," Burton reckons. "I loved the dichotomy of Emma being lighter than air, and floating, but then being held down by these heavy boots. Heavy, yet still elegant. It's a graphic representation of being peculiar, learning to live with something that can be a burden, and that makes you different, but can also be quite beautiful."

Power's early concept for the gardens of the children's home.

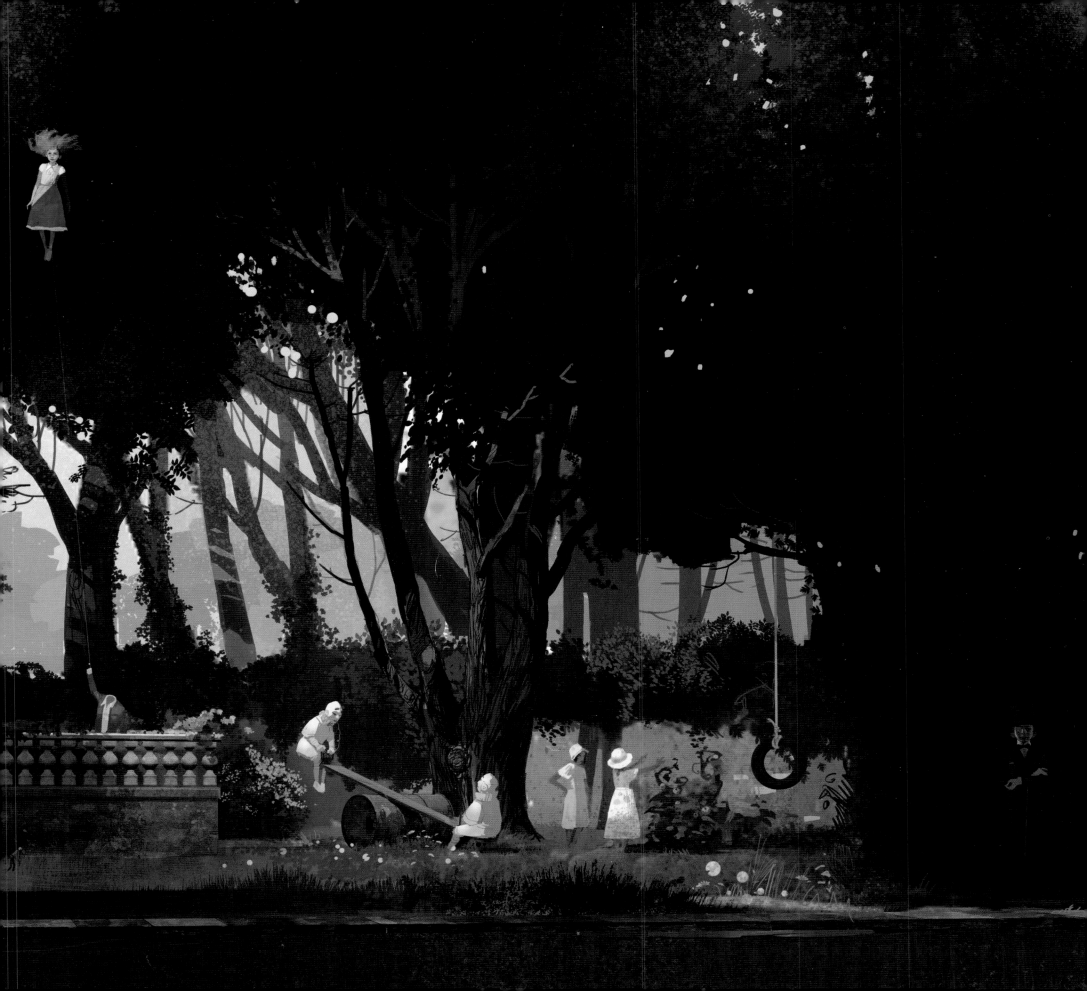

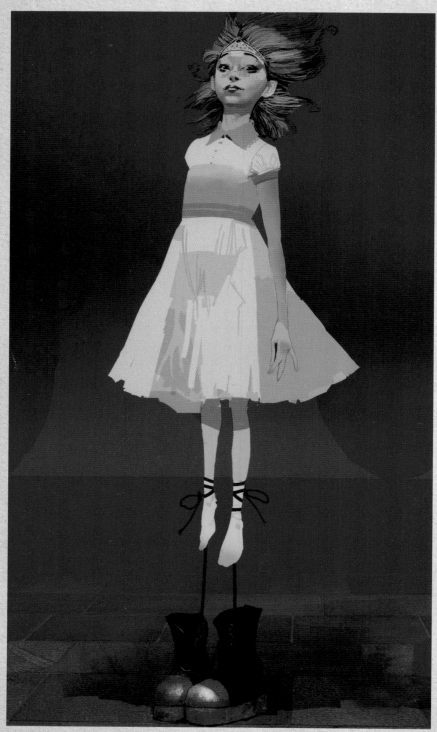

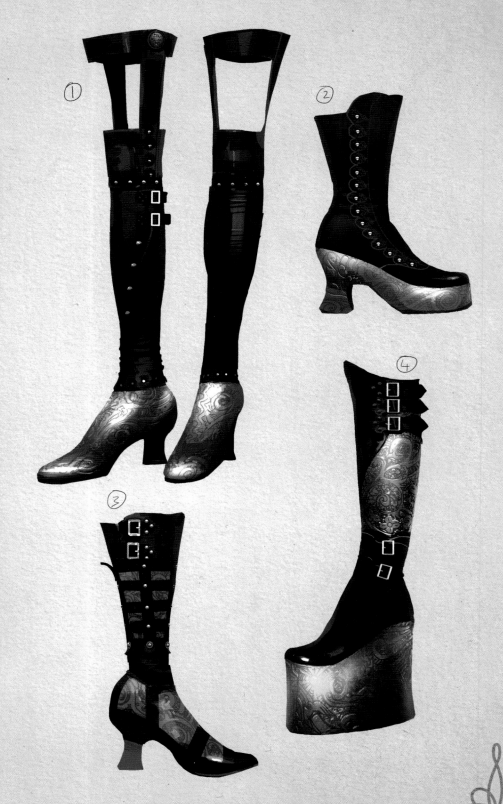

Power's early concepts for ABOVE AND RIGHT: *Emma and her lead boots;*
OPPOSITE LEFT: *Horace projecting his dreams;* OPPOSITE RIGHT: *Bronwyn lifting a boulder.*

By the time *Dark Shadows* wound to an end, Burton yearned for a break from big-budget filmmaking. The opportunity for a fresh perspective presented itself in the form of *Big Eyes,* a small non-studio project that he had been trying to produce. The film is a biography of the artist Margaret Keane, who achieved fame in the late 1950s and early 1960s for her paintings of saucer-eyed children. Burton had previously turned down the offer to direct, but the perfect confluence of circumstance and timing encouraged him to rethink this decision. Suddenly, *Big Eyes* appealed to him as a way to reconnect with a back-to-basics style of filmmaking. It was quick, down and dirty, and exactly what he needed. So, in 2013, he immersed himself in the project, putting *Miss Peregrine's Home for Peculiar Children* on hold.

Frey says the small film reinvigorated Burton and changed his approach. "*Big Eyes* helped connect him to the process of filmmaking again. He really enjoyed the experience and wanted to bring that same mentality to *Miss Peregrine's Home for Peculiar Children*, to try and keep things as grounded as possible and use real effects if he could." Burton wanted locations to propel the filmmaking. His new mantra—for the process to be as real and as location based as possible—would shape how *Miss Peregrine's Home for Peculiar Children* unfolded.

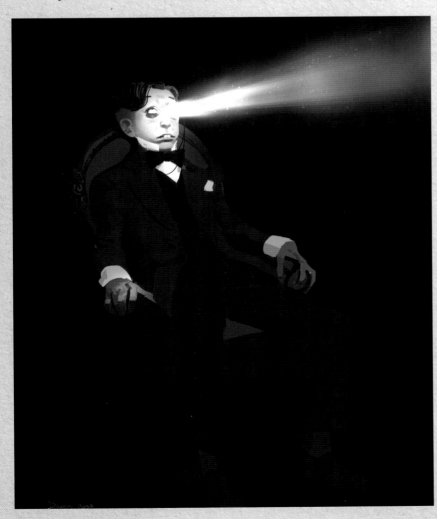

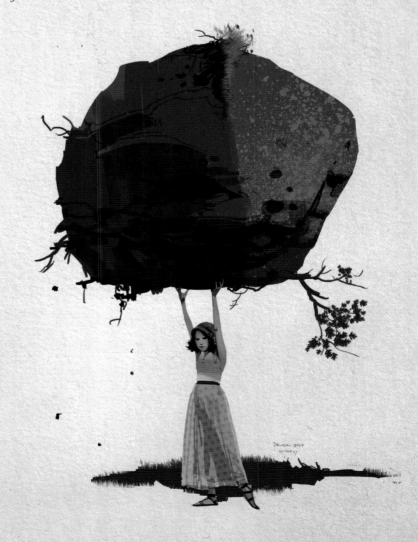

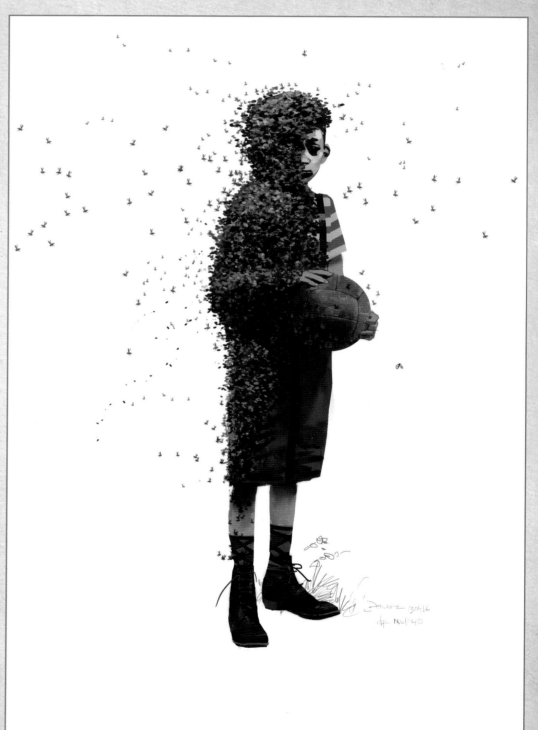

Power's early concepts for OPPOSITE TOP LEFT: *The twins and Bronwyn;* OPPOSITE BOTTOM LEFT: *Enoch introducing Jake to Victor;* OPPOSITE RIGHT: *Hugh and his bees;* ABOVE: *Fiona.*

2

Thinking Outside the Birdcage

CAST AND CASTING

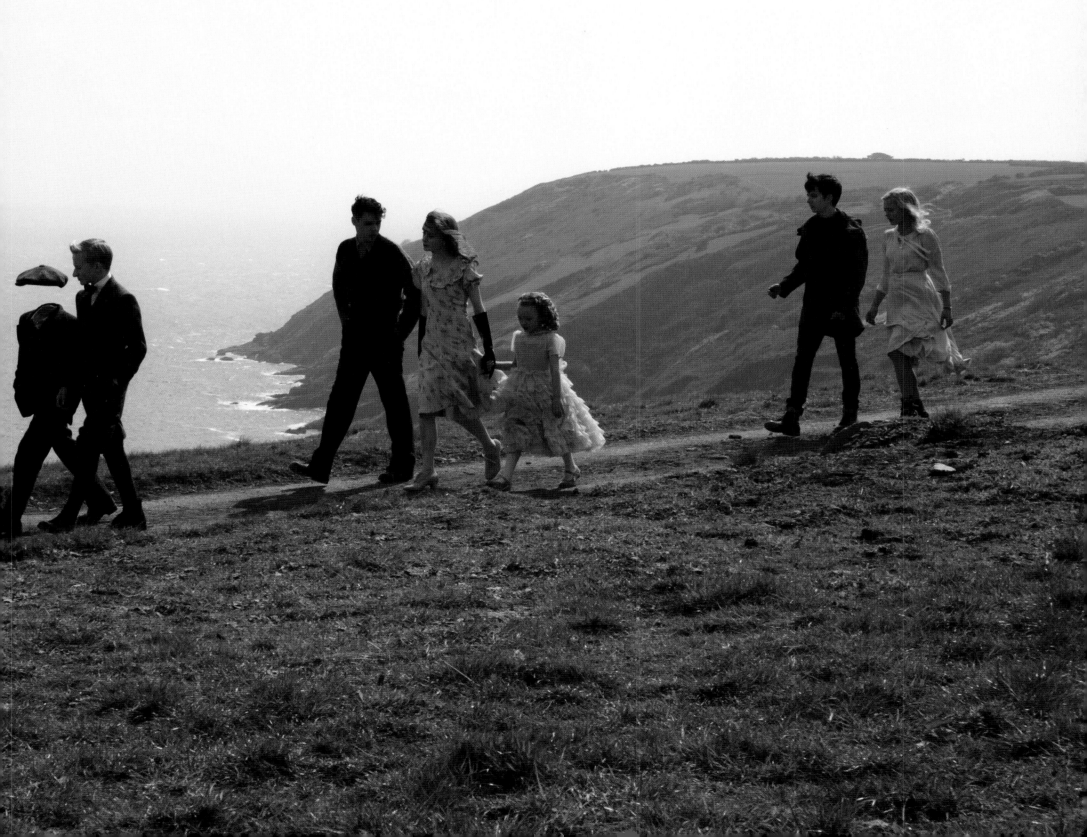

urton began casting for *Miss Peregrine's Home for Peculiar Children* (or *Miss P*, as it's often called) in early 2014, though he already knew the actress he wanted in the title role. He felt certain she shouldn't be too old or too severe; the ideal headmistress would need to strike a balance of stern, caring, and eccentric. Eva Green, known for such roles as Vesper Lynd in *Casino Royale* and Vanessa Ives in the TV series *Penny Dreadful*, was first and foremost in his mind. Having witnessed her take on a witch in *Dark Shadows* only two years earlier, he was confident she had the unusual aura he wanted. "I always thought of Miss Peregrine as a Scary Poppins-like character," Burton describes. "She is a strong, funny, and mysterious person who looks like she could turn into a bird. That's Eva."

"I tried to find a specific way of delivering my lines really fast. Like Mary Poppins on acid."

As screenwriter Jane Goldman explains, "Miss Peregrine is very precise, very scientific, very sensible. She's also nurturing. I love that there is always a rhyme or reason behind what she does, even though her actions seem completely off the wall. She's a fun character, a type that is more often a male. You don't usually see female characters who are allowed to be a little bit cold, a little bit crazy, a little bit unpredictable—on that kind of genius level. There's something slightly Sherlock Holmes-y about her. You know, brilliant but somewhat wrong in the head."

In the mythology of the novel and the film, Miss Peregrine is a *ymbryne*, a woman who can transform into a bird; in her case, she becomes a peregrine falcon. She also has the ability to manipulate time, creating a time loop—a 24-hour period that repeats itself—to protect her peculiar children. Those inside the loop never age. It's a place where peculiars can live in relative

safety, away from both the real world and their murderous nem-eses—the monstrous hollowgasts (called "hollows," for short). Green says she loves the character because of Miss Peregrine's devotion to her charges. "She is ready to die, to sacrifice herself for the children. The children are her life. It is the first time I'm playing a character without a love interest. It's all about the well-being of her children."

When researching the role, Green tells how she studied the creature whose form she assumes. "The peregrine falcon is a bird of prey, and it's the fastest animal on the planet. So I watched lots of documentaries about birds. That helped me tremendously to understand the physicality of the bird, like the sharp head move-ments and how to use my hands like claws. Also, because this falcon is known for its speed, sometimes I tried to find a specific way of delivering my lines really fast. Like Mary Poppins on acid."

For the remainder of the large cast, Burton hired his frequent

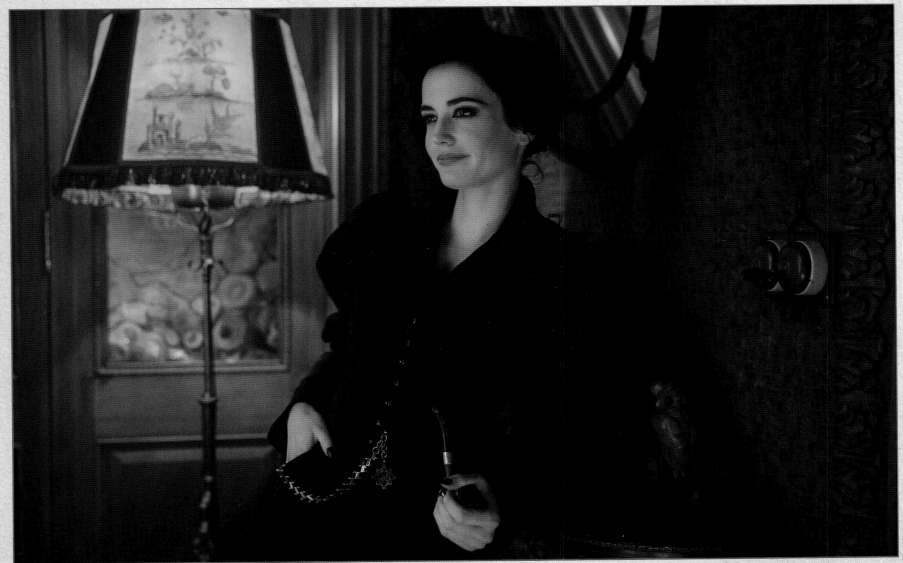

OPPOSITE: *A portrait of Miss Peregrine (Eva Green), part of a series that mimics the vintage pictures included in Riggs's novel.* ABOVE: *Miss Peregrine watches over the peculiar children under her care.*

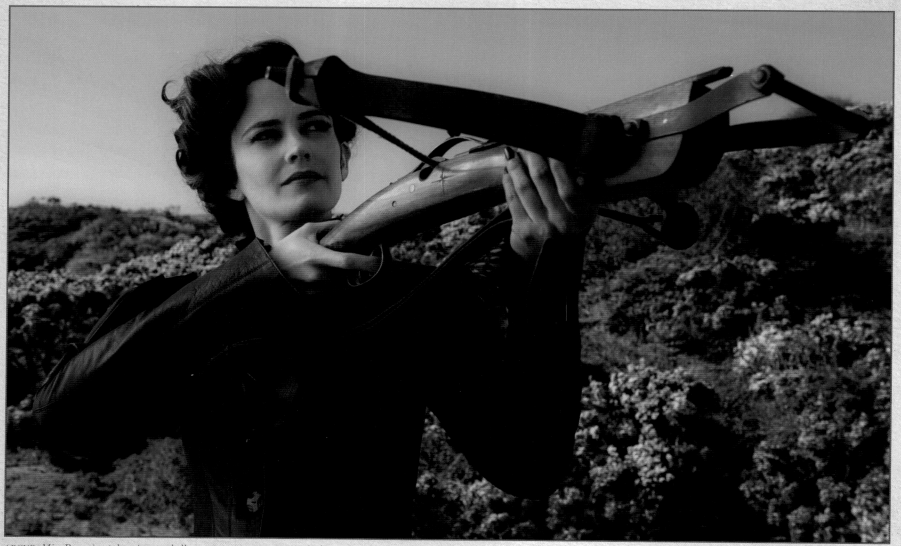

ABOVE: *Miss Peregrine takes aim at a hollowgast.* OPPOSITE LEFT: *Jake (Asa Butterfield) searches the woods behind his grandfather's house.* OPPOSITE RIGHT: *Jake, the film's protagonist.*

collaborator Susie Figgis, who also cast *Harry Potter and the Sorcerer's Stone*. Figgis's philosophy on casting was simple and counterintuitive. "People always think that Tim wants to cast weird and kooky people, and for this film, they think that everyone's got to be peculiar. I felt that what was really important was the opposite: to find people who were real and who touched you. Ultimately, it's about finding the least peculiar people. It's about those who feel uncomfortable living within the skin of normal life."

Once Eva was cast, next came the male lead. The film follows the perspective of Jake, a teenager who is propelled into extraordinary circumstances when his grandfather is killed by a hollow, the peculiar-killing monsters that only Jake can see. This tragedy propels Jake on a journey that eventually leads him to Miss Peregrine's time loop. Frey says it was obvious to Burton that the focus should be on finding Jake before any other roles were decided. "A cast of this size and makeup is particularly challenging; it's very much a puzzle," he notes. "You can't just dive into every role and start. You have to have an order. Jake is the central

character, and it was key to get that role right."

When Burton first pondered the role of Jake in early 2013, he considered Asa Butterfield, who had already starred in *Hugo* and recently finished *Ender's Game*. But Butterfield was too young. After time away from the project, Burton circled back to *Miss P* in 2014, by which time Butterfield had grown up substantially. Burton was certain that the young actor would make the perfect lead. He recalls: "I saw his [screen] test, and he had it, that blend of angst, innocence, and believability. He's not your usual action hero. He was earnest and vulnerable—he encompassed Jake completely."

Green describes working with her co-star. "Asa's very serious. He's extremely innocent, which is rare. He exudes an otherworldly quality, and that suits the character perfectly. There's something vulnerable about the way he plays Jake. It's very endearing, and he looks like Tim drew him."

Butterfield has his own views on Jake, who he says is a boy who thinks he won't make a difference in the world. "A lot of people just go about their lives thinking they're the most bog-standard person with a bog-standard life. The same goes for Jake, until he finds the children's home. He's not that sort of through-and-through hero. He's a kid who's been thrown out of everything he's used to, catapulted into this world where he is finally given an opportunity to make a difference. But it means letting go of

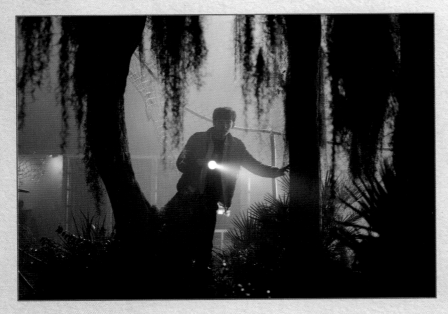

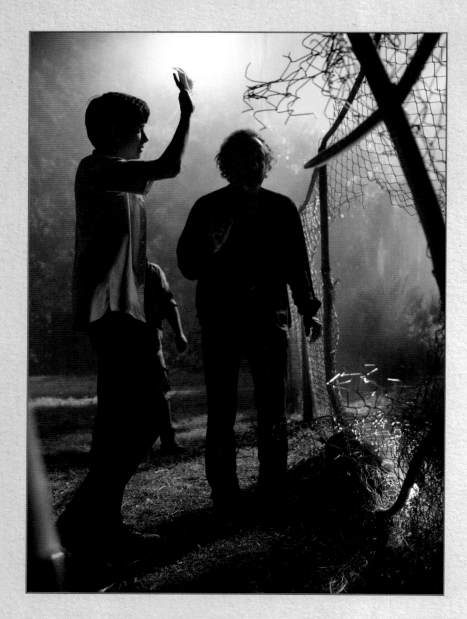

everything else and leaving behind normality. So it's a really big choice for him, and I think a lot of the time it's a choice we all have to make at some point in our lives. Take that big step."

Butterfield had read *Miss Peregrine's Home for Peculiar Children* along with its sequel *Hollow City*, and the novels influenced his interpretation of the character. "Both the screenplay and the story go hand-in-hand when creating the character. You do want to stay truthful to what's written in the book, but you also have to cater to what's going on in the film. I also try to bring something of my own—make it more personal to me. You need to do that in order to act the character, because you have to be able to relate to him and understand him. That's impossible unless you try to make those connections with yourself."

Though certain that Butterfield was the only choice for Jake, Burton and Figgis had to persuade the executives at Twentieth Century Fox, who believed he was too young. Figgis admits the job was hard. "Tim and I kept saying, 'Asa's six foot one. He's a handsome young man now,' and nobody was convinced."

Burton realized that a chemistry test was needed to sell Butterfield to the studio, and he began his search for the perfect female romantic lead who falls for Jake. Burton found his Emma in Ella Purnell, a teen star of such films as *Never Let Me Go*, *Kick-Ass 2*, and *Maleficent*. Topping praises the choice. "The second we saw her audition, she revealed a kind of mischievous sassiness, and also an otherworldly quality. You can imagine her living in some time loop on an island."

Purnell was brought in to test against Butterfield. It was a nerve-wracking moment for the actress, who remembers "sitting on the sofa, trying not to bite off my fingernails." She and Butterfield had been friends from their time at Young Actors Theater, a drama school, but neither realized it was the other they would

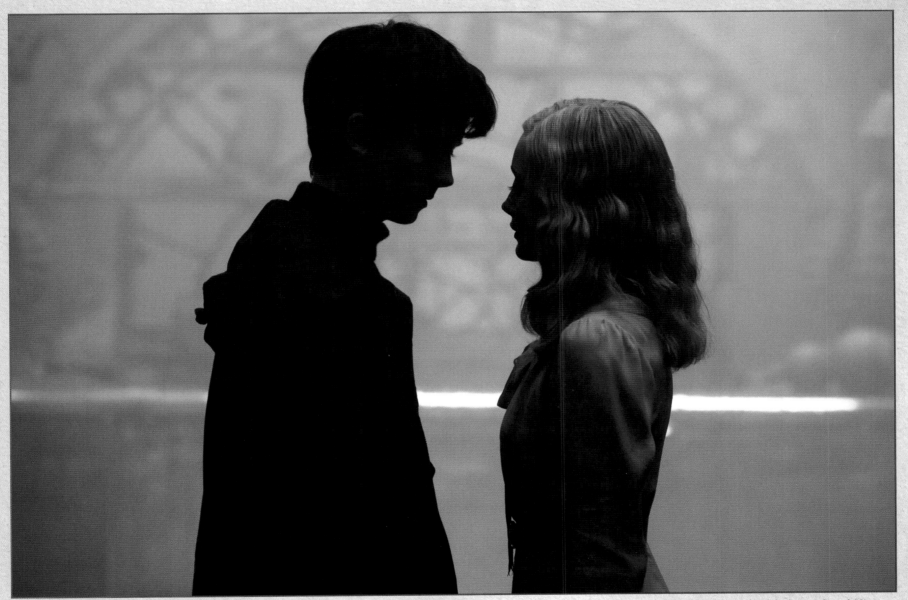

OPPOSITE LEFT: *Tim Burton directs Butterfield on how he should approach the fallen flashlight and ripped fence.* OPPOSITE RIGHT: *Jake meets Fiona (Georgia Pemberton), while the time-fixated Miss Peregrine chides the girl for her tardiness.* ABOVE: *Jake and Emma (Ella Purnell) share an intimate moment in the cocktail lounge of a sunken ship.*

read against. "The surprise on Asa's face that it was me of all people—he said, 'Oh, it's you! This is going to be the easiest chemistry test I've ever done 'cause obviously it's easier with a friend.'"

The screen test was everything that Burton and Figgis had hoped for. "There was this wonderful chemistry of these young people just at that point when you first meet somebody you really love, but you can't quite say it," Figgis marvels. "That was the touching quality that worked, and we sent it to the studio and they immediately said *fantastic*."

Butterfield was happy to be starring opposite one of his friends, offering his take on Purnell's character: "In the film, she's lighter than air and she can control it, too. She has a graceful approach;

"If I could describe Emma in one word it would be fierce."

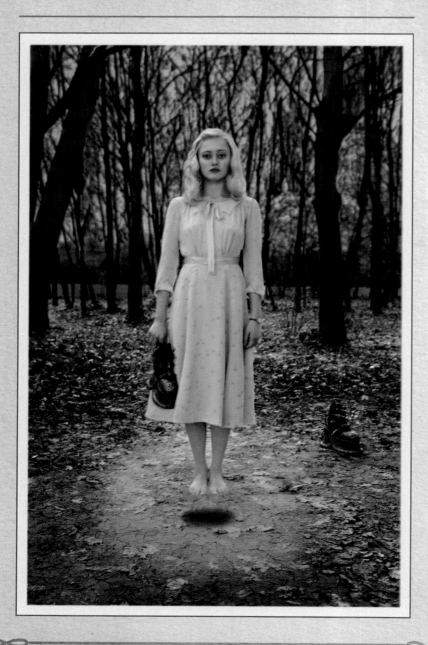

she's very airy and floaty, which is really cool. That contrasts with these lead shoes she's got on, which give her an extra five inches. She's smaller than me, but she gets a bit more height wearing these massive shoes. I think she enjoyed that quite a bit."

Purnell trained with a movement coach and choreographer, Francesca Jaynes, to achieve Emma's weightlessness. Jaynes, who had worked on four Burton films, describes working with Purnell long before the cameras started rolling. "Ella found it difficult to imagine what it would be like to be made of air. So I concentrated on the opposite: I asked her to imagine that her body was filling up with sand, making it really heavy. Then I asked her to imagine the sand was draining from her, right down her legs, out of her feet. Suddenly she started to lift. She understood it. That's all Tim really needed—something subtle, that feeling of lightness."

Purnell, who swam as part of her training routine, remembers one particular trick that helped inform her character's movements. "Francesca taught me to stand up, push my hands as close into my thighs as I can for thirty seconds, and then relax; my arms would naturally start to drift up. They don't go too high, but they kind of float here. Before every scene, I did that, just to give me that 'what it's like to be weightless' feeling."

Purnell and Jaynes also practiced how Emma's boots would affect her movements. "If everything is up, you constantly have to think up, but the shoes are also heavy," Purnell explains. "So it's up, down, up, down, all the time. It's always thinking that as Emma steps, she's heavy, and then, nope, she's floating up, but then she steps and she's heavy again. I find that now, even in my own walking—as Ella, not Emma—I still do that step thing. When my friends ask, 'Why are you walking so weird?' I say, 'I can't help it. I've just gotten into the habit of doing it.'"

Before settling into her role, Purnell explored the character online. "If I could describe Emma in one word, it would be *fierce*," she proposes. "But that's my interpretation; you could play her a thousand ways. The script is open to interpretation, and there are a lot of extra resources; there's a huge fan base behind the books. A million people have written their opinions of who Emma should be, and that was really good fun—researching her and thinking, you know, she could be shy. She could be the funny one. She could be this or that, whatever. But I think the important thing to

OPPOSITE: *Series portrait of Emma Bloom, whose peculiarity is air.* ABOVE: *Emma stands in front of Abe's wardrobe, about to find a tie for Jake.*

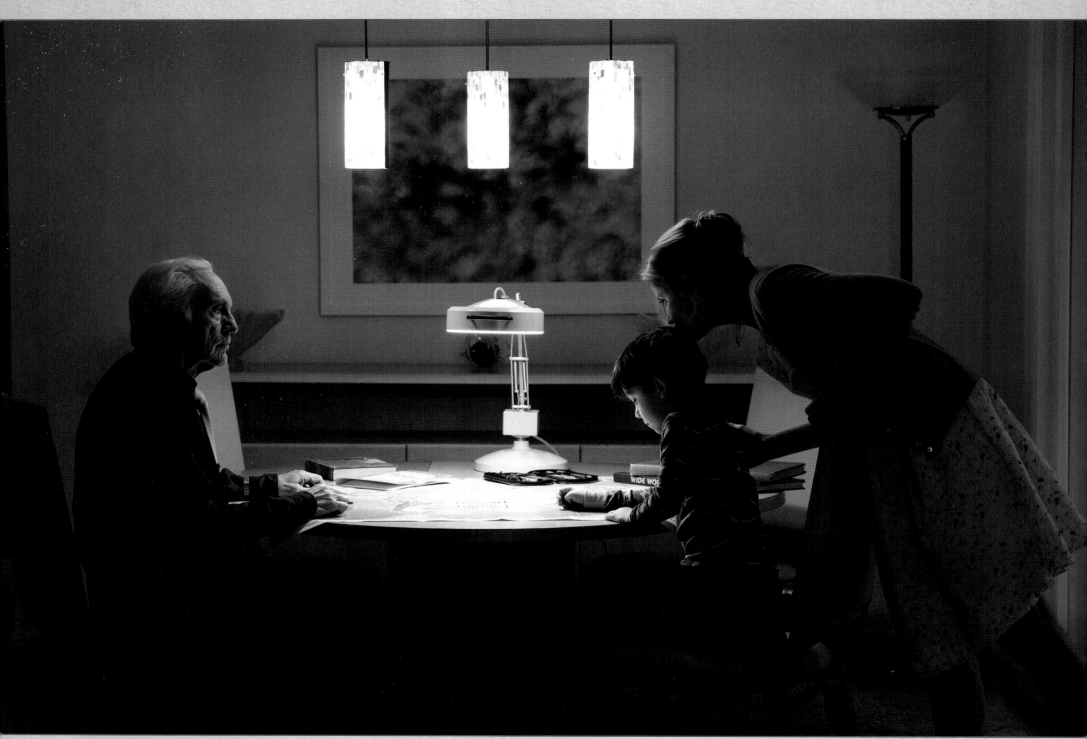

Abe (Terence Stamp) plots adventures for a young Jake (Nicholas Oteri), while his mother (Kim Dickens) arrives home after a night out.

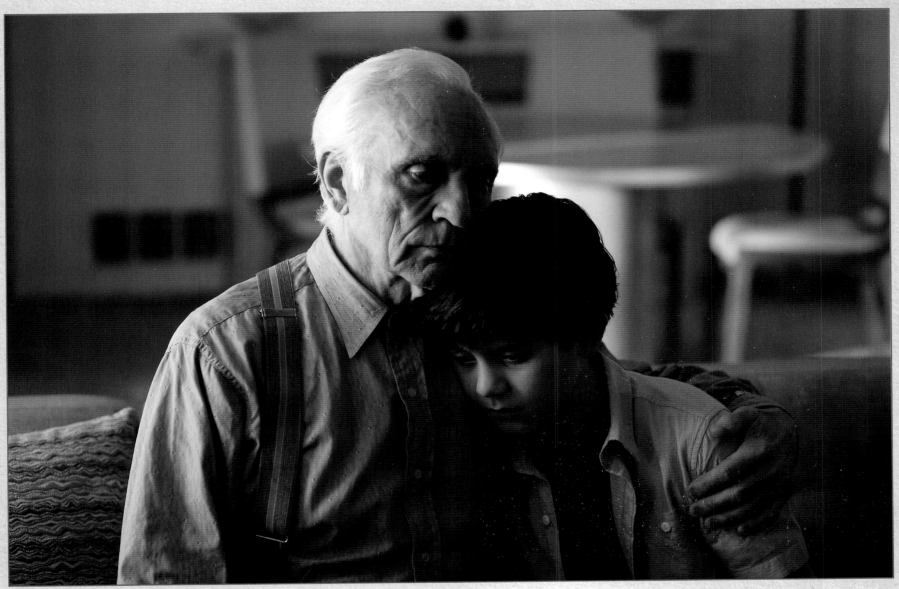

Abe comforts 10-year-old Jake (Aiden Flowers) after his classmates ridicule him for believing in his grandfather's peculiar photos.

remember is that she's loved and she's lost. Everything that goes on between Emma and Jake, it's gone on before. She knows it. She knows it's ridiculous to allow herself to fall back into this situation, but she does it anyway. That's the way the heart works."

The previous love Purnell refers to is the affection that existed between Emma and Jake's paternal grandfather, Abe Portman, back when he lived with the peculiar children in the 1940s. Gold-

man remembers that not everyone was comfortable with translating this aspect of the book onto screen. "We had many discussions about the fact that, in the book, it's clearly implied there was a great love, a physical relationship, between Emma and Abe, and some felt that might creep people out. Both Tim and I believed that somewhere in the middle was the appropriate way to go—that of course there was a love and a caring between Emma and Abe,

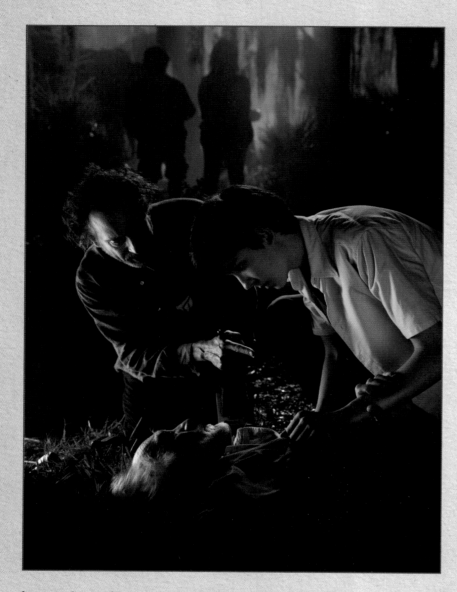

integral to the plot, for the character looms over the entire film. "It was an honor to work with Terence Stamp on *Big Eyes*; he's one of my heroes. I loved him as Toby Dammit in *Spirits of the Dead* and as General Zod in *Superman II* among so many other great roles. As soon as I started to think about the role of the grandfather, Terence came to mind. He had to come across as a strong character with only a brief amount of screen time. Terence has a powerful presence, and when Asa was cast, I then knew he had the necessary physical resemblance as well. He was perfect."

Stamp clearly remembers the letter Burton hand wrote to ask him to consider the role. "He told me that it's a very small part, but I could see when I read the script that it was a small part that kind of tethered the whole trajectory of the story. He wanted somebody who was the right archetype. What intrigued me was that Tim wanted me to play a storyteller. About a year earlier, I had one of my yearly meetings with the wonderful Julie Christie, and suddenly, in the middle of our Saturday morning chai, she said, 'You know, you just think that you were destined to be an actor and that's your big talent, but I think your biggest talent is a storyteller.' It was apropos of absolutely nothing. So when I got this offer, I thought, 'Wow, yeah, well, we'll see.'"

The storyteller aspect is also a quality that Goldman appreciates about the character. "Abe is an optimist in that he creates magic and has dealt with his hardships in such a touchingly courageous way," she relates. "It's one of the things I really loved from the book, and what I found very touching was that Abe speaks of monsters in regard to his childhood experiences; that's interpreted by the family as a euphemism for the horror of Nazism and the horrors of war that he experienced. That carries throughout the story. There are fantastical monsters, but there is also that shadow that human beings are, of course, the worst monsters of all."

The bond between grandfather and grandson lies at the heart of the story. It drives Jake's entire journey, so Frey says establishing the connection between them, with such little screen time, was crucial. "It's as if there's a connection between them caused by the peculiarity gene, which skipped a generation, heightening the bond between Abe and Jake. It's something that Jake doesn't get from his relationship with his father. I think a lot of people have experienced that, feeling a heightened tenderness for a

but perhaps the relationship is not as full blown as it was in the book. Certainly Emma has been deeply hurt by Abe's decision to leave and by the fact that he went on to have a life, one that included children and grandchildren and all the things she fears she will never have. He was able to grow up [unlike peculiars in a loop, who never age], and that's what drives the complications with Emma's memories of Abe and her feelings for Jake."

The casting of Abe Portman was a decision Burton contemplated for a long time. Though the role is small, Burton says it's

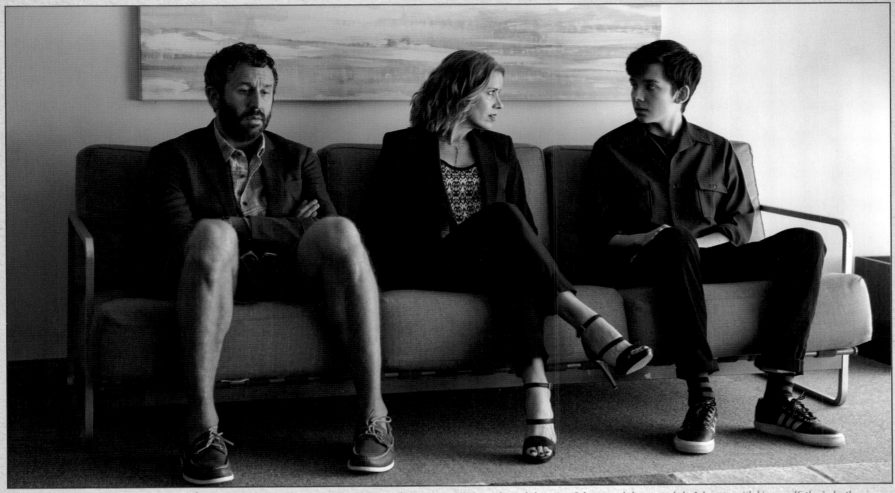

OPPOSITE: *Burton directs a tragic moment between Stamp and Butterfield.* ABOVE: *Frank (Chris O'Dowd), his wife, and their son, Jake, attend therapy to help Jake cope with his grandfather's death.*

grandparent. You don't have the baggage with them that you might have with a parent."

Stamp offers a more spiritual take on the relationship. "I've always believed that the greatest relationship a child can have is with a grandparent. There's a kind of mystical reason, which is that the grandchild has just arrived from where the grandparent is going. So they have a kind of mutual giving to each other."

Jake's life spirals into chaos when his grandfather is attacked by a hollowgast. Jake arrives at the scene in the moments before Abe dies, just in time to see a hideous creature that no one else can see. The trauma and surreal quality of the episode cause him to question his sanity. As Butterfield puts it, "It really tears him

apart and damages him mentally. That relationship is really important to understanding all of Jake's actions."

Though Jake was close with his grandfather, he is at odds with his parents. "Jake's mom is neurotic. She means well, but she's the kind of woman who would drive you crazy," Goldman observes. "Frank is also extremely well-meaning but just frequently gets it wrong in terms of not really being in tune with his son. Perhaps not trying as hard as he might to truly listen to Jake and take him for who he is and what he wants. But for me, it comes from an empathetic place, where I think it's tough as a parent to gauge that exact moment when your teenager is no longer a kid. So, whilst Frank and Jake's mom [who remains unnamed in the film] have

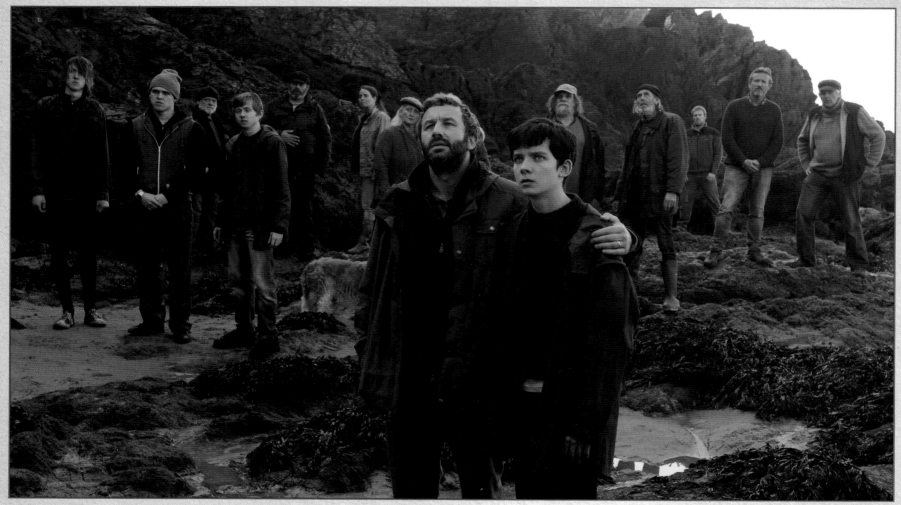

Frank and Jake deny any involvement with the death of the Cairnholm native named Oggie.

their irritating qualities, I also have great sympathy for them."

For Jake's hapless father, Burton cast Chris O'Dowd, of *Bridesmaids* fame, much to the approval of Topping, who had already worked with the actor on *St. Vincent*. "Tim kept saying, 'I just want somebody real, and I want somebody who's not a stock, asshole dad; I want somebody who encapsulates both warmth and dad-ness, but also someone who just doesn't get Jake,'" Topping remembers. "You have to believe that there's that classic communication gap. Chris is so facile and can fine-tune anything."

O'Dowd believes the film is about father and son relationships. "My character didn't really have a relationship with his

father," he says. "He was always away, and Frank thought he was having affairs. Frank didn't really trust him, didn't really like him. And then he found, as his own son was growing up, that his son had a great relationship with his grandfather, which is what often happens. As the story progresses, you begin to understand why his father was away so much. In the course of the story, his relationship with his own son develops a lot. So it comes full circle."

To play the mother, Burton turned to Kim Dickens, best known for her work as the hard-nosed police detective in *Gone Girl* and as a mother on *Fear the Walking Dead*. "I don't even have a name in the *Miss P* script, and that's purposeful, I think," Dickens theo-

rizes. "We are a part of Jacob's character that he doesn't identify with. He feels odd in our world. Everything sort of seems perfect, but he doesn't feel perfect there. He feels unusual and peculiar."

To help her son cope with his grandfather's gruesome death, Jake's mother puts him in therapy. The casting of the therapist was more difficult than one might think, because the character is one facet of a much larger role—a shape-shifting villain named Barron. "Like all good bad guys, Barron is charismatic," Goldman reveals. "He's got leadership qualities. As a peculiar, he also has

"In lots of ways the film is about fathers and sons and their relationships."

the extremely useful and unsettling ability to shape-shift, which made him enormous fun to write and play with, and it's a lovely surprise in the book when you discover that. A lot of the people you've been encountering are all the same person. So we wanted to capture that fun and the twists and surprises whilst also having a particular villain we could really focus on."

Because Barron has three faces, Burton first had to decide if it would be one actor in three roles or three actors for one role. It took him a while to settle on what route best suited the story, eventually deciding on three actors so that the reveal would be more of a surprise. Once the decision was made, he had to choose who would play Barron in his natural state before he could figure out his shape-shifted forms. Susie Figgis recalls the day Burton told her the actor he wanted. "I had a list of names, and I went to Tim's office one day to discuss this part. As I always do, being the optimist, I put two hours' worth in the meter and I'm always out after about eight minutes. I don't know why I never learn my lesson. He looked down the list. He said, 'I like Samuel L. Jackson.' That was it."

Jackson, known for his prolific and varied roles, from brittle-boned Elijah Price in *Unbreakable* to a bible-quoting murderer in

Pulp Fiction, agreed to play the part. The announcement generated a lot of excitement from Burton's camp. "Sam Jackson is someone that Tim's been a fan of for a long time," Frey reveals. "He had an opportunity to meet Sam on the awards circuit, and that's when the wheels started turning and Tim realized that he would make a great Barron. Really throw people a curveball. See Sam Jackson in a way you've never seen him before, and have a great deal of fun while doing it. Sam goes for it. He can play a villainous character, but you love him."

"I've been a fan of Sam for a long time," Burton agrees. "He's another iconic actor that I've always wanted to work with. I knew he could bring so much to the role. He was great—funny, scary—like a weird Halloween costume come to life. He was yanked, hit, wired, set on fire, attacked by children, blown by wind machines, all while wearing white contact lenses—it isn't as easy as it sounds."

In the film, Barron was once the head of a scientific organization whose members captured an ymbryne in the hopes of gifting themselves with immortality. The experiment went horribly wrong, turning Barron and his associates into hollows—invisible multi-tentacled monsters whose only hope of regaining a bit of humanity is, perversely, to chase down other peculiars and eat their eyes. After ingesting enough eyeballs, Barron turns into an "ex-hollow," visible and human-looking, though his irises remain

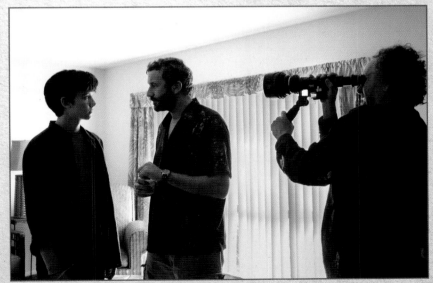

Burton peers through the viewfinder to find the perfect lens for a shot of Butterfield and O'Dowd.

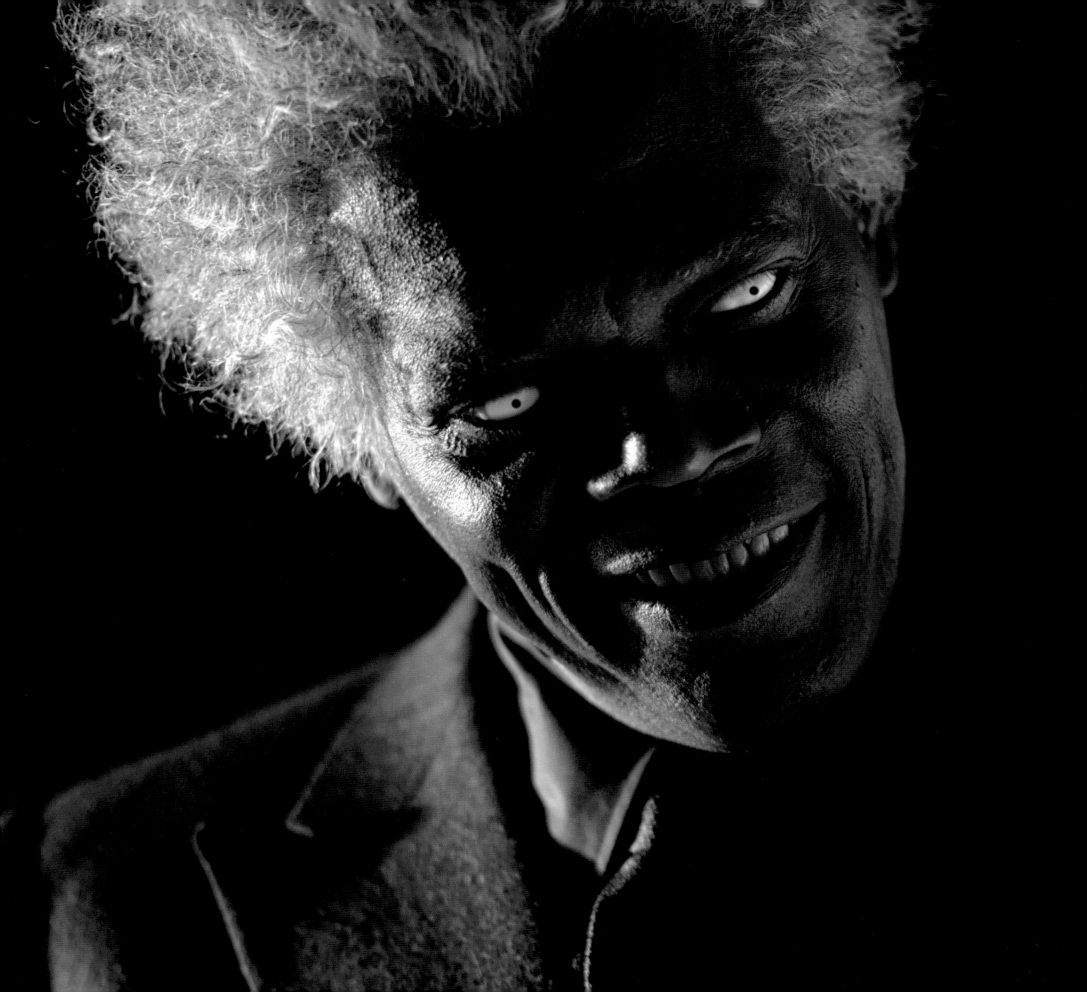

white with pinpoint black pupils. Jackson read the book and compares his take on the character to the version laid out in the novel. "I ended up having more fun being Mr. Barron than the book character, in terms of the psychosis he has, because he's still not quite human or back to human. There are moments when the madness takes over, and there are moments where his humanity is present, and it's not always driven toward finding the ymbrynes. It's not always something that's terrifying and mean. There are moments when he enjoys himself. There are moments when he looks at the kids and he thinks they're cute. I started to use those things that were kind of personal things of mine to make the character, I don't want to say more palatable, but more interesting and accessible to an audience."

> ## "There are moments when he looks at the kids and he thinks they're cute."

Butterfield praises Jackson's performance. "He does a phenomenal job of capturing this insane psycho killer who's so power hungry and crazy that he justifies all the things he does. He's so convincing that he almost justifies it well enough. He's got some pretty good reasons behind everything he's doing, even though obviously they're really not good, but it is quite clever how persuasive he is. And when you see him, with his voice, his hair, his makeup, and his big white eyes—it's terrifying."

With Jackson cast as the "main" Barron, Burton could then look for the shape-shifted alternate versions of him. The first takes the guise of Jake's psychiatrist, Dr. Golan, who is ostensibly trying to help her patient overcome the trauma of his grandfather's death. In reality, Barron is using Jake to find Miss Peregrine, whom he needs to conduct a sinister experiment. "Tim had such

a genius idea for this character and, in fact, for Florida in general," praises Topping. "There's something a little bit off about it that you can't put your finger on. It's weird, suburban life in America. Dr. Golan represents that reality in the sense that she seems fine. She seems like a reasonable person to go to when you have a problem. But there's something weird about her. It's part of the way most kids feel when growing up. Adults never really understand you, they never really listen to you. So that's one of the things I love about Dr. Golan. She sets the tone for the movie in

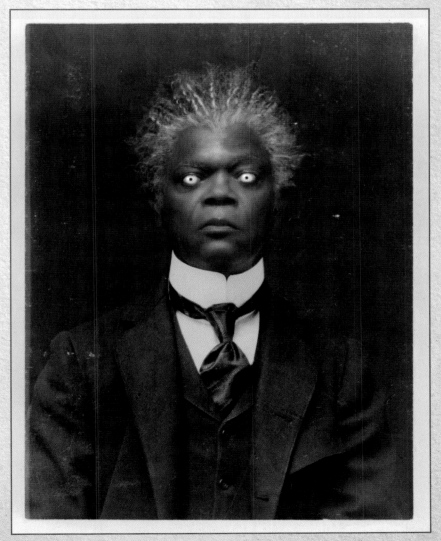

OPPOSITE: *The menacing Barron (Samuel L. Jackson).* ABOVE: *Series portrait of Barron, an ex-hollow who can shape-shift.*

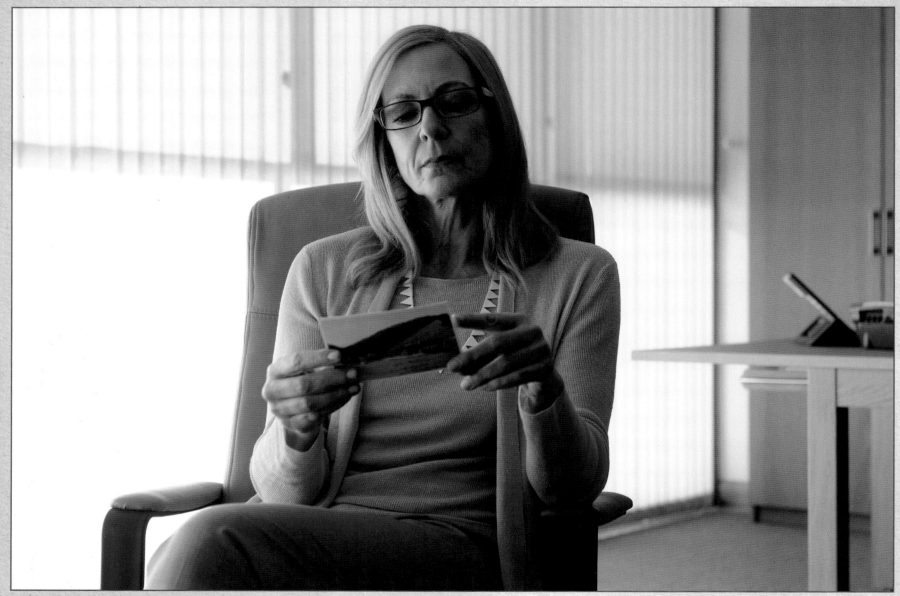

Dr. Golan (Allison Janney) reviews a postcard found by Jake. Her advice to travel to Wales for closure is self-serving: she is a shape-shifted Barron looking for Miss Peregrine's loop.

a really interesting way because here's an adult you're supposed to trust. You have every reason to think she is an expert in her field and she's going to help you get better. But really it's bull."

Burton asked Allison Janney, an Emmy Award winning actress known for her role as C. J. Cregg on *The West Wing*. When she heard the name "Tim Burton," Janney jumped on board without even reading the script. When she did, though, she says it was beautiful. "Besides Tim Burton, what attracted me to playing the part of Dr. Golan is when I realized that I shared the part with two other actors. I just thought that was going to be a pretty cool party trick." In the Florida scenes, however, Janney played the therapist without any hint of Jackson. "I can't give away the secret.

I just have to play her straight, as if Dr. Golan is a psychiatrist in Florida. And I have to be absolutely true to her." There is one moment in the film when the Barron trio morphs from one character to the next. "I was trying to see my line and sort of figure out how Sam would say it and the cadence he would use, and I was having fun with that." Later she jokes, "I am just going to blow Sam away with *my* Sam."

It is Dr. Golan who points Jake on the path to Wales to research his grandfather's history, secretly following him in a shape-shifted form in the hopes of discovering Miss Peregrine's time loop. Jake is accompanied by his father, Frank, who reluctantly agrees that the trip could be closure for his son. He also sees it as an opportunity to pursue his own hobby of ornithology. While in Wales,

> ## "What attracted me to playing the part of Dr. Golan is when I realized that I shared the part with two other actors."

Frank and Jake encounter the third face of Barron, in the form of another ornithologist. For this character, Burton wanted someone who looked like a handsome, successful, posh Englishman, in direct contrast to Frank, who is a bit unkempt. He turned to Rupert Everett, an English actor known for *Cemetery Man* and *My Best Friend's Wedding*. Everett agreed to join the cast, and his philosophy proved to be similar to Janney's: he, too, played the character straight. "There's no shadow of Barron's character in the ornithologist beyond the fact of him tracking Jake and Frank," he says. "The ornithologist is really a role that had to play in tandem

with Barron and the psychiatrist," Frey notes. "These all had to be dynamic and quite opposite roles. Rupert is someone Tim felt fit the characteristics of the ornithologist he was looking for. Someone who's typically English, a little snooty, mysterious, always kind of creeping around, constantly looking around the corner. Rupert pulled that off perfectly; he encompasses all those characteristics. And he couldn't be more opposite from Sam Jackson as Barron or Allison as Dr. Golan."

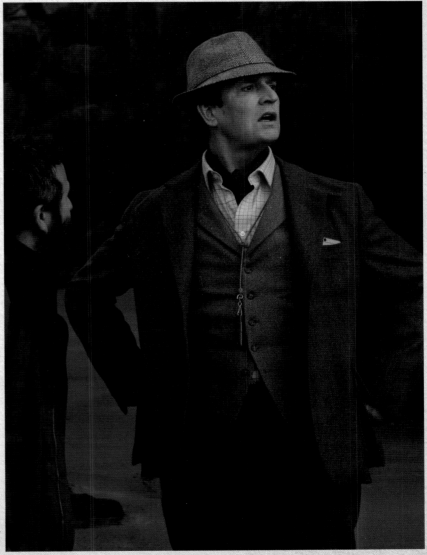

On Cairnholm, Frank meets an ornithologist (Rupert Everett) who is in fact Barron in disguise.

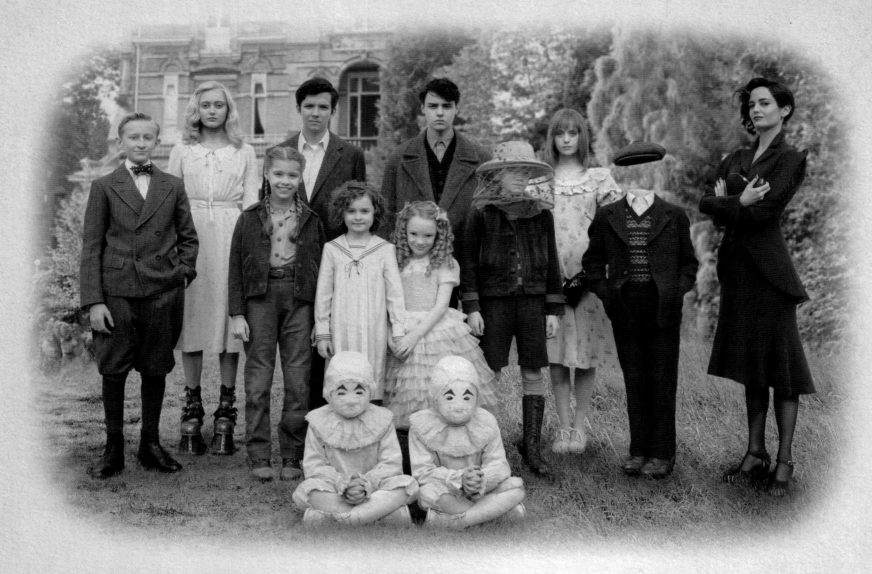

A photo of Miss Peregrine's loop that appears as a prop in the film. Butterfield body doubles for Terence Stamp, who was later added digitally.

Once on the island, Jake begins his exploration and discovers Miss Peregrine's time loop. After passing through its entrance, Jake finds himself in a repeating day in 1943 and a large mansion where eleven children live under the care of Miss Peregrine. Each child is unusual and unique, and casting these characters was an exacting process that took Burton nine months. "It was a lot of kids," he admits. "A lot of auditions. Each role was very specific and had to work within the context of the other kids who were cast. But gradually they fell into place one by one, and I think they complement one another really well—a miniature dirty dozen."

"Susie collected these children for Tim to look at, and, across the board, she hit it out of the park," Frey adds. "You couldn't really have two children with similar physical characteristics, even height. She gathered a nice mix and match of actors who were all distinctive. You have to be able to grasp who they are, what they look like, and how their powers go in tandem with their distinct looks. I feel like each child really does that perfectly."

Because the peculiar children repeat the same day again and again, they have lived decades longer than their apparent age. Goldman remembers that when crafting the script, this particular element in the story was a point of discussion. "There were many debates. I think Tim and I were on the same page, that whilst they have lived long lives, it wasn't a vampire troupe, where you've got someone who might look twelve, but they're actually a hundred and eighteen with the commensurate life experience. The difference with the children who live in Miss Peregrine's home is that they've been completely protected from the outside world. They haven't had the life experience that would make them young-looking old people. It's also Miss Peregrine, the way she treats them; they are essentially arrested in their development at that age. So although they may technically be much, much older, I think they are genuinely teenagers and children who have stayed that way for a very long time."

When Jake arrives, most of the kids are thrilled to meet someone new. Enoch, however, doesn't hide his distaste. His talent is particularly macabre—he can bring dead or inanimate objects to life by using the hearts of other previously living creatures. Goldman loved writing about his peculiarity. "That was enormous fun, and I think both Tim and I enjoyed thinking of loads of really gruesome things Enoch could do that he wasn't allowed to. He's obviously such a dark and broody character. Someone who isn't inherently bad. I think he's just troubled. He's a rebel."

Two taped auditions and one in-person meeting later, Burton had found his rebel in newcomer Finlay MacMillan, who Topping asserts is perfect for the part. "Enoch was a really crucial role because he had to be a rival to Jake. He had to be a little bit sexy, a little bit dark, but not depressing. And Finlay has a sauciness to him that's fun. It's not a bummer or a downer. It's like, oh, that's the kid who plays with dead things. It's kind of cool."

"Enoch gets very jealous when Jake comes on the scene," MacMillan remarks, "because he thinks, hmm, there's another guy here, you know? In some respects, he feels like the alpha male." Goldman says it's also his unspoken feelings for Emma that turn him so surly when Jake arrives. "I loved the notion that Enoch's always had a soft spot for Emma. And that even after Abe's departure, Emma still wasn't interested, and Enoch hasn't

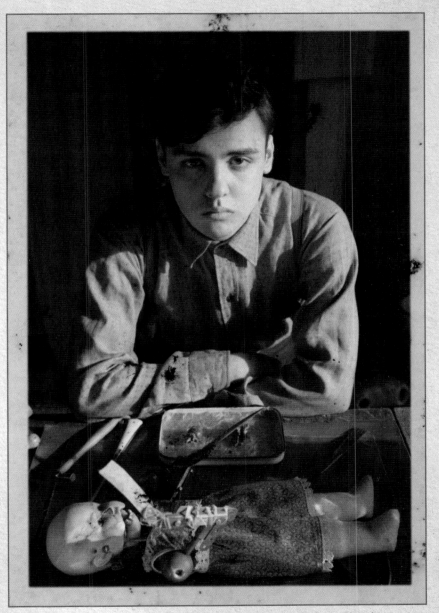

Series portrait of Enoch (Finlay MacMillan), a peculiar who can animate an object by inserting another creature's heart.

really accepted that. So when Jake shows up, naturally he's threatened. He immediately sees there's a connection between Jake and Emma, and so, as far as Enoch's concerned, Jake is the worst thing that could have happened to the house."

The other elder of the group is Olive, whose film character

has adopted the power of fire that the character of Emma possessed in the book. She keeps her hands in gloves to protect those around her from her scorching fingertips. "Tim was looking for someone to be a bit delicate, to act as a balance to this power of fire," Frey explains of their casting search for Olive. "She's not someone who is necessarily fiery in persona. She's quite the opposite."

Lauren McCrostie auditioned for the part but didn't hear any news for seven months. She was convinced it had gone to someone else. Then her agent emailed and asked if she would like to meet Tim Burton. She couldn't believe her good fortune.

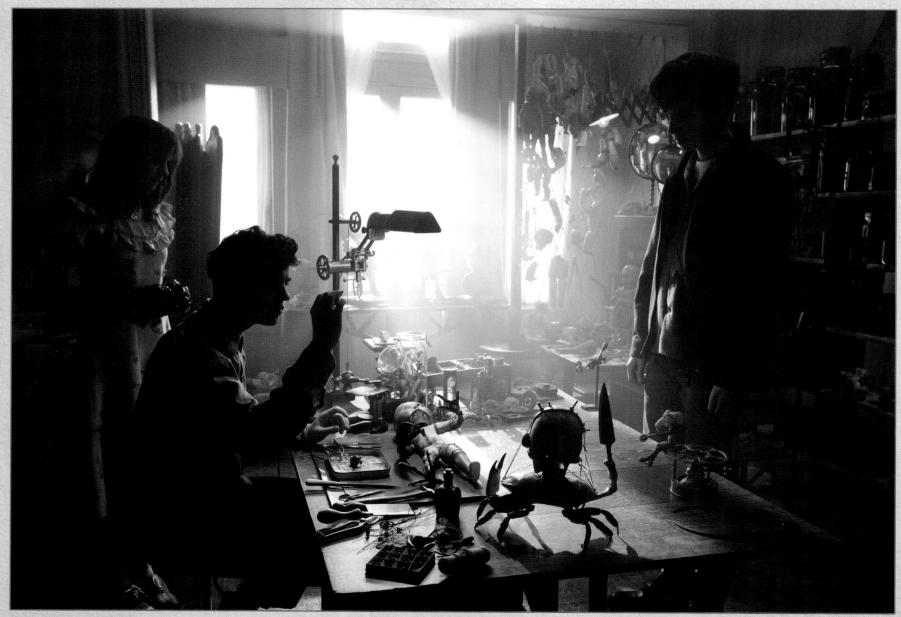

Jake visits Enoch's bedroom-turned-lab as Enoch uses rabbit hearts to bring his dolls to life. Olive (Lauren McCrostie) watches adoringly.

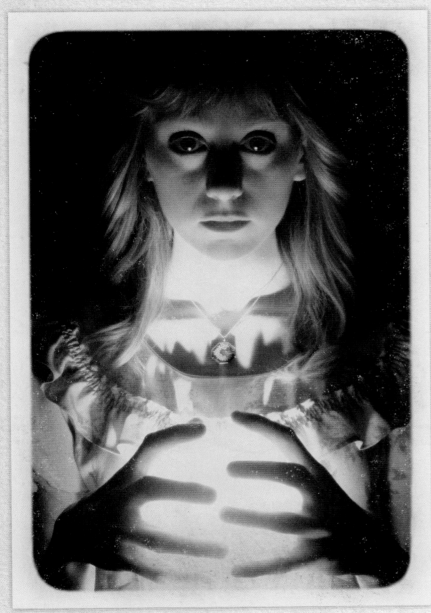

Series portrait of Olive, a peculiar whose hands set fire to anything they touch.

"It was so out of the ordinary for me, I didn't really know what to do. I'm still in shock. I went to his house and it was after Halloween. There were pumpkins and dead dolls everywhere, and blood, and I was just sitting in Tim Burton's living room and I told myself, 'Okay, this is a normal Thursday. This is a normal

Thursday afternoon.' And then a couple of weeks later I heard that I got the part and I screamed for four hours. I was waiting for someone to pinch me and say, 'You know, just kidding.'"

Once McCrostie recovered from the shock of being given the part, she began to develop her character. "She's very adorable and she's sensitive," she notes. "She's very loving. She's caring, which is so ironic, because she's almost got the most destructive peculiarity. She sets fire to things, which is a huge power, but she never abuses it. She really only uses it to help the other children around her or if they're in a bad situation. But she loves making things and she's creative and she's sensitive, and she loves Enoch way too much. I would say it's unrequited. He appreciates her, but not the way that she adores him."

MacMillan elaborates on Enoch's relationship with Olive. "He's very dismissive. Just because he's so internal and dark, and he does take Olive for granted. But she understands him. She can see underneath his wall of darkness, and she knows him properly. So their connection is quite special. Lauren McCrostie is brilliant. She really brings Olive to life, setting her up to be the complete contrast to Enoch. Because he's so dark, but Olive is just this really happy, chirpy, lovely, warm girl, and that's why they make such a good team."

Olive and Enoch are both older in the movie than they are in the book, not only to give the peculiar children a more varied age range but also to allow this dynamic between the two of them. "The relationship between Olive and Enoch was new to the story, and it was fun and interesting to build it from the ground up," Goldman says. "I think it humanized Enoch a lot. I think this situation is something that most of us have experienced at some time in life, that yearning for somebody who wants somebody else and they take you for granted."

During Jake's first evening in the time loop, he and the children watch a film—the projected, and sometimes premonitory, dreams of the sartorially obsessed Horace. "When you think about what that would do to somebody, to have all those different images and experiences funnel through your body, it would prematurely age you," Topping speculates. "He projects that a little bit—a sophistication, but also a bit of a weariness—'cause this is his burden in life, being the conduit for all this stuff."

The role of Horace went to newcomer Hayden Keeler-Stone.

ABOVE: *Series portrait of Horace (Hayden Keeler-Stone), a peculiar who can project his sometimes premonitory dreams.* OPPOSITE: *The peculiar children watch Horace's dreams.*

"When we met Hayden, he had that look," notes Frey. "He had that distinct, little Englishman look about him. And you put him in the threads of the time period and he *is* the character. He looks like someone who could be lost in dreams, and lost in his books."

The most cheerful member of the group is Hugh, a boy with bees buzzing in his stomach. Though he can communicate with the insects and direct them to do his bidding, he can't prevent them from flying out of his mouth when he opens it. To find the perfect belly beekeeper, Burton wanted what Frey calls "the boy next door." "Hugh is written as a character who by all accounts looks like a normal little boy. If you were to look at him, you couldn't guess his ability. But when he opens his mouth, bees come out. The only way for him to control it is by wearing a bee-keeper's hat. I think that was part of the casting, to see how the

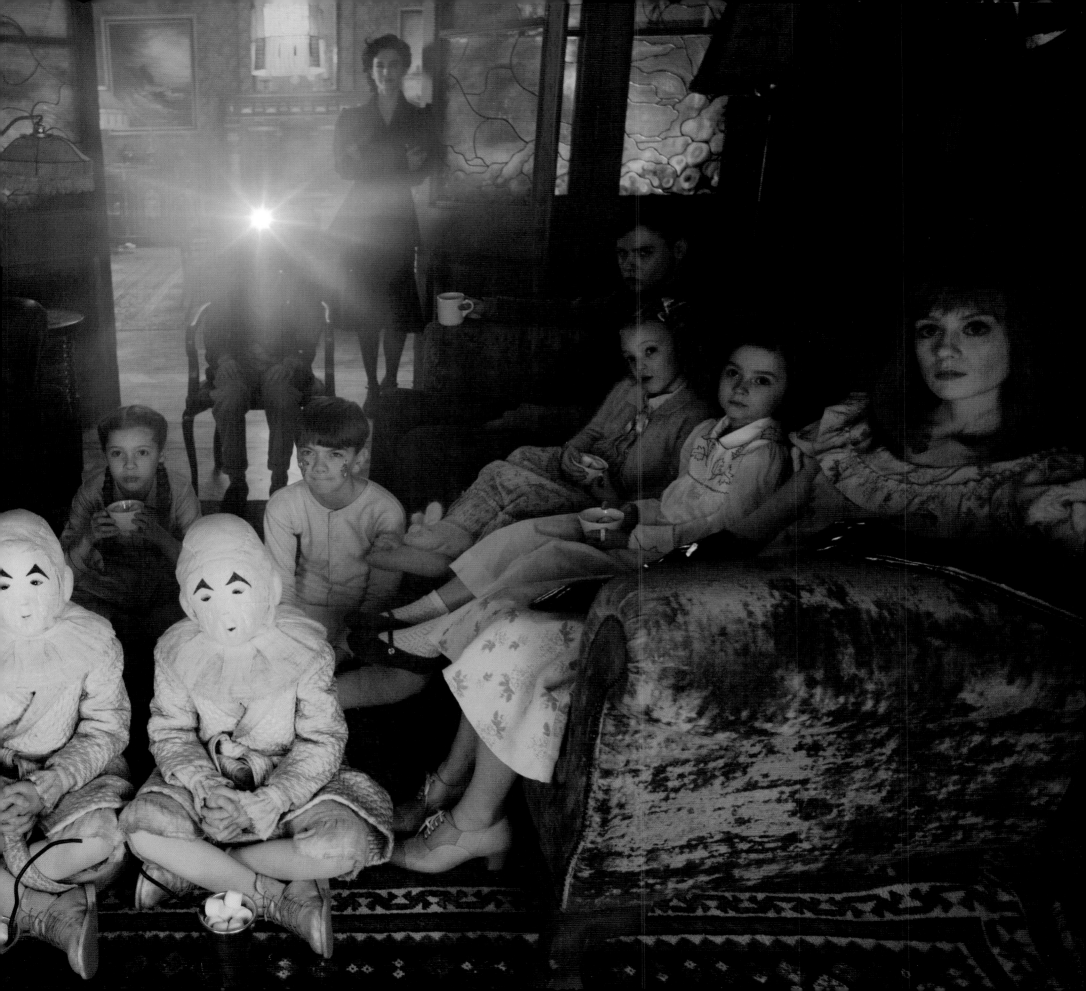

"Don't be afraid to look at the bees, because they're marvelous creatures."

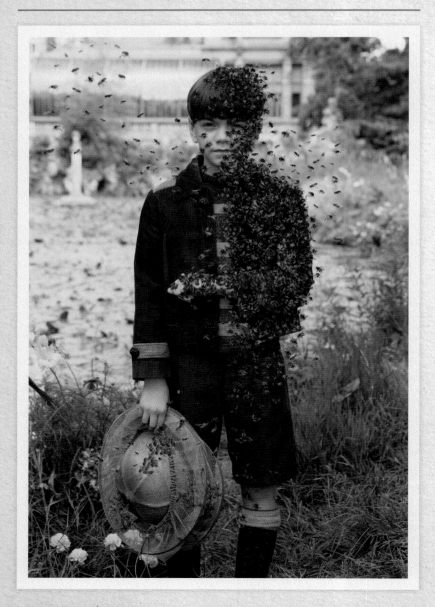

actor would look in that hat. And [the actor we chose] looks great. He occupies that space perfectly."

Burton's search led him to Milo Parker, who coincidentally had played a boy who tends to bees in *Mr. Holmes*. Figgis laughs when remembering the process of selecting Parker, whom she praises as a really good actor. "When Milo came in, Tim talked to him for a few moments and then said, 'Could you open your mouth really wide?' Milo opened his mouth really wide and Tim said, 'Yeah, that's great. That's great.' That was his audition."

Among the group of kids, Hugh provides a bright, easy-go-lucky energy. "I think he's quite a calm, friendly personality," Parker notes. "He doesn't want to offend anyone. He's not an attention-seeker. He just wants to please, and I think he's got lots of friends."

The biggest challenge facing Parker were the bees themselves—not because they were real, but because they weren't. Jaynes worked with Parker on imagining how he would coexist with them, what his movement would be like if bees were living inside him. Parker agrees that the pretending exercises helped him envision his character. "Fran taught me how to just feel the bees and where they were likely to go and to look at them," he explains. He paraphrases Jaynes's guidance this way: "Don't be afraid to look at the bees, because they're marvelous creatures. They're just working away inside your body and you can just watch them whenever you speak. Just look at them for a minute or two. Walk away into the distance and then *fffff*, suck them back in."

In addition to these diverse peculiars, the group also counts a green thumb among its members. Fiona is a girl who can cause any plant to grow to gigantic proportions within mere minutes. Frey explains that they needed someone earthy for the role. "Georgia Pemberton has a spirit about her; you can really believe she's able to harness the power to grow things. I remember that on Georgia's tape, the thing that was really interesting is that she actually did move like she was growing something. To see her hand movements, that sold it. It was clear she was really getting into the character. And it was just so strange to see this young girl pretending to harness the power to grow a vegetable to a mammoth size."

Figgis, who has been casting for thirty-six years, was blown away by Pemberton's audition. "I've never seen a kid do something

so brilliantly as she did. She came in and she had to make the plant grow. Her concentration was extraordinary. I didn't particularly ask her to do that, and it was incredible." When Pemberton got the call to meet Burton in person, she remembers how her whole family was excited. "My mom had been really calm and prepared, saying, 'Georgia, calm down, it's just an interview. He's still a person.' But as we walked into his house, 'cause his house was filled with props from his movies and spooky pictures, my mum became the child, and I had to say, 'Mum, calm down, he's just a person.'"

A short audition later, Pemberton repeated her "little bit of improvisation" for Burton, and soon she became Fiona. "She can grow fantastic enormous topiaries and enormous vegetables and plants," she relates. "But that's really interesting because I don't like vegetables. And she feeds the family. She just has to put her hands over the top of the plants, and then her hands take over her mind. I almost think part of her brain drops out, and the nature part of her brain takes over, and she's in a trance; as soon as she removes her hand, she's back in normal life. Well, not nor-

> ## "Fiona doesn't care if she gets little ants between her nails. She doesn't care because she is almost a plant herself."

mal life, but normal life for what the peculiars would call it." Fiona stands out in other ways, too. "She's not at all scared to get muddy or dirty," Pemberton continues. "Some of the other characters, like Claire, if they got a bit of dirt on their dress, they would freak out, 'Oh my God, I got something on my dress!' But Fiona doesn't care if she gets little ants between her nails. She doesn't care because she is almost a plant herself."

One of the peculiar children is only ever heard, not seen. Millard is an invisible boy, distinguished in physical space by the

OPPOSITE: *Series portrait of Hugh (Milo Parker), who lives with bees in his stomach.*
ABOVE: *Series portrait of Fiona (Georgia Pemberton), a peculiar who can control vegetation.*

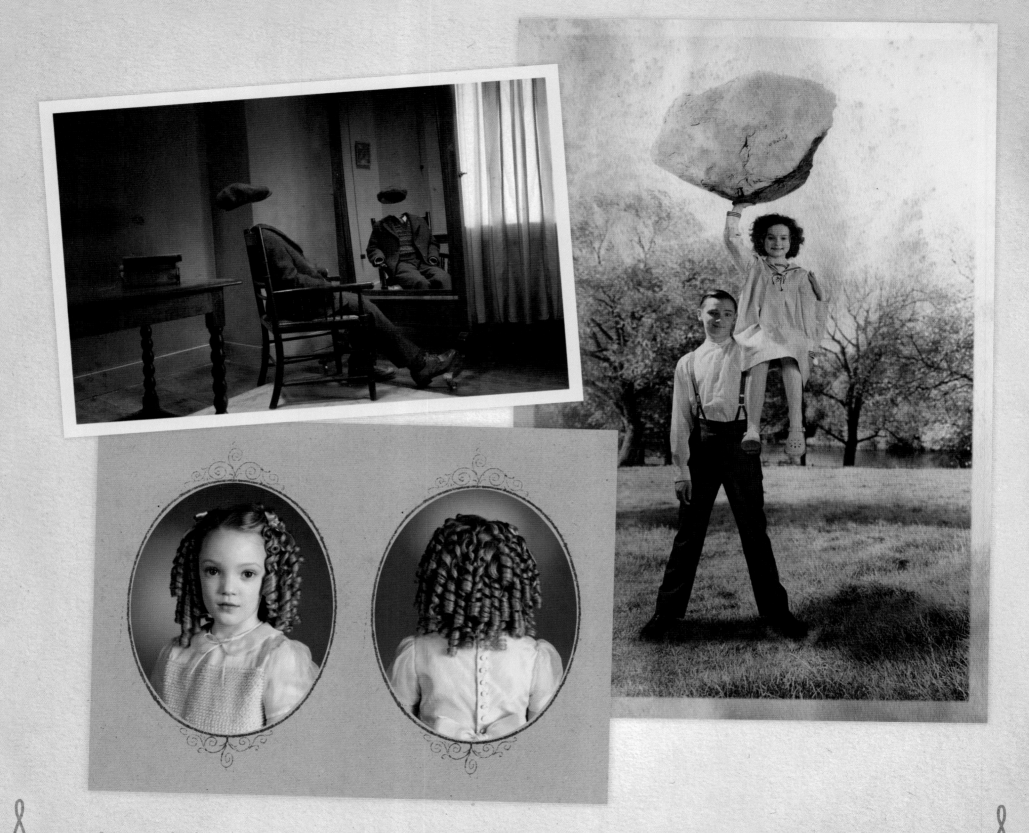

Series portraits of peculiars CLOCKWISE FROM TOP: Millard, an invisible boy; Victor (Louis Davison) and Bronwyn (Pixie Davies), a super strong brother and sister duo; and Claire (Raffiella Chapman), whose curls hide the mouth in the back of her head.

clothes he wears, when he chooses to wear them. Figgis says there was never a question whether the role would be played by a real actor or not. "Tim decided it absolutely needed to be an actor, because he wanted to have movement and acting involved. But for casting, we had to focus on just the voice. Tim talked to me about the voice he wanted, and I sent him audio tapes." Cameron King won the part, which Frey says hinged on his voice. "You had to have a voice of a child that was distinct, different from the others, but really anchored down and maybe raised your imagination to question, 'Well, what does this kid look like?' He seemed to have the right kind of personality for this character, a personality that comes through his speaking qualities and body movements."

Millard studies and documents the minutia of day-to-day life on the island to keep himself occupied. King finds him rather endearing. "I love him. I love playing the part of him. He's funny but he doesn't mean to be funny. He's smart and he's knowledgeable. He's got notebooks. He's very observant; he looks at stuff in a different way. Millard spent three years studying pigs alone, which is quite a lot, to be honest."

The strong woman of the group is Bronwyn, whose small size contrasts with her enormous strength. "Bronwyn is a feisty little character," Frey reveals. "Almost feral, in a way. A brave personality, but pint sized. Instead of having strength harnessed by someone who's muscular and gigantic, here's this little, tiny person that you would never imagine could have that ability. It really appealed to Tim's sensibilities." They looked no further than the aptly named Pixie Davies, who played Sophie Hawkins in the TV series *Humans*. "Of all people having that kind

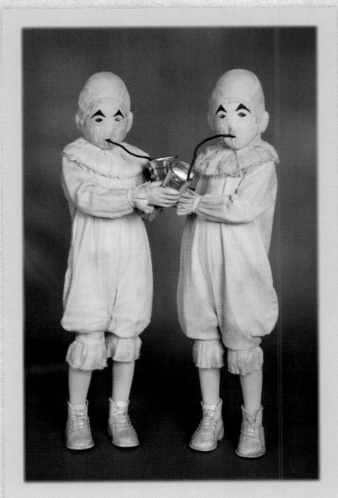

Series portrait of the twins (Thomas and Joseph Odwell), peculiars who turn people to stone with one unmasked glance.

of a name, I mean, who else could you pick?" Frey asks. "That was an easy sell."

Topping believes the character reiterates an important philosophy of Burton's. "What I love so much about Tim's work in general, but specifically in this film, is that it's so much about not judging a book by its cover and having people surprise you and remembering that people are capable of really extraordinary things that you might not expect. Bronwyn's a perfect example of that. You see that little cherubic face and you just think, oh God, she's going to be so sweet sitting in that chair, and then she upends a house."

Jaynes tells how Davies practiced so that her strength would appear normal and effortless. "We kept coming up with different ideas until finally we found a way for her to carry the carrot without it looking difficult, because all these things should never look difficult. Funnily enough, she shouldn't look strong. It's not in her general character, because it's not a trick. It's not a superpower. It's not something clever. The children don't see it as something clever, because they've lived with it. It's part of them. So it's almost thrown away. It doesn't become important until the end of the film."

The youngest and sweetest-looking girl of the bunch is Claire, whose perfectly coiffed ringlets hide her second mouth—a giant razor-toothed maw in the back of her head. "One of the more peculiar peculiarities," Frey says. "Again, Tim wanted someone whose appearance was completely the opposite of what their ability is: something you would never guess from looking at them."

Burton gave the role to Raffiella Chapman, who played a young Lucy Hawking in *The Theory of Everything*. Says Figgis: "I

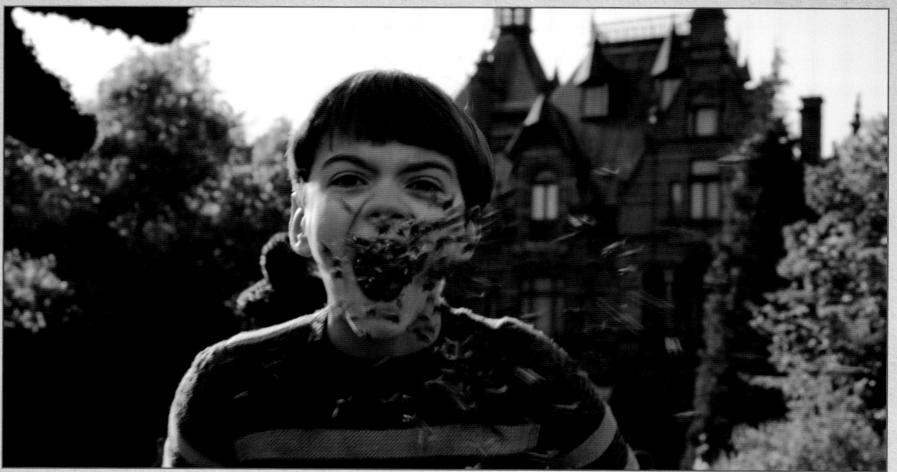

Hugh lets his bees fly in the gardens of the children's home.

think Raffiella had a slightly strange look, with something very sweet about her, that worked."

Chapman gleefully remembers the first time she saw a re-creation of her back mouth. "It's a rubber version, but it's really scary. I touched the back of the throat. And it's got three wobbly teeth and it's quite weird because I've got three wobbly teeth."

The youngest members of the peculiar family are the twins whose faces the viewers don't see for most of the film because they're shrouded in masks. Only later is it revealed what the masks are for: they protect those around them with their Medusa-like powers. Frey says that Burton decided he needed real twins. "We wanted to have brothers who could interact and mimic each other, because every time we're seeing these characters they are mirroring each other. We never hear them speak. We hardly ever see their faces. We only see their simultaneous movement. So you not

only needed twins, but you needed twins who were inherently in tune with each other."

Thomas and Joseph Odwell proved to be the perfect pair. "When we met Thomas and Joseph, I remember them standing there, and they were saying the same things at the same time," Frey continues. "It wasn't even coached. It was evident that they had this connection. Plus, they seemed to be the right size, to have the right demeanor. There's something sweet about them, something slightly creepy about them as well. You need that to come through the mask, and I don't think that's something you can easily find."

Jaynes says she worked with the boys' synchronicity, to make it as exact and as eerie as possible. "They've got masks on, so they really had to feel each other without looking at each other. When we'd practice, we did a count, and they quickly understood it; they have that natural affinity that twins have, really. When they walk,

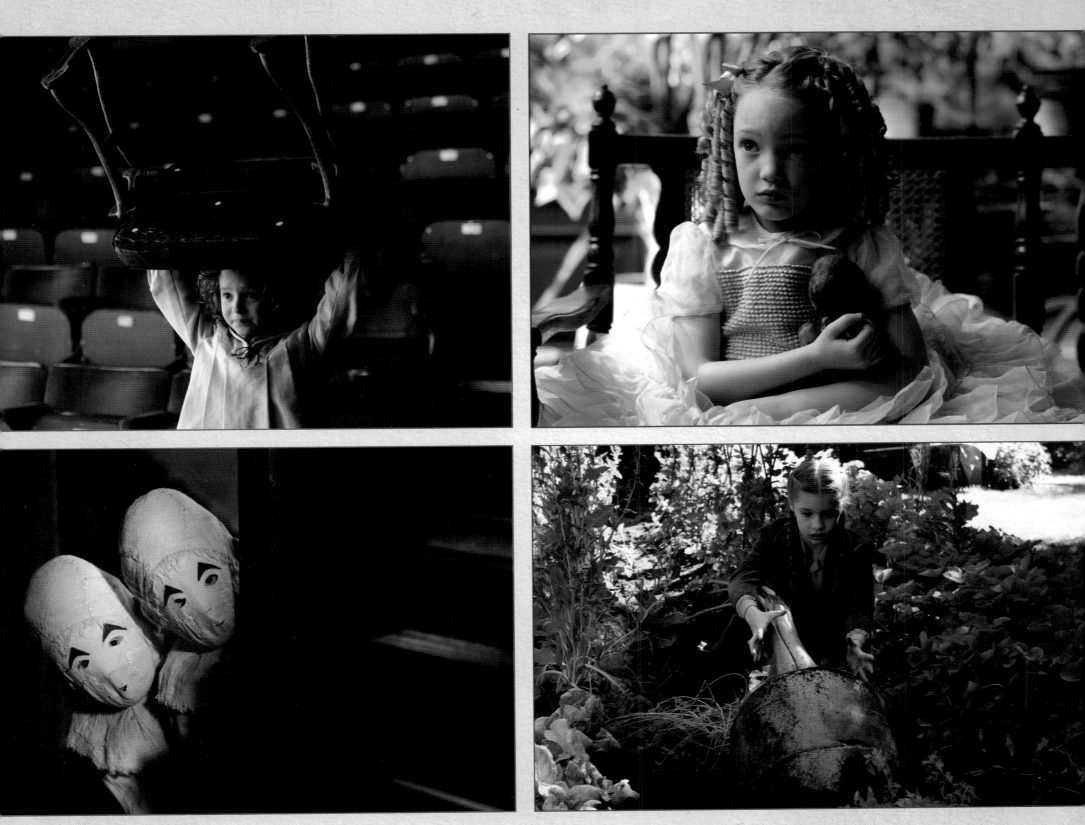

TOP LEFT: *Bronwyn rips a circus chair from its base.* TOP RIGHT: *Claire clutches her teddy in the conservatory.* BOTTOM LEFT: *The twins peer out from behind a door in the destroyed children's home.*
BOTTOM RIGHT: *Fiona grows a carrot to enormous size for dinner.*

they walk with the same foot first. They stop at the same time. They start at the same time. It's like they're one person."

One former member of the home has only a single scene. Victor, Bronwyn's brother, is the unfortunate child to have been murdered by a hollow on the day the loop was created. His body is preserved, but his spirit is gone. Except, that is, when Enoch decides to briefly bring him back as a way to spook Jake. "Victor's body is resting in one of the rooms in the house," MacMillan says. "So Enoch thinks, hmm, I can scare this guy, Jake, I bet. So he says, 'Come on and meet Victor.' And he brings Victor to life in front of Jake and makes him talk like a puppet. It's quite funny but at the same time, it messes with Jake."

The character appears without eyes in the film, and Frey says that Burton considered that aspect when casting him. "It was important to Tim that he have a distinct look without eyes. He also had to look like he could be Bronwyn's sibling. Although his screen time is minimal, his character is the emotional foundation by which Miss Peregrine makes certain decisions later in the story. She's lost one child already, and she will do anything and every-thing to stop another one from being harmed."

Burton cast Louis Davidson as Victor. Since his performance in the scene is all about the jerkiness of his movements, Jaynes worked with Davidson to perfect that quality. "Tim wanted it to be a little bit like a marionette," she explains, "so I worked on marionette moves. Louis was quite brilliant actually. He starts lying down and he has to sit up with a completely straight back. He's got quite long legs, so it's hard to do. And then his eyes open and he never really focuses, he just stares straight ahead, so he has sort of dead eyes. Then he made the movement quite random, and we put a little sequence together."

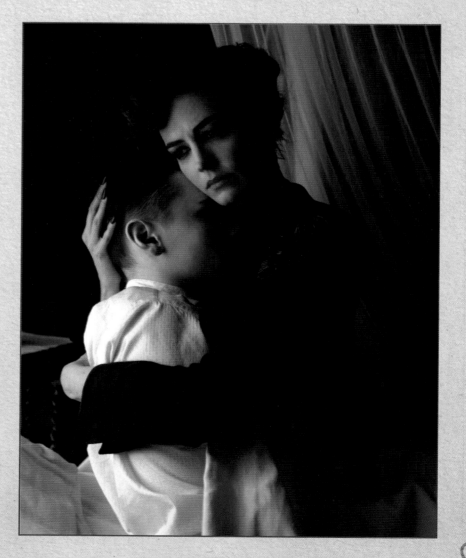

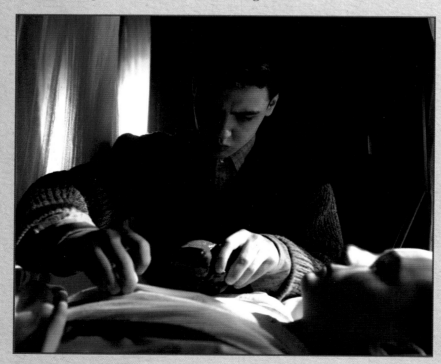

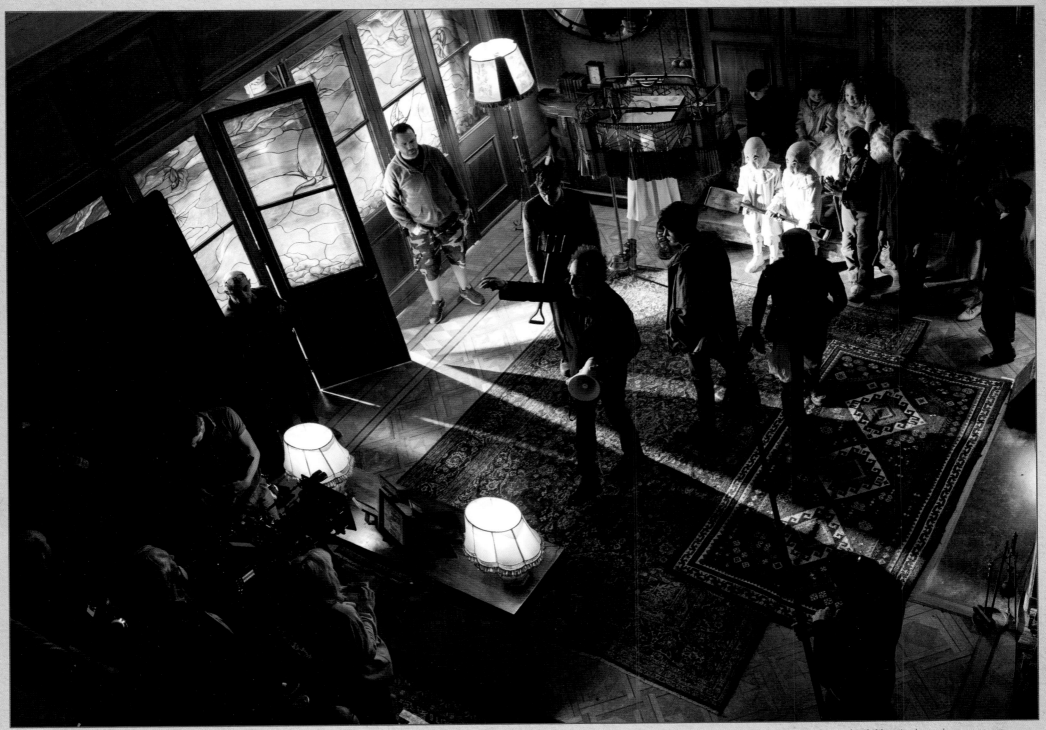

OPPOSITE LEFT: *Enoch uses a heart to reanimate Victor.* OPPOSITE RIGHT: *Miss Peregrine hugs Victor's corpse, determined never to let anything hurt her children again.* ABOVE: *Burton directs the children in the parlor.*

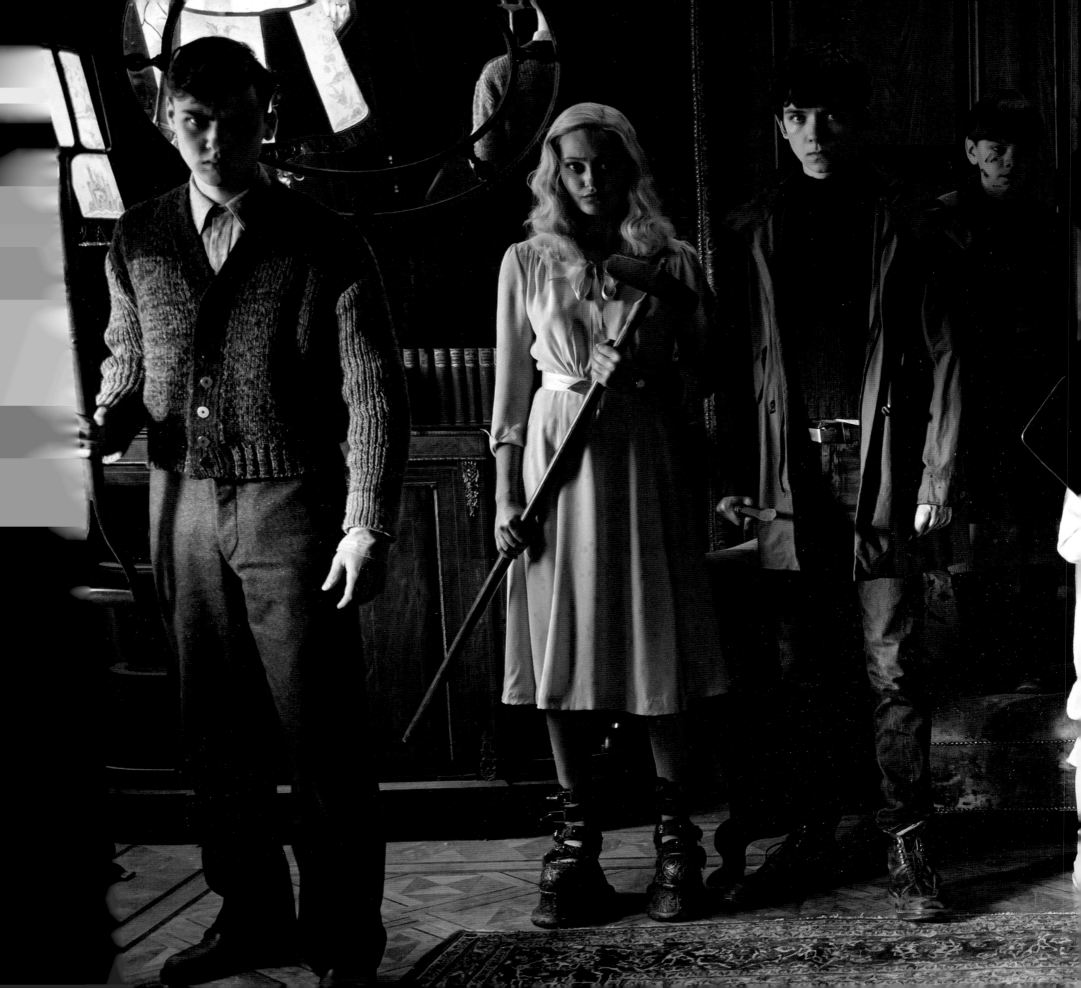

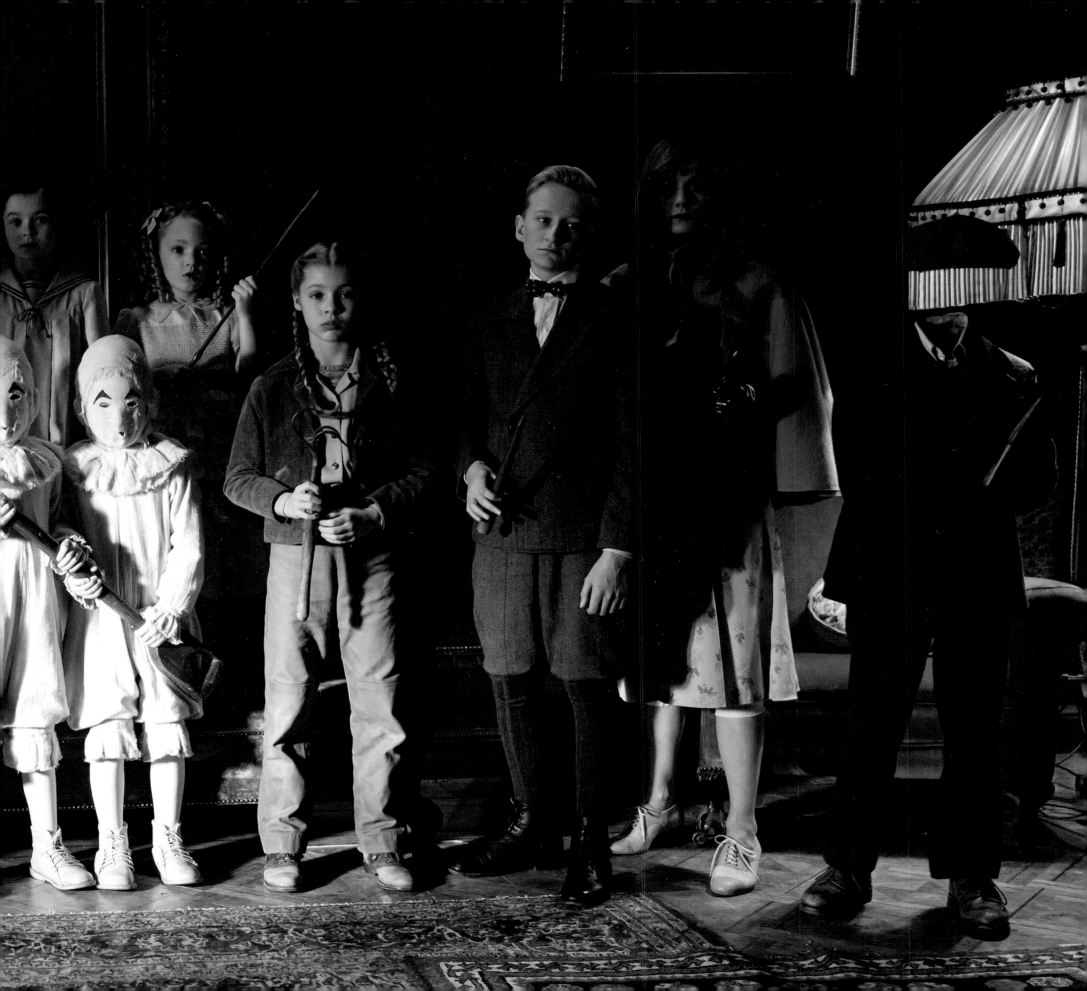

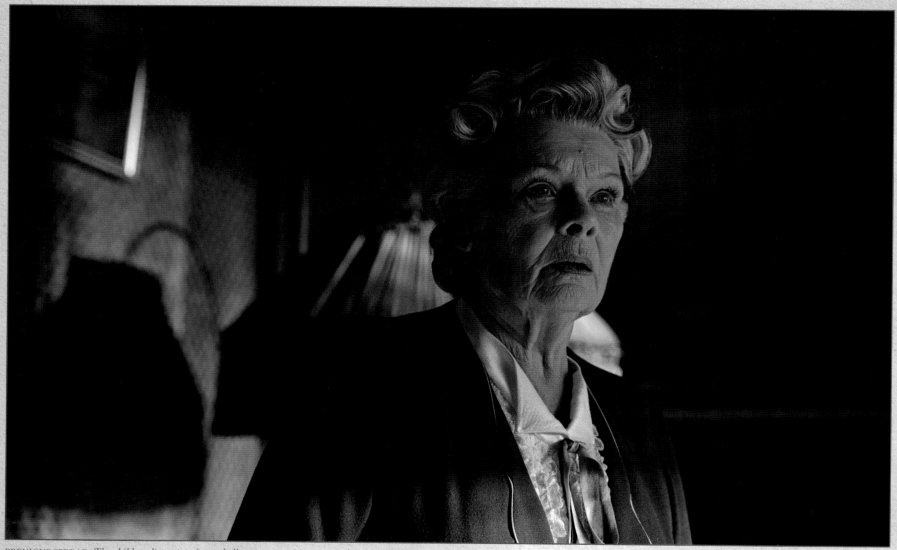

PREVIOUS SPREAD: *The children line up to face a hollow.* ABOVE: *Miss Avocet (Dame Judi Dench) instructs the children to bar an approaching hollow from entering the house.*

Shortly after Jake discovers the loop, Miss Avocet, another ymbryne, hurls into the loop entrance in bird form. When she recovers enough to change back into human form, she warns Miss Peregrine and the children that the ex-hollows are setting up their time experiment once again. She fears that Miss Peregrine's loop is no longer safe with the ex-hollows now hunting down ymbrynes. For this role, Burton cast screen legend Dame Judi Dench, known for a litany of varied roles, including a novelist in *A Room with a View*, her iconic take on "M" in the *James Bond* series, and the title

character in *Philomena*. He reports how excited he was to work with her. "She's another icon. One of the great things about my job is meeting people like her that have been through so much and still have this spark and curiosity and artistry and positive spirit. And it's fun to work with someone like her in a different way than she's used to—in this case, portraying a bird. Her bird has a lot more nervous energy than Miss Peregrine. But she's also very sweet, and determined to protect the children. She and Eva complement each other really well." Green, too, was thrilled by

the opportunity to work with such a talented and respected star of screen and stage. "She's such an iconic actress, I was in awe of her," she confesses. "It was interesting to see her embody an avocet who is a fragile and nervous bird, unlike Miss Peregrine, who is more like a predator and can be harder. Judi Dench and I have a scene together and it's a dramatic scene. Tim was asking us to move our heads at the same time, so it looks very birdlike and very sharp, and that was quite funny."

Similar to Jackson, Dench's casting came about by a fortuitous meeting with Burton during the 2013 awards season. "I was with my daughter and he was absolutely charming and we said, 'What a lovely man,'" Dench recalls. "I was already a fan of his films. I wanted to work with Tim and then I was told that I was going to play Miss Avocet. I've never had to play a bird before. I played a stoat and I played a rabbit, but never a bird. It's not like being asked to do something again, or a part that you think is a bit similar. I dread what very often happens, which is you play a part and then you get sent a script, which is almost exactly the same kind of character as you've just played. And so the wonderful thing is to be sent something that you haven't tackled before."

When researching the role, Dench also studied the bird that represents her character. "I looked up an avocet, which is a bird with extraordinarily long legs. That's why I'm doing this film. Very, very long legs. I wade about a lot in the shallows. Also the first bit I read was, 'Ms. Avocet flies in through the mouth of the cave, and hits herself on the end and falls to the ground horribly hurt.' I thought, 'I'll never be asked to play that again. I better get on with it and do it.'"

Unfortunately, Miss Avocet's warning to the loop's inhabitants arrives too late, and Barron steals Miss Peregrine away to his hideout in Blackpool, Miss Avocet's former loop, where he and four of his ex-hollow comrades have gathered in anticipation of the upcoming experiment. Frey reports that Burton wanted them all to look distinctive. "They were cast virtually in tandem so that we could see how they looked against one another." Burton chose Helen Day, an actress and aerial performer, for Miss Edwards. Mr. Archer is played by Philip Philmar, who had appeared in two of Burton's films: as Mr. Fogg in *Sweeney Todd: The Demon Barber of Fleet Street*, and Slugworth in *Charlie and the Chocolate Factory*.

Barron's society of scientists. The photo appears in A Peculiar History, *a prop from the film.*

Jack Brady was cast as Mr. Clark, and Scott Handy as Mr. Gleeson.

Because the four actors play ex-hollows, they all have the signature white eyes with pinpoint black pupils, a mark of what they used to be. "They often say that the eyes are the gateway to the soul," Handy muses. "So in some sense, I think that's the last part of them that are hollow."

The hollows have banded together is to try to improve on the earlier failed experiment, using the power of the ymbrynes to bring them immortality. "Barron has gathered us together," Philmar describes. "We are all hoping that this experiment, which will make us immortal, is going to work. So it's the crux of the story."

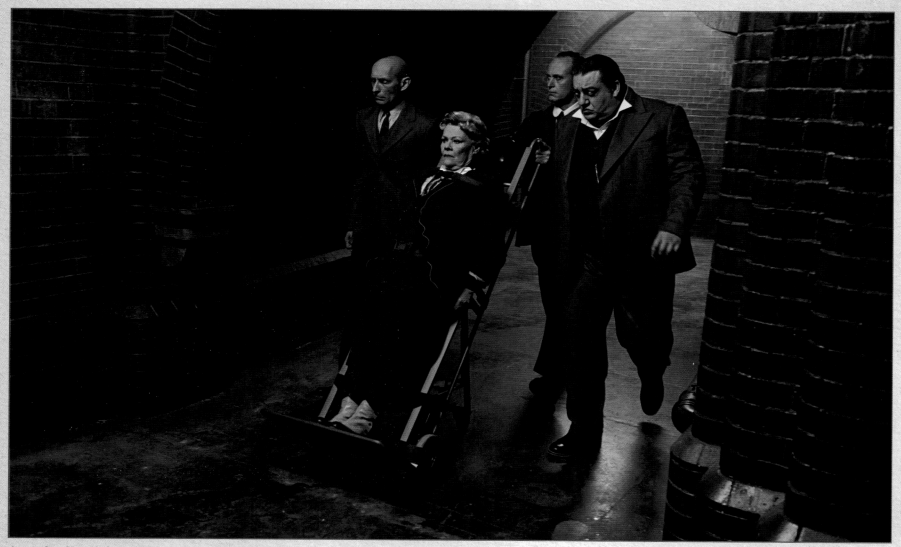

A scene from Horace's dreams—Miss Avocet is carted around by ex-hollows (from left to right) Mr. Archer (Philip Philmar), Malthus (Robert Milton Wallace), and Mr. Clark (Jack Brady).

In the film's climactic scene, a battle ensues between the remaining ex-hollows and the children. Miss Edwards and Mr. Gleeson each get a chance to display their unique talent. To get into character, Day discussed with Handy the psychology of an ex-hollow. "We've had a few conversations about how we think these hollows might be," she explains. "Because of course, Barron is quite free in his speech. We were thinking, well, do we need to be free? But the direction that Tim has given us is that we've eaten less eyeballs. We're not quite as developed. We're much more

stilted and we've got a robotic quality. The humanity isn't there as much as it is with Sam's character. We've been planning around that." For Mr. Gleeson, who is able to freeze things, Handy recounts the reasoning behind using his power against the children. "It goes from being the best day of my life to the worst day of my life," he says with a laugh. "Mr. Gleeson begins by waiting for Mr. Barron, for all the elements that will combine to produce immortality and, most specifically, the ymbrynes. Unfortunately, these pesky kids are alive. And a battle ensues."

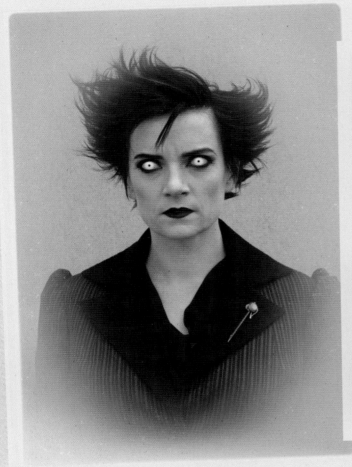

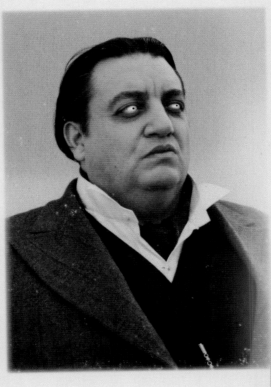

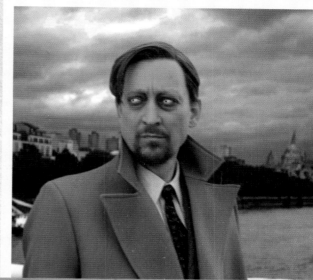

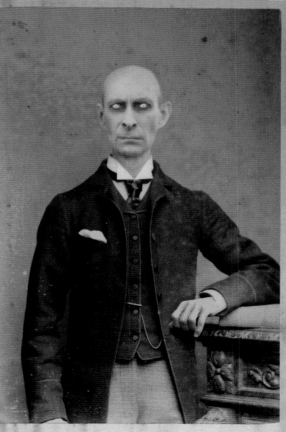

"They often say that the eyes are the gateway to the soul ... I think that's the last part of them that are hollow."

Series portraits of ex-hollows LEFT TO RIGHT: *Miss Edwards (Helen Day); Mr. Clark; Mr. Archer; and Mr. Gleeson (Scott Handy).*

3

There's a
New World Coming

LOCATIONS AND SETS

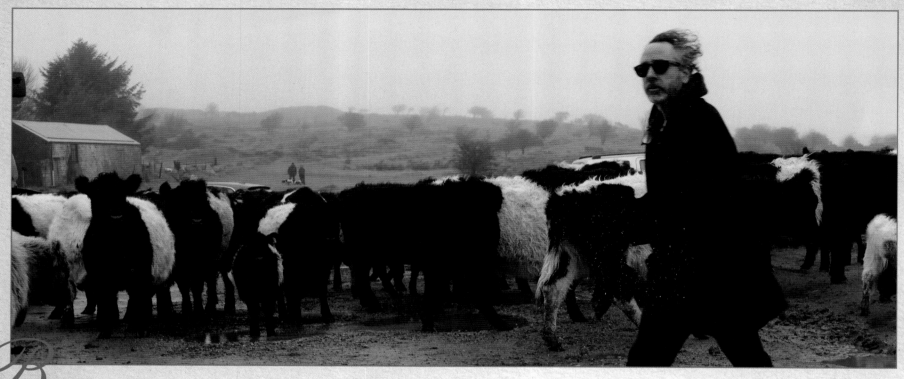

Burton began assembling his team by calling up first assistant director (first AD) and executive producer Katterli Frauenfelder, who has served as first AD on every Tim Burton film since *Planet of the Apes*; executive producer Derek Frey, who has worked on every Burton film since *Mars Attacks!*; and executive producer Nigel Gostelow (*Thor: The Dark World*, *Dark Shadows*). These three players were key to constructing the schedule, the budget, and the remainder of the film team per Burton's wishes. "Tim often has a specific vision of how he wants stuff done, and he surrounds himself with people who can achieve it," Frey says. "That means he often works with the same people, and it becomes like a family."

Certain people, such as the director of photography and the production designer, are needed sooner than others so that they can scout locations with Burton. Many of the artisans that fill his head-of-department roles are veterans of his previous films, but occasionally, due to scheduling conflicts or the nature of the project, new members are added to the crew. These connections are made through research and word of mouth. For *Miss Peregrine's*

Home for Peculiar Children, Burton asked Gavin Bocquet (*Stardust, Star Wars: Episodes I, II,* and *III*) to be his production designer. "You occasionally will work with the same director again, but their time scales are very different from yours," Bocquet observes. "They might only do one film every three years, whereas you're looking for a job every nine or ten months. I'd just finished quite a large project, *Warcraft*. It was time for a rest. But I've known Katterli Frauenfelder for a long time, and she had mentioned the possibility of this film coming up with Tim. Of course, when someone like Tim is put in front of you, it's a very hard job to put off because they don't come up very often, if at all. It was interesting because a lot of the crew had come with Tim from previous projects, so I was almost like a new boy coming into the classroom. But they were all very welcoming, especially Tim."

On this particular project, Burton made it clear to everyone that the approach should be as practical as possible. "We're trying to do it in a more human-based way, with a lot of the effects live, so that it's not overly digital. The visual effects are not used in an action movie way, that's what I love about it. There's a little bit

that's used for stopping the bad guys. But we used the effects more for—oh, we're going to go here, we're just going to go here in a different way. We tried not to make it overly green screen. We went to a mixture of locations. We had a real house. It helps with kids, and other actors too, to have something tangible, so they can really feel it. I've done movies where the technology was amazing, and then there was the Academy Award winning effects in *Beetlejuice*. It's fun either way you go. But it's important to use the effects appropriately for whichever project you're doing."

To make a schedule, Frauenfelder breaks down the script into its component parts, such as cast, special effects, visual effects, and props. From there it's a puzzle she breaks down into further pieces, such as what will be shot on location and what will be filmed on set. As she sees it, the *Miss P* film had two key locations. "One was the island of Cairnholm. The other was Miss Peregrine's

house. Those two places were our anchors, and we spent the most time searching for them."

Supervising locations manager David Pinnington (*Quantum of Solace* and *X-Men: First Class*) began searching in England, to little avail. Large houses on grand estates loomed too cold and institutional. "Tim wanted something that looked like a house, and not a huge, stately home," Pinnington explains. "In England, there's an awful lot of stately homes and their footprint is quite wide and they often are at the edge of large drives. In the UK we looked at everything. The architecture in England wasn't hitting the mark, and that's why we ended up looking further afield."

They expanded their search across Europe, and a tip from Ransom Riggs brought them to Belgium. "I followed one of these urban explorer photographers whose hobby is breaking into homes where no one lives anymore and documenting the urban decay,"

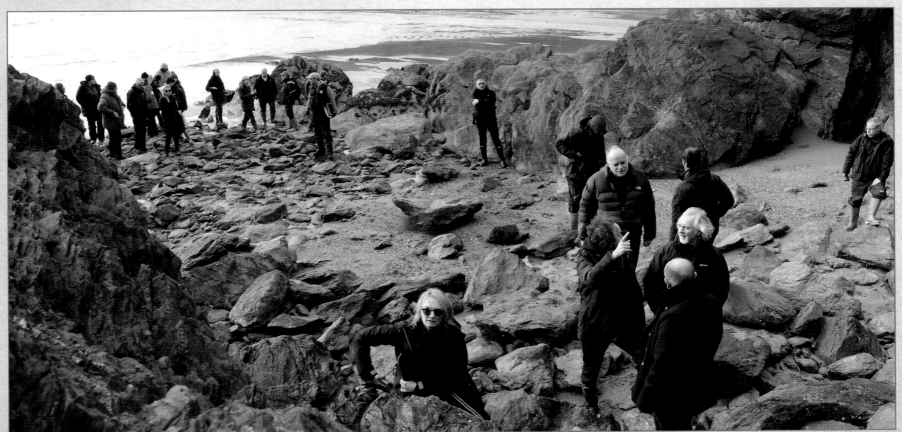

PREVIOUS SPREAD: *Director Tim Burton and executive producer Derek Frey walk through the gardens at a Belgian location.* OPPOSITE: *On the way to a location scout in Bodmin Moor, Burton's path is blocked by cows.* ABOVE: *A location scout of a Cornwall beach that became the cliffs where Oggie fell.*

Burton photographs Château Nottebohm, the Belgian house that inspired Ransom Riggs's description of the children's home in his novel.

quite grand. They didn't look like castles. There were three or four that we went to see. Torenhof was the favorite by far. But you never know whether you're going to get the favorite."

Part of the reason Burton liked the house so much, Pinnington relates, is because no one had been living in it. "It was a pretty open palette for us, in that respect. It looked slightly lost. You would never think that there's a large town half a kilometer down the road. It felt a little magical, a little lost, a little unkempt. There's a secrecy to it. It's not a surprise that Tim likes it. There's something about it that you feel straightaway."

After exhausting a search that encompassed hundreds of houses and several countries, it seemed important to everyone to secure Torenhof. There was just one hitch—the house was up for auction. In an unconventional move, Gostelow recalls how they considered buying the castle straight out. "In our brief to consider every way we could make that house part of the movie, we went to Twentieth Century Fox and we said, 'Do you think we could consider buying that house, film it in this movie, then once we're

Riggs reflects. "They come across these amazing places and one of them seemed perfect. It was being eaten by vines and returning to nature, and when I saw that, I felt like that's how I have to describe the Miss Peregrine house in the book."

The château, called Nottebohm, was tucked away in Brecht, just northeast of Antwerp, near the border with Holland. Riggs had visited the site to film a book trailer about his novel. After seeing images of the house, Burton decided it was worth scouting. It rapidly became apparent that the state of Nottebohm was too dilapidated to film in safely, but it did turn the scouting team's attention to Belgium. They began a broader search within the country and turned up several potential structures, including a castle called Torenhof, in nearby Braaschaat. "They started to see these rather strange gothic houses in Belgium, which are quite common, called 'castles,' but they're castles in a slightly separate meaning of the term," Bocquet explains. "The ones we were looking at were red brick. They were very tall, very gothic. They were very square. But they looked like houses even though they were

"Finding the right house was as important as casting a lead."

happy, put it on the market again?' They were great. They said, 'Yes, why not?' We did attend the auction, but there was a lot of interest in the house locally. In the end it was bought by somebody from the area who'd always dreamed of owning a house like that, and we weren't going to deprive him of that dream. He was a lovely guy with a lovely family. So our representative approached them at the auction and just mentioned the idea of filming at the house and left our details."

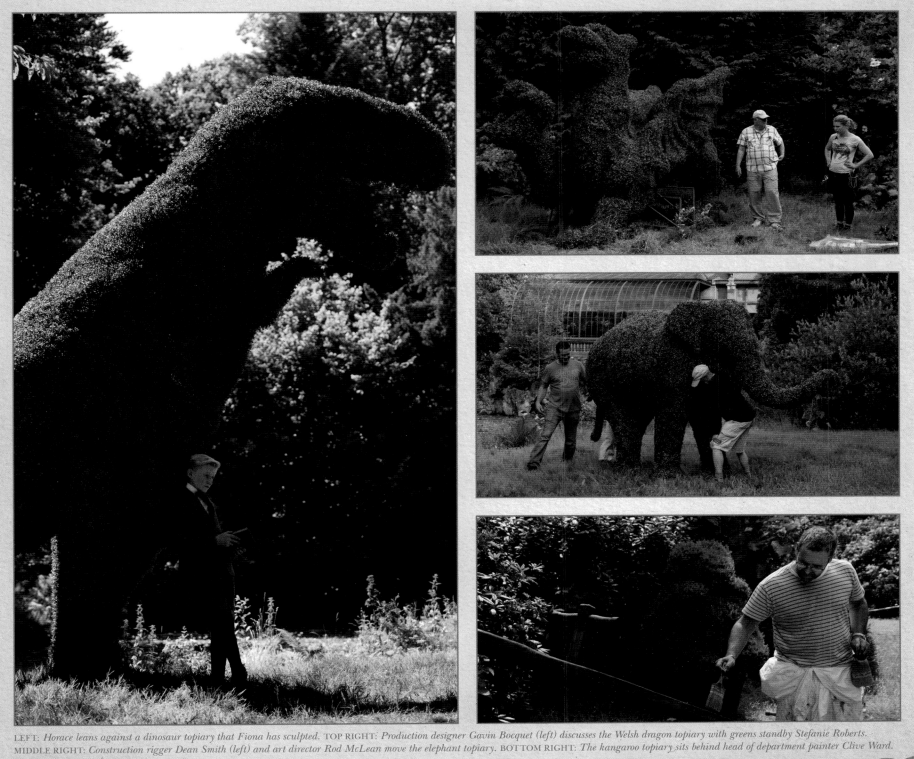

LEFT: *Horace leans against a dinosaur topiary that Fiona has sculpted.* TOP RIGHT: *Production designer Gavin Bocquet (left) discusses the Welsh dragon topiary with greens standby Stefanie Roberts.*
MIDDLE RIGHT: *Construction rigger Dean Smith (left) and art director Rod McLean move the elephant topiary.* BOTTOM RIGHT: *The kangaroo topiary sits behind head of department painter Clive Ward.*

Torenhof Castle in Braaschaat became the children's home. Only minor modifications were made to the house, including building a conservatory over the existing one and adding topiaries and other greens to the grounds.

Bunt Leo Verbruggen, who bought the house, remembers the first time he was approached by Burton's production team. "Right after the auction they came to me and I was completely not interested. No. Because film doesn't interest me. A few years ago in Belgium I had an experience with film and it was not so nice. I was totally not interested. So I said, 'Leave me alone.' That was the first time. And then the second time, they asked again, when I was at the notary. And yeah, I was not so interested. I didn't know who it was then. I came home, in the afternoon, I told my son. We were mailed a few films from Tim Burton. I said, 'Okay. Then we have to think about it. Maybe it's going to be serious.'"

Burton arranged to go on a scout in Belgium, so he could visit Torenhof in person and reassure Verbruggen that they would treat his home with respect. Burton was willing to exert whatever extra effort was necessary because securing the right house was integral to the film. "Finding the right house was as important as casting a lead," Burton asserts. "It had to represent Miss Peregrine and the kids and their lives. It had to be a home, not an institute. We searched for a long time but when we found Torenhof, I thought—it's unusual and the vibe was right. They could live there. Also, I wanted to be in Antwerp." Eventually, Verbruggen relented and says he has not regretted the decision. "They're so nice, everybody. It's fantastic. I'm very happy and they made the house nicer. A lot of flowers and things."

These "nicer" touches were partially the work of the greens team, a group of artists responsible for onscreen plants and horticulture. Though most of the house was exactly what Burton and his team needed, including the lily-covered pond in the back, the greens team did need to tweak a few elements. In addition to planting flowers, they added giant topiaries. "Fiona has the power to control the growth of the vegetation," says Bocquet. "So the yard features a few of her sculptures. There are four or five back there." Three of them were built by the greens team: a Welsh dragon, a centaur, and a Tyrannosaurus rex. Then they purchased three additional topiaries—an elephant, a giraffe, and . . . something else. "We were told it was a kangaroo when we requested it, but it looks more like a koala bear to us," Bocquet says. "But we bought that one from Belgium, so maybe the details were lost in translation."

Power, who by this point was working directly with Bocquet

and the art department, shifted his focus from concepts of the house to making what already existed work, with modifications. "It became about color and brickwork and whether there needed to be additional elements, such as the conservatory and so on," Power comments. "Also we did a lot of visuals of the house in its ruined state. There was a team up and running at this point, with Dom Lavery and Norm Walshe joining me to do the visuals, and the art department working on models and drawings."

Though Torenhof already had a conservatory, Bocquet relates that Burton felt strongly that it needed a different aesthetic. So they built over the existing one. "The structure underneath is much more austere and sharp, and Tim wanted a softer approach and a slightly birdcage-y look. We had a little bit of a challenge trying to fit another conservatory over an existing one and still hold our visual qualities. We could only shoot the interior in London because the interior at Torenhof has the other conservatory within it."

The new conservatory is lined with extraordinary stained glass. "The design of the stained glass is something Tim really wanted to investigate," Bocquet remarks. "We went through many, many different styles, from classic Art Deco to Art Nouveau. He just felt they were all looking too much like his grandma's house—quite sweet. He wanted something much more chaotic and abstract. So we went through a process of stripping that down, so it wasn't like a very rigid geometric pattern but something that would blend nicely with the

ABOVE: *Sun shines through the stained glass of the new conservatory.* OPPOSITE: *Dom Lavery's concept art showing the children's home in Miss Peregrine's 1943 loop day, and its modern-day, bombed-out condition.*

trees on the outside when you saw them together. There are also elements of birds flying around in there. It worked very well onstage, but seeing it in real daylight, the stained glass comes to life even more."

For Eva Green, acting in the house and gardens immersed her in a world that enhanced her understanding of her character. "We shot most of my scenes in Belgium, in this amazing, gothic house. I felt, okay, I could live there. Miss Peregrine could live there; that makes sense now. And this garden with those animal topiaries, like a dinosaur, a centaur, an elephant—it's very Tim Burton, and that was very helpful to establish the mood. Miss Peregrine lives there for sure."

The other cast members were also impressed by the choice of architecture and setting. "I'm a very visual person when I read," Sam Jackson reveals. "So when I was reading the script, I envisioned this whole thing. There are times when the reality is bigger than the dream, and that's what happened here. When you show up, you look at the house. The house is perfect for the time and for the loop that it's supposed to be in."

Asa Butterfield too was amazed. "I've never been anywhere like this," he admits. "When I first drove up around the corner on the horse and cart during filming, I hadn't actually seen the house, so my reaction is real. It's tall and it's sort of twisted. It's got huge spikes and spires. It looks like something out of a fairy tale, which I think Tim really wanted to capture, both with the house as well as the garden."

Port Holland, Cornwall, became the village of Cairnholm with the addition of a graveyard and a few extra buildings, like the Priest Hole pub.

The second key location sought by production was the village on the island of Cairnholm. Pinnington explains how they needed an appropriate coastline, so the search was concentrated in the United Kingdom, which had the correct aesthetic and where the film's stage sets would be built. "The action occurs on a Welsh island, so that was where we started. But we never considered going to a remote island, given the problems of taking a production of this size to such an isolated place. Rather, we were always looking for a coastal location. Scotland was figuring quite high at one point, but then we looked in Wales—some very unpronounceable coastal villages there. We did quite a lot of scouting around and ended up in Cornwall, in a beautiful village called Port Holland, and that's where we chose to film."

"You use the location for what it is— for the scale, for the scope, for the sea— but then you put in your own character."

Bocquet remarks on how small the village is, encompassing only about fifteen houses. "It was meant to be quite drab and austere. But every village we looked at seemed to have something missing. Like, the pub wasn't in the right place. Or it wasn't the right size or the shops weren't right. Eventually we found Port Holland, which had a big car park in the middle, and we suggested to Tim, 'Well, here's an opportunity to build two or three buildings to augment the village that is already there.' This eventually became us building the pub, as an interior and an exterior, and three shops. That was a nice bit of synchronicity—a really good way that a location could work. You use the location for what it is—for the scale, for the scope, for the sea—but then you put in your own character."

Jake escapes his room at the Priest Hole to visit his friends in Miss Peregrine's loop. The three buildings shown were all built by the production team.

Bocquet shows Burton a model of the village. All buildings already existed except for the three in the central tan portion, which were constructed by production in the town's carpark.

"The sets are really extensive and beautiful, as you see in all of Tim's films," Chris O'Dowd observes. "And in Port Holland, they've built three new buildings on the sea front that look like they've been there since the eighteenth century. The locals are frustrated because we built a pub where there was none, and they're worried we're going to take it away. I'm hoping to move it, one Styrofoam brick at a time, to the back garden of my house in Los Angeles. It's just fantastic. You would never know it wasn't originally part of the village."

Because of its remote location, Pinnington relates that access to the village presented its own set of challenges. "An awful lot of Cornish villages are down little lanes. This village is down a little lane that was a mile long. The logistical problems were servicing the shoot. Getting the big vehicles in to drop off, getting a unit base, getting catering in there—the problem was getting in and out without disrupting filming. It all worked out well with the assistance of Cornwall Council and the estate. The villagers played along with us famously. They even moved all their cars out of the village."

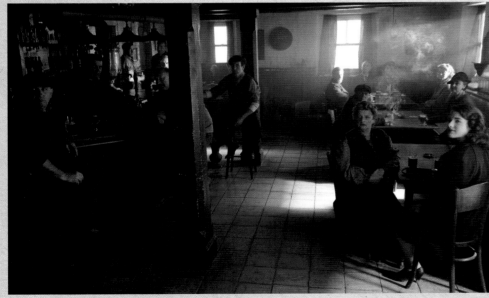

TOP: *Concept art by Norman Walshe of the pub's modern-day interior.* BOTTOM LEFT: *The patrons of the 1943 pub watch Jake.* BOTTOM RIGHT: *Jake and Frank settle into their room upstairs at the Priest Hole.*

Though the primary sites were determined, much work remained to be done. There were still two major locations to sort out: where the beginning of the film would take place, and where its climax would occur. These bookends of the script were Florida and Blackpool. For the former, Frey reports that only the Sunshine State itself would suffice. "We briefly scouted in the UK and other parts of the United States, but it quickly became clear that Florida is distinct, and nowhere else could properly mimic its vibe. The light, the foliage, the architecture—it's unique. So the goal became to find real locations around Tampa and St. Petersburg for where Jake works, where he lives, where his grandfather lives, where he sees his psychiatrist. Having real locations adds a grounded believ-ability to the story, which is necessary at the beginning, when we're trying to depict a suburban middle-class life. A world where Jake feels like an outsider. So that the audience feels a contrast when he arrives in this amazing sleepy seaside village."

Bocquet explains that they were searching specifically for uninspiring architecture. "We all joked on the scout that we were looking at some very uninteresting cityscapes after traveling four thousand miles," he says. "But that was the basis of it; that the retirement-home world of Tampa and surrounding area have incredibly simple architecture, incredibly graphic—that it's got no embellishment at all. We stripped those things back even further. Tim wanted everything to be the sort of place you probably didn't want to live. We didn't really build anything. We found an empty shell of a supermarket to dress as our supermarket, which was great. And we found two houses to shoot for the grandfather's house and the parents' house. We were basically stripping every-thing down, whether it was the greens, the trees—anything—just to evoke a boring suburban retirement-home life."

Frey points out that there was one distinct element of the landscape that production retained and actually enhanced: the line of tall thin trees behind Abe's house, all dripping with Span-ish moss. "What happens in those woods is the dramatic catalyst for Jake's journey. It was all real, too—we found a home that bor-dered an abandoned golf course lined with trees. It looked so ideal and perfect, you would have thought we built it. You don't really equate Florida with spooky, but in that particular setting, with the fog and Bruno Delbonnel's lighting, it is."

LEFT: *An empty supermarket in St. Petersburg, Florida, became Smart Aid, Jake's place of employment.* RIGHT: *Jake listlessly goes about the duties of his job, feeling as if nothing he does ever matters.*

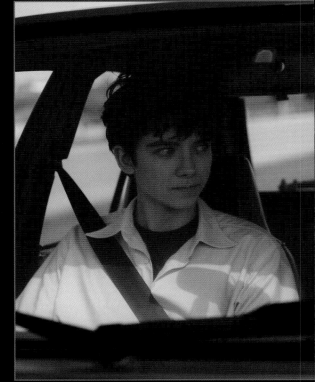
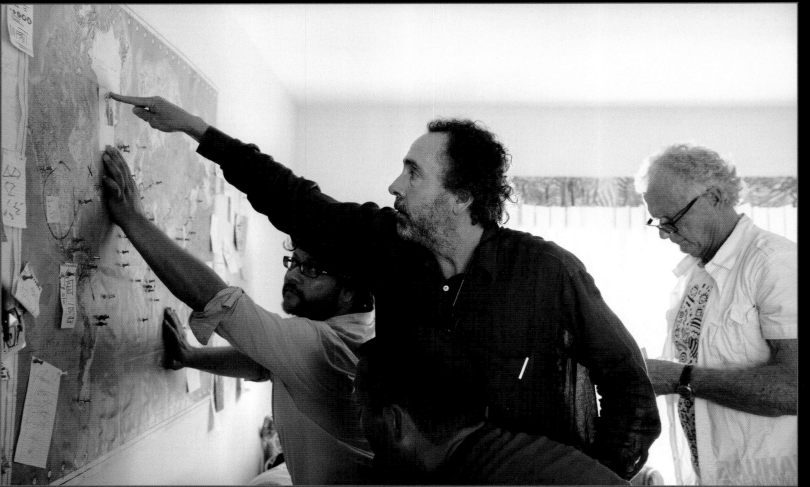

TOP LEFT: *Shelley's car.* TOP MIDDLE: *After receiving a disturbing call from his grandfather, Jake has his Smart Aid co-worker Shelley (O-Lan Jones) drive him to Abe's house.* TOP RIGHT: *A community in Sun City Center, Florida, doubles as Abe's neighborhood.* BOTTOM LEFT: *Burton's attention to detail shows as he directs Florida unit prop master Josh Roth (left) where to place more Post-its on Abe's map. Chargehand standby props Gregor Telfer (crouching, center) and Florida unit set decorator Chris August (right) watch and take notes.* BOTTOM MIDDLE: *Burton in front of Abe's house with the distinctive tree line lit in the background.* BOTTOM RIGHT: *The wrecked interior of Abe's house.*

ABOVE: *The production team built a 1943-era Ghost Train on the North Pier of Blackpool, England, to double as the entrance to Miss Avocet's hijacked loop.* OPPOSITE: *The newspaper that Jake finds in Abe's letter to Miss Peregrine.*

The newly imagined climax to the film occurs in Blackpool, a lively coastal British resort since the 1840s, full of piers, rides, and amusements. "Blackpool is probably not known to many people outside of England, but within England it has a certain reputation," Frey states. "During Victorian times, it was a popular beach destination. Over the years it's fallen into a trace of what it used to be. They're working hard to bring it back, but it still has a haunted quality. You sense there could be some spirits walking around, and I think that vibe is what draws both Tim and Jane to it, as they're coincidentally both fans of the town. Tim shot a music video up there and he knew he wanted to incorporate the town into the Miss Peregrine story. It's a place that can occupy many different eras, and in our story it brings our characters from 1940s Blackpool into the present day through a time loop."

"I love Blackpool for reasons too psychologically complex to describe."

"I love Blackpool for reasons too psychologically complex to describe," Burton admits. "When I go there, I always feel inspired and I never want to leave. I keep joking that I'm going to move there, but it may not be a joke." For the film, Burton masterfully utilized the local iconic scenery, and specifically the tower that can be seen from virtually anywhere in the town.

Bocquet says he also made good use of the piers and the circus. "Tim loves the whole sort of slightly kitsch version of a seaside town. We knew we had to have a sequence on the pier. So we shot a little bit on the North Pier in Blackpool, which has more of a 1943 look. And then we shot within the Victorian Blackpool circus for about two weeks, for one of the final sequences. It's an extraordinary location. There's probably nothing like it in the world, that circus, built in the base of the Blackpool Tower."

The Lancashire Correspondent
January 10th 2016

Blackpool Tower Circus to Reopen Tomorrow

Tickets for the Grand Opening on January 11th 2016 sold out

By CHARLOTTE PIDDINGTON

New Circus Extravaganza

CELEBRATIONS BUILDING UP TO THE GRAND OPENING OF THE BLACKPOOL TOWER CIRCUS HAVE BEEN TAKING PLACE ALL WEEK OUTSIDE THE NEWLY RESTORED BLACKPOOL TOWER.

Performers from the circus delighted the tourists and locals on the Tower front, which certainly made the bright cold January day seem more like Spring.

The opening performance promises to be the biggest yet in the history of the Tower, with many new and exciting acts and amazing technological gadgets enhancing the super-human abilities of the circus performers. A thrilling and awe inspiring experience is anticipated.

After the closure of the Tower for a £5m revamp, a healthy return is much needed by the council to cover the costs of the renovations. The famous landmark attracts hundreds of visitors and was bought by the council last year.

DEATH DEFYING

The intense program of regeneration is hoped to invigorate interest in Britain's version of the Eiffel Tower and attract a new generation of paying customers from all over the world.

Other attractions attached to the site have also undergone updating, such as Louis Tussauds, now Madame Tussauds.

Funding for the development was provided by the Great North West Development Agency, the European Regional Development Fund, Homes and Communities Agency who are hoping that the restoration will make a major difference to the profits of the area for many years to come.

NEW STUNTS

When the tower first opened on 14 May 1894, 3,000 customers took the first rides to the top. Tourists paid sixpence for admission, sixpence more for a ride in the lifts to the top, and a further sixpence for the circus. The first members of the public to ascend the tower had been local journalists in September 1893 using constructors' ladders.

When the top of the tower caught fire, and the platform was seen on fire from up to fifty miles away. The tower was not painted properly during the first thirty years and became corroded, leading to discussions about demolishing it. However, it was decided to rebuild it instead,

HERITAGE RESTORED

Performers from the Circus delight the Winter onlookers in anticipation of the Grand Opening tomorrow.

and between 1921 and 1924 all the steelwork in the structure was replaced and renewed.

BREATHTAKING

On 22 December 1894 Norwegian ship Abana was sailing from Liverpool to Savannah, Georgia but was caught up in a storm, and mistook the recently built Blackpool Tower for a lighthouse.

Abana was first seen off North Pier, and later drifted to Little Bispham where she was wrecked, and can still be seen at low tide. The ship's bell still hangs in St Andrews Church in Cleveleys.

AMAZING ANIMALS

During the Second World War, the crow's-nest was removed to allow the structure to be used as a Royal Air Force radar station known as RAF Tower, which proved unsuccessful. A post box was opened at the top of the tower. The hydraulic lifts to the top of the tower were replaced and the winding-gear replaced by electric. The top of the tower was painted silver as part of H.R.H. Queen Elizabeth's Silver Jubilee celebrations. A giant model of King Kong was placed on the side of the tower.

Escapologist Karl Bartoni and his bride were married suspended in a cage from the tower. The Reverend was not happy that day.

It is in the circus that Barron gathers his ex-hollow friends in preparation for his new time experiment. For Sam Jackson, the ampitheatre's atmosphere helped immerse him in his character. "Those things help you find your way in a story, when you walk into a space and the space is correct. Walking into that circus set was just: Okay, I get it. I get where we are. It's just off enough not to be Cirque du Soleil. But it's just wacky enough to be Barnum and Bailey at the end of its run. It's frayed around the edges and the lights aren't as bright, but there's the big ring and the pool of water. And you look up and you expect to see a raggedy ladder going up. The water doesn't look that clean but it's right for what that moment is. And it's cobwebby enough to go, oh, well, this is kind of old. What is it? Why is it here? So all those details inform and help us do our jobs."

Although Burton wanted shooting locations to drive the filming, it was necessary for some sequences to occur on a set. However, finding enough space in one studio proved difficult. The UK film industry has been on the rise since a tax relief scheme was introduced in 2007, so the more established film studios, such as Pinewood, Leavesden, Shepperton, and Longcross, were booked. Production finally located a suitable facility at Gillette, the former razor factory that closed in 2006. Its warehouse spaces have since been customized to film projects like the television show *24*. "We took it over lock, stock, and barrel and created within that complex some stage space, some workshops, and offices for all our departments," Gostelow says. "It's very nice when you feel that you've created a community. When you step out of the office and walk across the complex, everybody you meet is working on the same movie. I don't know whether it triggers tribal responses or security, bonding, I don't know what it is, but it provides a little extra something."

Sets are built for different reasons, but sometimes the logic is simple—because no real world-location would suffice. In the script, Emma shows Jake her "hideaway" under the ocean in the form of a wrecked cruise liner named the RMS *Augusta*. Later, the vessel becomes a mode of transport for the children to escape the island. Bocquet jokes that since production was unlikely to find a sunken ship in which to film, they built one. "John Bohan, our construction manager, and Clive Ward, our head scene painter,

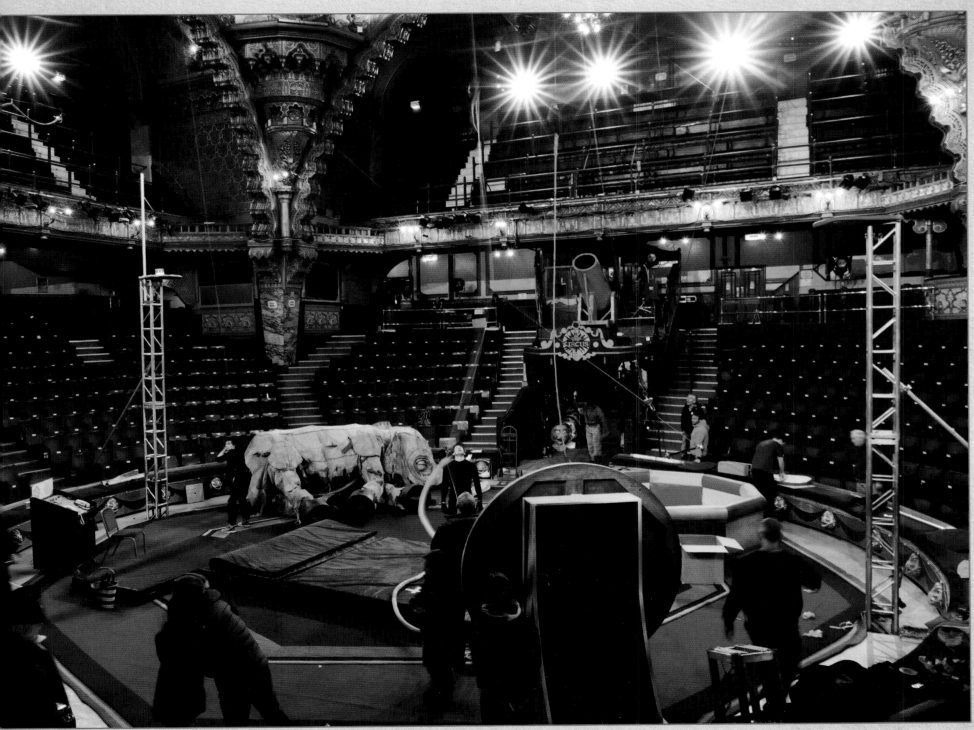

LEFT TOP TO BOTTOM: *Details of the circus set, which was filmed inside the real Blackpool circus.* ABOVE: *The crew readies the circus set for filming.*

love those sort of sets because it's a challenge. You're playing with textures, you're playing with ideas, rust, barnacles. We looked at lots of references for the state of ships underwater. The *Titanic* has an awful lot of references. Not many sunken ships are photographed to that extent."

The parts of the boat that were constructed weren't always authentic in their deterioration. "It's not like we see a perfect cocktail lounge and then we see it sunken underwater," Bocquet continues. "You had to be careful that you left enough intact so that people realized what it had been originally. We had to pull back a little bit from the reality of what probably would have happened. We did some wall samples of different levels of corrosion. Tim's very involved—he loves to come and choose the samples. He actually took a lot of the corrosion away; he kept stripping it back. We worried at one point that the ship would end up not looking sunk enough. But when I saw it on the rushes, I think we got it just right. We also talked about having live crabs in there at one point. But I think the idea of having live crabs on the stage was probably a bit too much for a shooting unit to cope with, when you've got intimate romantic dialogue scenes going on and a crab crawling over there."

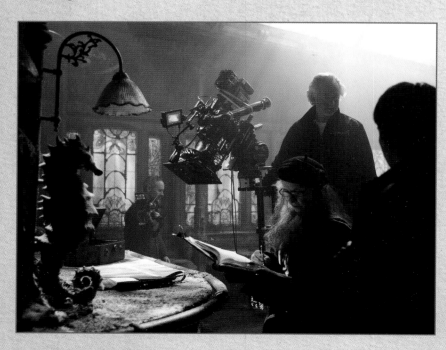

OPPOSITE PAGE: *The kids attempt to navigate in the wheel house of the raised cruiseliner.* TOP: *SFX floor technician Rupert Morency (left) and SFX prep assistant tech George Buckleton spray down the cocktail lounge before filming.*
BOTTOM LEFT: *The boiler room.* BOTTOM RIGHT: *A piano rests in the corner of the cocktail lounge.*

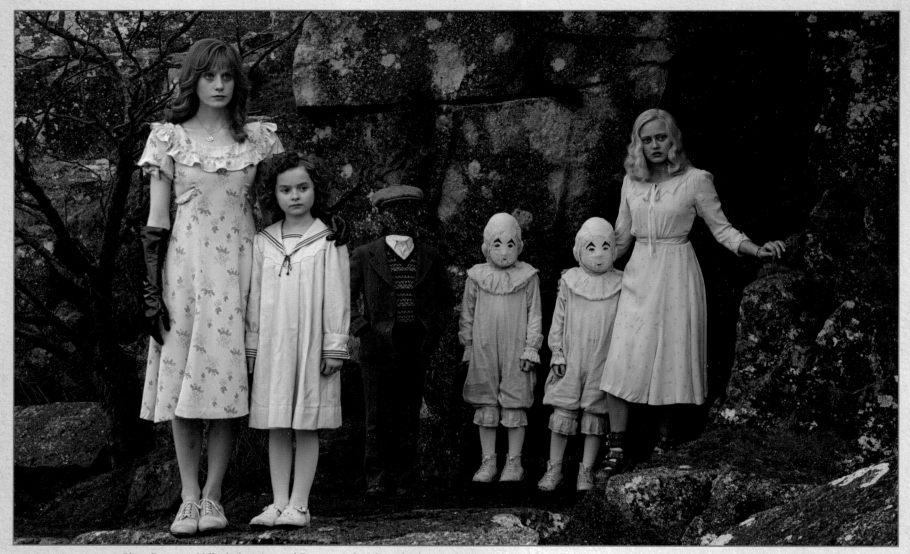

FROM LEFT TO RIGHT: *Olive, Bronwyn, Millard, the twins, and Emma wait for Jake at the entrance to Miss Peregrine's loop. The set was on location at Bodmin Moor in Cornwall.*

Other locations provided their own challenges. For example, Miss Peregrine's loop entrance, which is hidden inside a cave. Though its exterior was built on Bodmin Moor, in Cornwall, Gostelow explains that the interior was a separate set that had to be built for practical purposes. "It's very hard to film on a cave at the seaside, since most of them tend to flood when the tide comes in. So we built a cave, rather than either lose crewmembers or just have to vacate every six hours."

One set that was a crew favorite was the underground vault where Barron had performed his time experiment in the past, and where he planned a second, grander version in the current day. "We built the basement and the vault to the circus, which is meant to be underneath the circus ring," Bocquet reveals. "It's where our bad guys really hang out, in their big machine room. There was no room to do that in Blackpool, and I think there was a schedule issue as well. So we brought that back to Gillette."

There are two versions of the vault—the old and the new—and the property department was heavily involved in both, including

such key elements as the central birdcages for both versions, the helmets the scientists wear during the original experiment, and the associated equipment. The property master David Balfour, who has collaborated with Burton on *Sweeney Todd: The Demon Barber of Fleet Street* and *Dark Shadows*, oversaw most of the pieces in the room. "The lab [seen in the flashback] was one my favorite sets. We had a visual concept, and in the end it was difficult to tell the concept and the finished set apart."

The circular room is a lattice of helmets and wires, with a large machine nested in its center. For Balfour, the large central gadget was also one of the most complicated props to make. "There were so many component parts that were all handmade, and not a 3D printer in sight. It was important that it was handmade—it

had to feel authentic. It was concepted from images of Victorian machinery, and then Duncan McDevitt, the head of model making, and his team did a brilliant job constructing it. John Wells (my right hand) figured out how to hang it and operate it, as he does with everything technical that we do."

Resting below this mechanism is the cage where the ymbrynes are kept. "We were making props that had to be functional and safe to put real birds in," Balfour continues. The cage had to tie in with the machine, the helmets, and the circular rig holding them. The helmets themselves were a long process. The first concepts didn't work, and then Tim gave me a sketch of what he wanted and we developed the helmets from there. His sketch made so much sense."

Director of photography Bruno Delbonnel (left) and John "Biggles" Higgins discuss the lighting inside the cave set, which was built at Gillette.

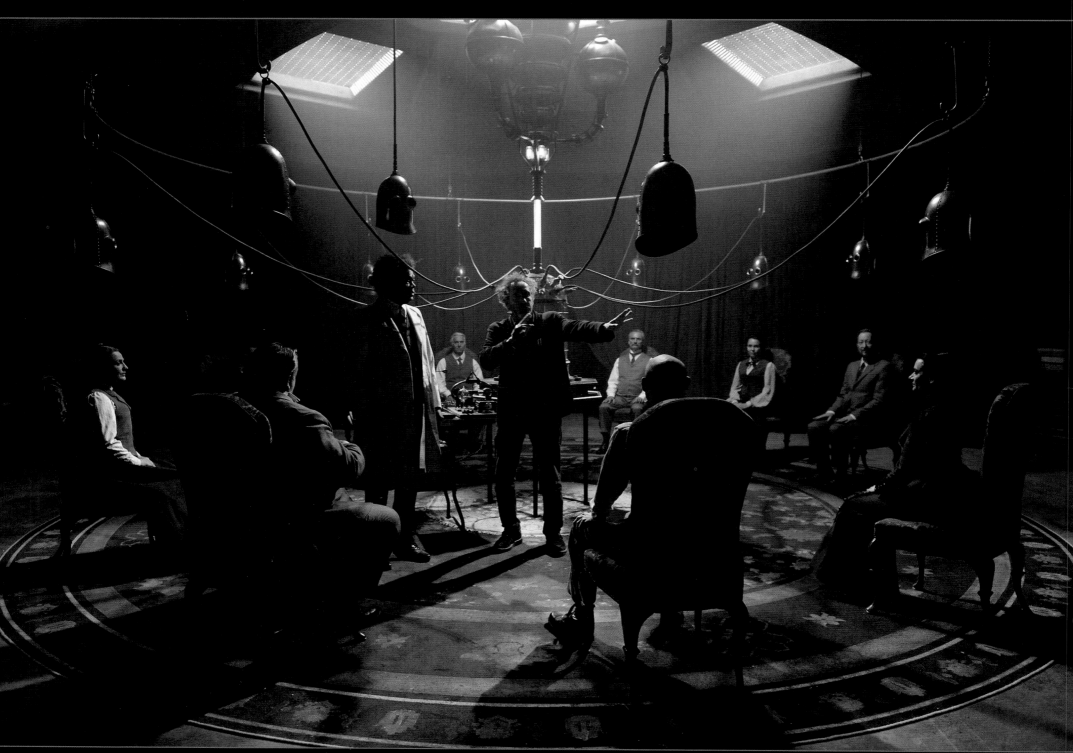

ABOVE: *Burton directs Jackson during a flashback scene in Barron's underground vault laboratory set built at Gillette. They are surrounded by a cast of scientists looking for immortality.*
OPPOSITE LEFT: *A helmet from the flashback scene.* OPPOSITE RIGHT: *Power's concept art of Barron's experiment.*

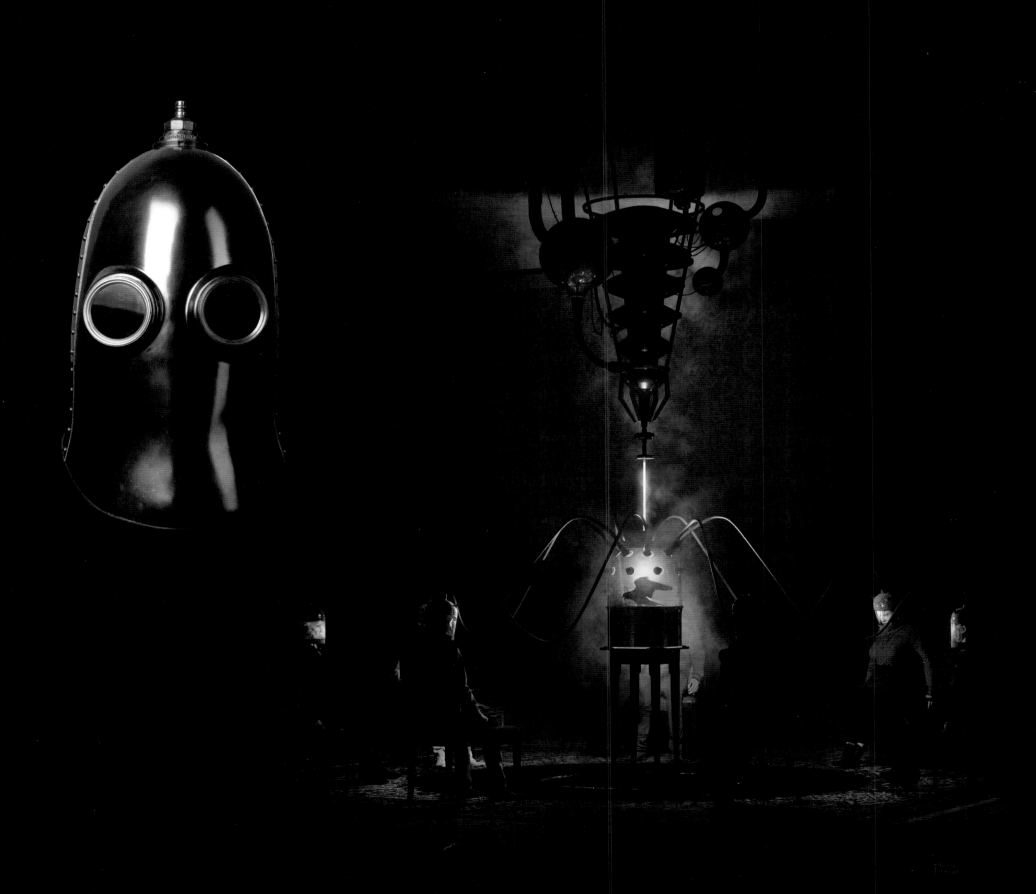

In addition to completely unique sets like the vault, Bocquet explains that many were duplicated based on existing originals at Torenhof. "We built the conservatory, the parlor, the dining room, and part of the lobby in London for a couple of scenes that have a lot of stunt work and special effects. Tim's desire was to have as much of the in/out interiors, exteriors, all working at Torenhof. But inevitably, because of the action, we had to build some of the interiors onstage simply because we couldn't do those sequences and special effects on the real house. We would have pulled it to pieces."

Bocquet says that one of the benefits of rebuilding rooms was extra space, and though his team was concerned that people might notice, the gamble paid off. "Between Bruno and Tim, they decided that the set in London could have an extra meter and a half one way, meter and a half the other way, just to give the camera room to get in and not have to be always floating walls out. The consensus was that nobody could really tell the difference."

British laws and regulations regarding minors also affected filming and the use of sets. Because the attic roof has an escape scene that occurs at night, it had to be built inside since, as Frauenfelder explains, children cannot work at night. "Working with kids in the UK is very specific. Each age group has a certain number of hours they can be on set. Being on stage allowed us to go between sets, so we could start the day with one group of children and then, when you lose them to their maximum hours, you could go to another set with either adults or the older children who had more hours."

This ability to bounce back and forth between different scenes and actors necessitated re-creating the dining room and children's bedrooms on a stage at Gillette. One of the most fascinating sets built for this purpose was Enoch's bedroom, another crew favorite due to its myriad jars of organs, bits of dolls, and tiny details in every corner. "I think the nice thing about this space is that it's more like a collage of imagery," Bocquet theorizes. "Tim didn't necessarily focus on anything—it's just there in the background. Bruno Delbonnel, the director of photography, has done some beautiful work. It's all incredibly moody, but in a good way. You just get glimpses of shapes and things showing through. Enoch's room is mysterious. You won't really know what all those things are, but you'll know that it's something a little bit weird."

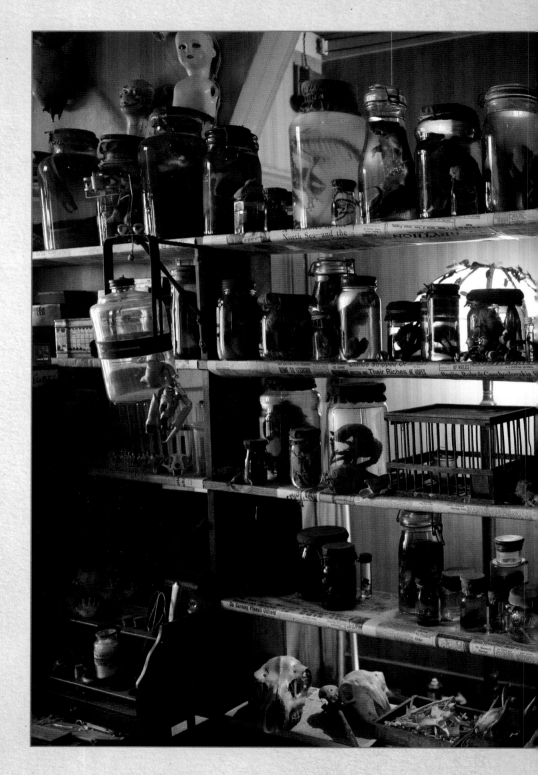

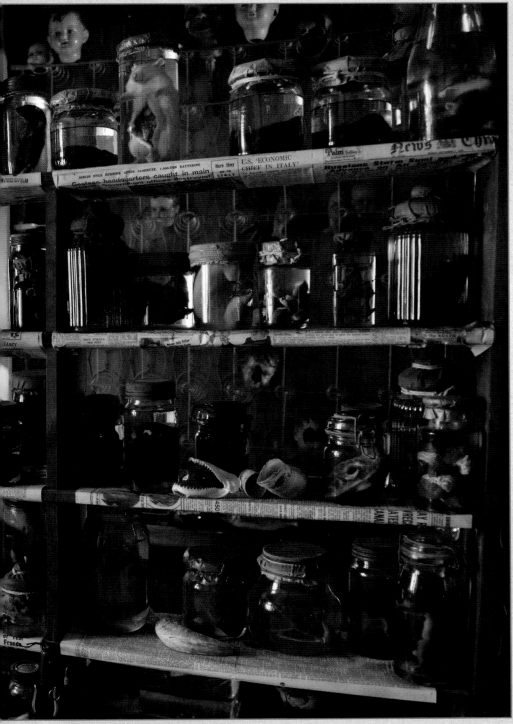

"You won't really know what all those things are, but you'll know that it's something a little bit weird."

ABOVE: *Shelves in Enoch's bedroom.* RIGHT TOP: *Property master David Balfour studies one of Enoch's jarred creatures.* RIGHT BOTTOM: *The special makeup effects department created preserved weasels for Enoch's jars.*

Enoch's bedroom is also an excellent example of the overlapping skills required for a single set, a perfect blend of art department, production design, set decoration, and props. Balfour took special care with the hundreds of props, personally overseeing the room's many elements and coordinating closely with Elli Griff, the set decorator. "She put all the elements in place, and we managed to put together the coolest set."

Burton, too, enjoyed spending time in Enoch's world. In fact, the first props he wanted Balfour to concentrate on when they started pre-production were the Frankenstein-like dolls. "The dolls are some of my favorite props," Burton reveals. "They're an assembly of bits of actual dolls, household items, and real creatures. It was a lot of fun to think up different elements you could add to make something functional. Dermot helped turn them into images that David could work from." The dolls were also some of Power's favorite concepts. "They were darkly funny, which really appeals to me, and I did some simple quirky animations to show how they might move or work. Concept design is about finding the narrative in what you are designing so that when you are asked to do something as complex and bonkers as the dolls made from weird, found objects, it's great fun trying to figure out how they might work and, more importantly, how you can show that as clearly as possible to the audience."

In addition to the dolls, Enoch's room is filled with dozens of jarred animals and organs. Each one had to be bought or created. "Enoch's jars were fun to do," Balfour remembers. "Duncan employed a prop maker who had worked in taxidermy, so her experience helped a lot. The props department made all of the hearts and organs, but some of the jars are filled with real taxidermy." There were so many jars that the props department had to employ the help of special makeup effects designer David White (*Thor: The Dark World, Guardians of the Galaxy*). "We made weasels at one point," he remembers. "They were flayed weasels that go in a jar. It's quite a strange job to have all these weasels lined up on lolly sticks, painting them."

Finlay MacMillan was thoroughly impressed by his character's room. "You go in and it's got all those normal things that rooms have. There's a bed there. But it also has dolls, tools, hearts, snakes, jarred animals. That's the best bit. It's hundreds of jarred animals. Enoch needs to keep them preserved so he can use them at some point. He's got an archive of organs. Props has done such a good job. In between takes, me and Asa and Ella went out and looked at these jars, see what they're holding. And they look great. They look real."

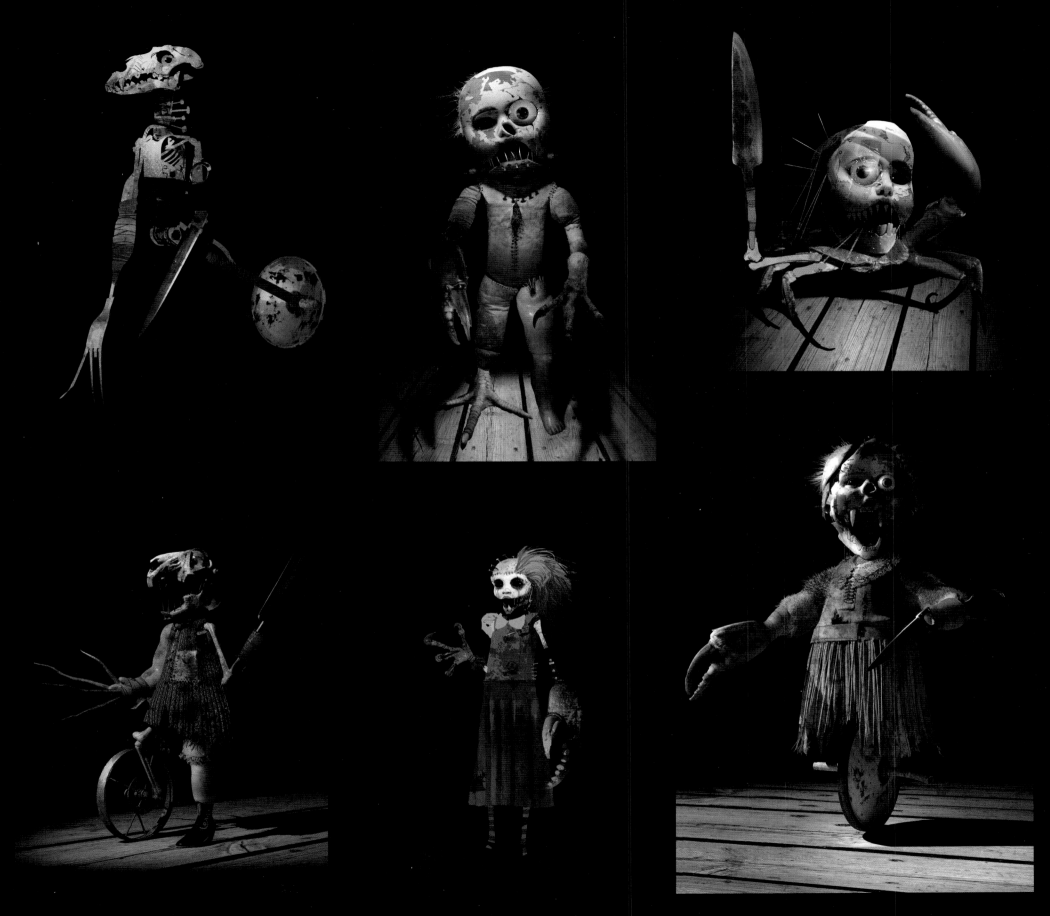

OPPOSITE: *Burton's sketches that guided Power when brainstorming ideas for Enoch's dolls.* ABOVE: *Power's concepts for Enoch's creations.*

A panorama of the funfair pier built at Longcross on a makeshift set walled off by used freight shipping containers.

Bocquet remembers how Burton would get involved in moving pieces into and out of the set. "He's almost a set decorator. He is always interested in the pieces we're getting, so you have to go through a process of whether something's more decorative or plainer or more graphic. But eventually you get to the point where all the pieces fit together. Tim wanted Elli and me to overdress most of the sets, 'cause he likes taking things out. He would rather have too much in there to begin with and then just gradually move things out. Whereas if you start with them underdressed, it's harder because he doesn't know what isn't there. The process has become a humorous aside, in a way. He likes to have his world to play with once we've dressed the set, and then he does his own thing with it."

Enoch's room is seen in its 1940s, functioning state as well as, briefly, in its modern-day, destroyed condition, after the house

"We have the **funfair** on the pier with a Big Wheel, Dodge 'Ems, a ghost train, and a carousel— Tim basically has his **own fairground**."

has been bombed. Any areas of the postwar house that the viewer sees were re-created sets. These included both interiors and exteriors, like the conservatory, where Jake first enters the house. The bottom part of the structure was built, though the top portion was rendered by the visual effects department. "I don't think the new owner of the the Belgian castle would have taken too kindly to us bombing his house when we first got there," Gostelow guesses.

Because of space limitations, a few sets were built at Longcross, a production studio just outside London, including the exterior of the wrecked conservatory. The largest set they re-created at Longcross was the Blackpool funfair. Bocquet says that they considered shooting in Blackpool, to get the "gritty reality of it," but the unpredictability of weather and tides swayed them in favor of a more controlled environment. "We have the funfair on the pier with a Big Wheel, Dodge 'Ems [bumper cars], a ghost train,

and a carousel—Tim basically has his own fairground," he concludes. "Which is very nice. I'm sure he's never had his own fairground before."

Though inevitably sets had to be built, the influence of Burton's decision to stay as grounded as possible can be felt in every scene. "What's unique about this project is that the real locations are driving everything else," Frey says. "A lot of times you'll build a set and then you find the right environment to occupy it. In this film, we set forth to find the environments before designing the sets. So even if we end up building a set like the funfair, because of the stunts work that takes place or because it's too tricky to film on location, the set is still driven by the real environments that inspired it. And most of what was built was done so involving very little green screen, so it's still real and tangible. This approach will definitely carry over into the experience of watching the film."

4

A Vintage Look

COSTUME, HAIR, AND MAKEUP

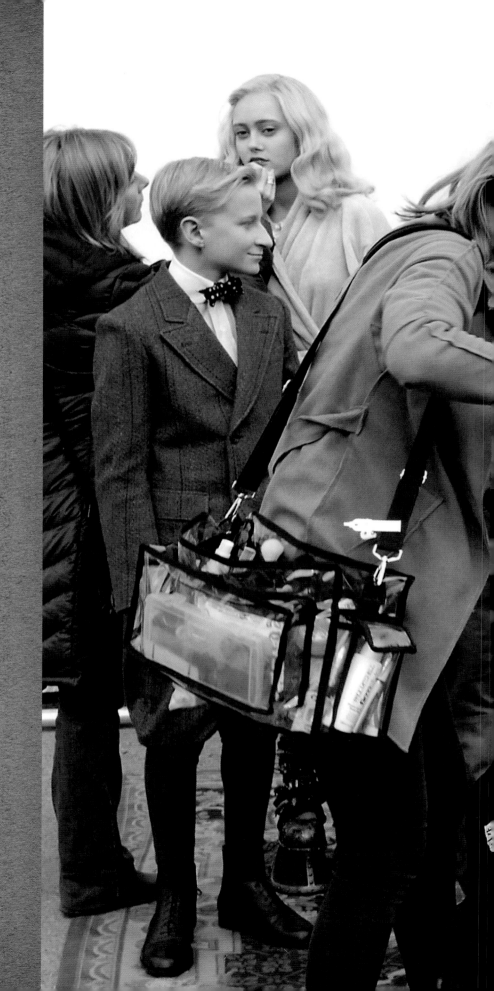

*T*he aesthetics of the characters in any film are a collaboration among the actors, the director, the hair and makeup team, and the costume department. *Miss Peregrine's Home for Peculiar Children* was the eleventh time that Tim Burton has teamed up with the three-time Oscar-winning costume designer Colleen Atwood. She started her creative process on *Miss P* by meeting with Burton and discussing his vision for the script and characters. Then she met with the actors, gathering their input before beginning to design the costumes. "You're creating a character to help move a story forward," she states. "Tim told me what he was thinking for the children. He had an idea of the feeling he wanted each one to have and how to push that particular quality."

The children wear the same outfits every day, a purposeful decision Burton made early on with Atwood, so that they are easily identifiable. "It was a choice, to help keep so many characters distinct," he says, "but to also emphasize that these kids live the same day, every day."

Atwood says that reading Ransom Riggs's book helped her think about the costumes. "The feeling, mood, and images in the novel evoke a certain style. Each character is almost an exaggeration. Claire is like a little doll; Horace is like an explorer. Each kid embodies a quality that's part of our psyche as children. So every one is sort of the iconic version of that quality, which made designing the costumes a fun challenge."

Atwood also referred to the time period for inspiration, specifically the 1940s. "I wanted graphic textures in the costumes," she says. "So Hugh's knitted sweater has a honeycomb pattern. It doesn't look like a honeycomb, but his costume has all kinds of textural variety. Because it's a group of people wearing the same costume throughout the entire movie, I wanted to vary the colors in the palette, so they didn't fight each other but, rather, were balanced. I'm happy with how all the children flow together and look as a group. It makes me feel good when I see them playing together and they look real. I think taking a story like this and keeping it real is probably the biggest challenge."

The film's hair and makeup designer Paul Gooch joined Burton for their fifth film together. "I think Tim is unique in his visual input," he opines. "A lot of other directors tend to let you just get on with it, and whatever you decide to do, they're happy

PREVIOUS SPREAD: *The costume, hair, and makeup teams ready the cast for a group photo.*
TOP: *Costume designer Colleen Atwood discusses a costume with Burton on the pier set.*
BOTTOM: *Atwood illustrates her concept for Hugh's costume.*

Milo Parker as Hugh.

to go with. Whereas Tim's got a particular style, and it's very important for every department to be on the same page. But he's also very much a director who will let you have your own creative input. For example, if a script asks for a particular hairstyle, I tend to get ten wigs and do ten different versions of my ideas. Then I will show those to Tim and to Colleen in Costume, and together we'll choose the one we think works best for the character. From that point, I'll try it on the actor, and we boil it down bit by bit until we get the final look everybody's happy with."

Gooch read Riggs's book as a starting point, but ultimately old-fashioned research, the script, and Burton's guidance helped him most. "We've got loads of museums and art galleries in London. So that's where I started looking, reviewing materials from the war and the 1940s. Then there's the element of fantasy that you always have in a Tim Burton film. That gives you license to stray from the historical facts and looks, and to be a bit more creative with the visual aspect of the film."

The process of deciding a character's look can take months before the camera ever rolls. Orla Carroll, Eva Green's hairstylist, recalls how they tried numerous styles on Green to determine Miss Peregrine's coiffure. "Eva and I started 'playing,' as we call it, about four months before the shoot. She started leaning towards a gray pompadour style, but with a bang of a bird. We explored every possible gray 'do, but as always it's not serious playing until

Hair and makeup designer Paul Gooch combs Butterfield's hair before a take.

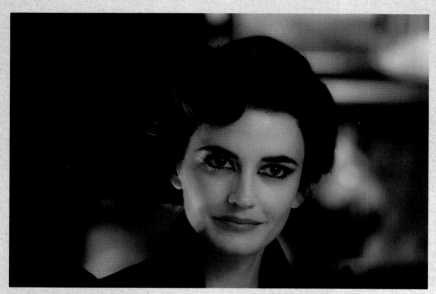

Eva Green as Miss Peregrine. The hair and makeup helped give her character a birdlike feel.

she fits the costume and we hear the wish list. Once Colleen arrived for her fitting, it all started to go in a more definite direction. Tim wanted blue-black, and I felt the hairstyle had to be something more alive, with flicks and kicks but also some structure. I came across a photo of Marilyn Monroe, and she was our core."

Burton chose blue in the wig to harken back to the peregrine falcon, whose feathers are imbued with the color. As Carroll explains, "For the first camera test, I dressed a wig I had colored with highlights. Tim liked the flick and the flash of blue going through. It's like cooking a recipe—adding a pinch of that curl and half an ounce of that quiff, and so on. When the wig arrived, it was an intense week of a million 'dos. Photos plastering the wall for inspiration and the endless journey of trying every possible 'do till at last Eva looks in the mirror and recognizes her character. That is the best part of what we do—helping people find their character and helping create everyone's vision."

Props can also be crucial to a character's overall appearance. In both the book and the film, Miss Peregrine smokes a pipe, a rather striking visual. This, along with her crossbow, convey to the viewer someone who is both an independent thinker and a formidable foe. Balfour says that the designs of both were conceived under Burton's guidance. "Tim was very specific about the style of the pipe. We were lucky to find a traditional pipe

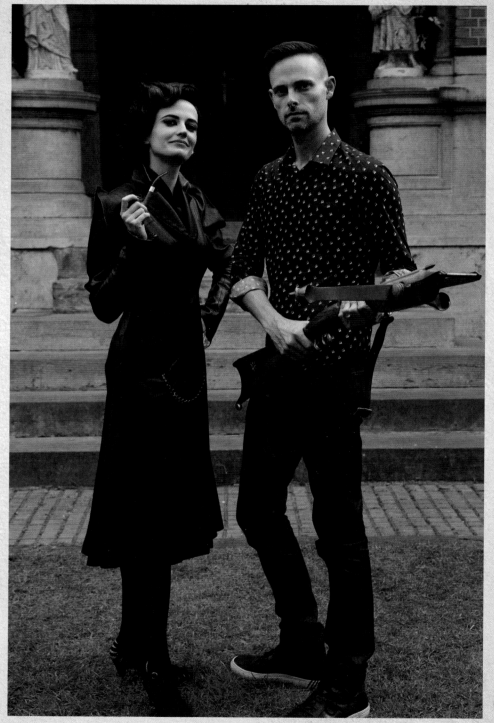

Eva Green and Ransom Riggs in front of Torenhof. Her jacket was tailored to perfectly fit over her costume.

maker named Ian Walker, who made them exactly as we asked. With the crossbow, Tim was again very specific. After much research we came up with a few different styles designed into the one you see onscreen."

The most integral prop to the costume of the time-obsessed Miss Peregrine is her watch. It was originally scripted as a nurse's pendant, which was pinned to a uniform to allow a hands-free, disease-free timekeeping option. Balfour explains why they changed it in development. "Miss P was supposed to wear it on her jacket. This didn't work for the shots Tim needed, so I looked into period pocket fob watches and thought that a French-style railway watch would work. They are bigger than a normal pocket watch and were renowned for their accuracy, which I thought was crucial for Miss P. After researching many different styles, I decided that both the perpetual clock [that Miss P brings out during the time reset] and the watch should have the same face to link them both together in the story. Then Tim and I decided on a casing that looked elegant and suitable for Miss P."

Green notes the differences between her onscreen character and the book version on which she's based. "In the book, Miss Peregrine smokes the pipe, but in the photographs, she looks quite different from Tim's version. My Miss Peregrine looks more stylized from the forties, very feminine, quite sexy, and a bit more birdlike than the original Miss Peregrine. It took quite a while to find the look, to combine the bird with the woman without being too obvious. In the film, my character has a flick in the hair, kind of a specific eye shape that makes it quite birdlike. Colleen Atwood, the costume designer, is a genius, and it's all in the details. Costume, hair, and makeup are always so important for an actor. They help you get under the skin of the person. The moment I put on the dark blue wig and the sexy costume and those high heels, I felt more centered and became Miss Peregrine. Everything makes sense when you're in costume."

"Miss Peregrine is a character who transforms herself," Atwood observes. "She becomes a falcon. So we wanted elements of the bird, but without having a bird design in the costume, to be something that Eva could use to point herself in that direction. So she has pointy shoulders and clothes that flutter a bit. There is a quirkiness to the end of her sleeves, little details that could take

"We wanted elements of the bird, but without having a bird design in the costume, to be something that Eva could use to point herself in that direction."

Miss Peregrine's pocket watch.

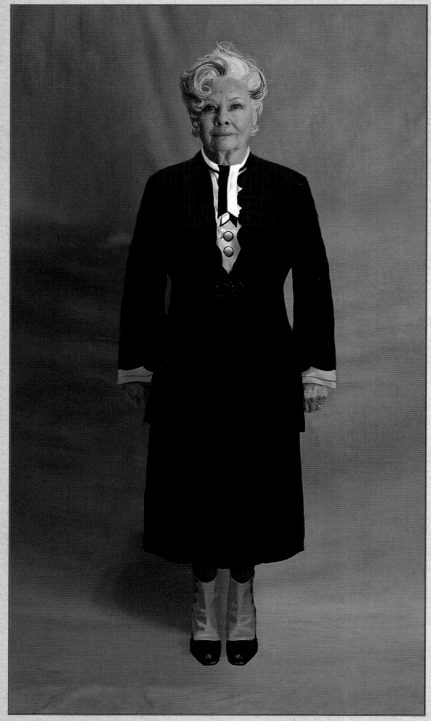

A photo/illustration composite of Judi Dench to show Atwood's concept for Miss Avocet's costume.

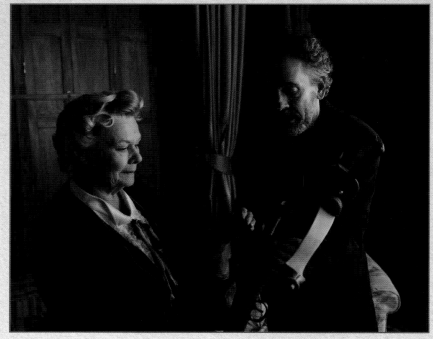

Burton directs Dench on how to hold Miss Peregrine's crossbow.

flight, in a way. Her fabrics are from the period. The costume is made from a wool crepe, and on her shoulder is an embroidery detail of a metallic feather that catches the light when she moves. I used a midnight blue for her costumes to avoid the cliché of black and to have that lightness we wanted."

Dame Judi Dench plays Miss Avocet, another ymbryne in the film. Hair and makeup designer Paul Gooch says that this look was also influenced by the character's avian side. "The avocet is a shallow water bird. Its colors are white, with a black stripe through its body. So for the hair I had a wig made that's basically a white-gray color, and we gave it white flecks throughout. I wanted to keep a 1940s feel, so I came up with a hairstyle in keeping with that period, but it has a slight madness to it. When we first see Miss Avocet, she is a bird and she's injured, having been kidnapped by the baddies, and she crashes into the wall of a cave. She's then taken to the children's home, where she's nursed back to health and is able to transform into the human that Judi Dench plays. So the hair reflects all of the adventure she's experienced."

"Judi was very keen on being a bird. She was very happy to be playing one," Atwood adds. "She brought me pictures of avocets

and said, 'Look at their wonderful gray legs.' So we did her costume with little gray legs and gray boots, which she was very fond of. And again, we designed a costume that could flutter, that had fluted edges so it looked kind of winglike, but without having birds directly on it. The material could move, and she could kind of flap in it a little. The fabric of her dress is a lighter weight. It's a silk crepe and lined with a lighter color to give the feeling of the inside of a bird's wing, which is generally lighter on the underside than on the outside." Dench agrees with the overall effect. "This is quite a birdlike costume," she says. "I think it is absolutely exquisite. It's got a lovely little peplum to the skirt, which makes you feel rather good, and excellent boots, which you can't see, but take my word for it."

In contrast to the 1940s costumes of the ymbrynes, the villain Barron and his eclectic group of ex-hollows are modeled after a more timeless feel, which takes them from a quasi-Victorian era to modern times. As Atwood describes it: "They're created in a kind of fantasy way to be slightly out of period but to still work within any period. For Barron's costume, I used a nice kind of forties wool. I wanted it to have structure. We sort of exaggerated the shoulders. His jacket has a peak shoulder and a flanged collar. It's almost two-dimensional, which is what I wanted. I didn't want

A photo/illustration composite of Samuel L. Jackson to show Atwood's costume concept for Barron.

Creepy eyes and teeth add to Barron's villainous demeanor.

a lot of buttons and gewgaws on it, so I kept it minimal. For the earlier part of the film, he wears a lab coat that's based almost on a Victorian lab coat. It's a sort of made-up thing he wears in a flashback scene."

Samuel Jackson had nothing but praise for Atwood, calling her brilliant and her concepts spot-on. "I was in the midst of doing something else, so when I got there and I saw what she'd come up with, that was my first information about Barron in that particular way, and the elegance of who he is and what his appearance means to other people or how he presents himself. The lab coats, the suit that I wear, the length of the collar, all these things enhance the strangeness of who he is. They also inform his intellect and his station in life, which I guess is odd because a lot of people don't expect to see African Americans in that Victorian garb or to be in that specific situation. I think that goes along with the oddity of the story and how it all works. But without her visual of me, the people that I'm with, the children, how all the people that we interact with look— none of it works."

Barron's appearance is dramatic and distinct, in large part because of his hair and makeup. "His look is based on a flashback, in which he's trying to gain immortality through a big machine that he's invented," Gooch comments. "But the machine goes wrong and electrocutes him and his colleagues. So his shock of gray hair is standing on end, reflecting that moment. We've also given him some horrible razor-sharp teeth that he uses to full effect in his characterization of the bad guy."

In addition, the ex-hollows all have signature white irises with pinpoint black pupils. "We had to make what are known as false glare all lenses, which basically cover the entire eye, not just the small disks used for reading and day-to-day vision," Gooch explains. "These things are huge, like half a golf ball. We had a small hole made in each of them, for all of the characters, just so they could walk around and see while acting. The effect is truly scary."

TOP: *Barron's weaponized hand threatens Miss Peregrine as he locks her in a cage.* ABOVE: *Costume, hair, and makeup attend to Helen Day as Miss Edwards.*

The ex-hollows line up in their specially tailored costumes, ready to intimidate.

The hair, teeth, and eyes all helped Jackson find his character, especially since he had very little time to do so. "When I got the job and I accepted it and I read the book, I started thinking about the characterization, but I was in the middle of doing another film. I had three days after I finished that film to get on set and start figuring out who Mr. Barron was. I got the hair, the eyes, and the teeth in, and then I was able to wrap my mind around what I was about to do."

Jackson also wears a prosthetic when he uses his peculiarity to shape-shift his arm into a weapon. The blade-appendage was created by David White and his team. White describes the process: "It's sculpted from a plastilene material over the hand of the actor, so that it can fit like a glove. Tim didn't want it to wobble at the end because then the gag is gone. The material that it's cast in actually changes along its length. It's hard, and then it gets softer as it comes up through the hand, and it's tight around the wrist. So it looks real and moves a little bit. That's a really strange combination of materials. It's a polyurethane. We cleaned it and processed it in a spray booth, where we gave it a high-gloss finish with a mirror effect. It's fantastic. A really shiny surface. It looks dangerous, which is what Tim wanted."

Sometimes the costume design acts as a way to connect various characters. For example, Atwood says that she wanted to strengthen the bond between grandfather and grandson. "I sort of did Jake and Abe together because I thought, even though Jake had a dad and a mom, his real tie, in his heart, is to Abe. So I put him in the most classic, modern version of 1940s clothes. He and Abe are tied into each other on a design point, even though Jake is dressed in contemporary clothing."

Clothing heightens their kinship even more directly when Jake dresses up for dinner in Abe's old clothing. Frey says that the scene intimates their bond not just as relatives but as peculiars. "His grandfather stayed in that bedroom and wore those clothes. He's lived the day Jake is about to live a hundred times. It's a powerful reminder of who Abe was and a hint at who Jake may someday become."

Atwood found that working with Terence Stamp, a man who prides himself on his clothing, was a complete pleasure. "Terence is an extremely dapper gentleman, so it's always fun to dress him.

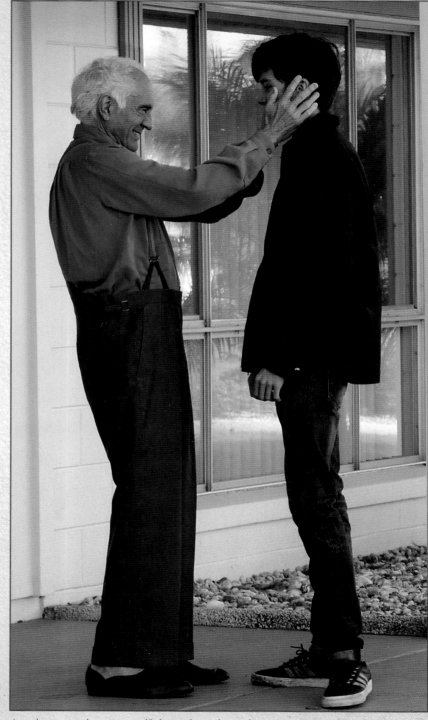

A tender moment between grandfather and grandson, whose costumes are tied together stylistically.

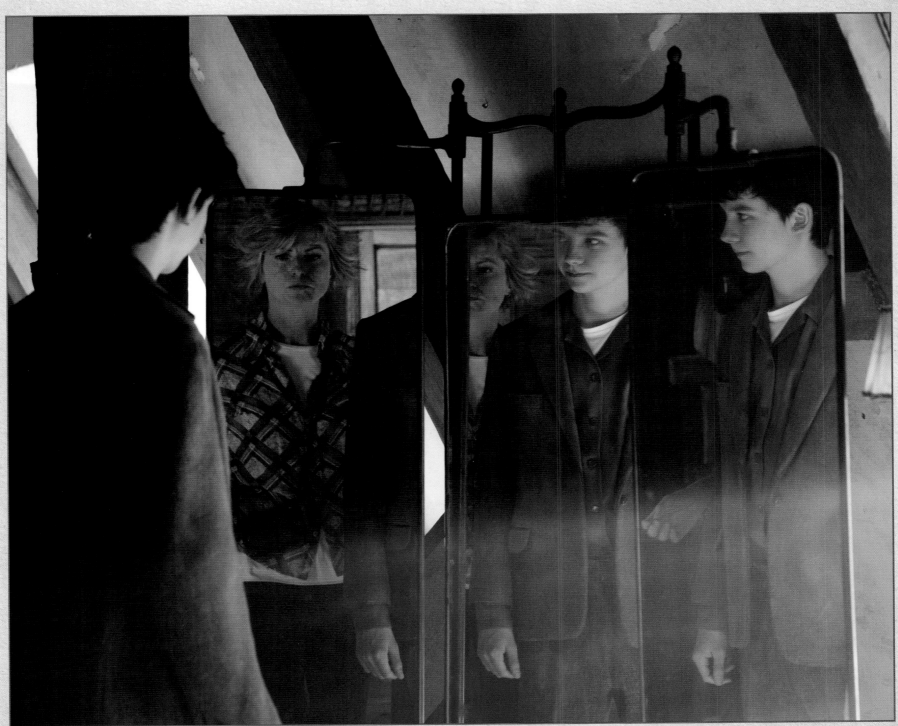

Set costumer Ciara McArdle studies Butterfield's wardrobe in the mirror of Abe's bedroom set, before a scene in which Jake wears his grandfather's suit to dinner.

His character is a man who'd really seen the world, who was a seasoned traveler, and yet he was living in a retirement area in Florida where most people are probably sporting stretchy waistbands and polyester. But he wasn't a guy who succumbed to that. He was a guy who still had a bit of the discipline of the military in him. So his costumes were chosen with comfortable fabrics, but with a little bit more tailoring detail. As though he harkened to the past, even though he lived in the present."

Stamp has only praise for Atwood. "For many years I was considered the best-dressed man in Britain . . . so I kind of know about gear. It's not often that I come across anybody who knows

"I wanted the boots to look like they were old irons that you pressed clothes with."

considerably more than I do, yet Colleen was one of those people. It was just delightful to work with her. You know, she really questioned me profoundly about what I wore, what I liked to wear, and how I saw the character. At first I didn't really understand why. Then when I came for the fittings and I saw what she'd done . . . The two very best costumists I've worked with, the ones that I've had empathy with, would be Piero Tosi, who was the great Italian dress guy whom I worked with when I worked with Fellini, and Colleen. I think they're the two very best."

For the children, Atwood tells how their peculiarities often informed their clothing. "Emma is a character who's about air, so for her costumes I chose a very airlike material and color. The fabric is a really light silk that we hand-printed with tiny flowers. We played around with two or three options and settled on this textile because it floats really well. It was not about what it would look like when it was on the ground; it was all about how it would appear in the air."

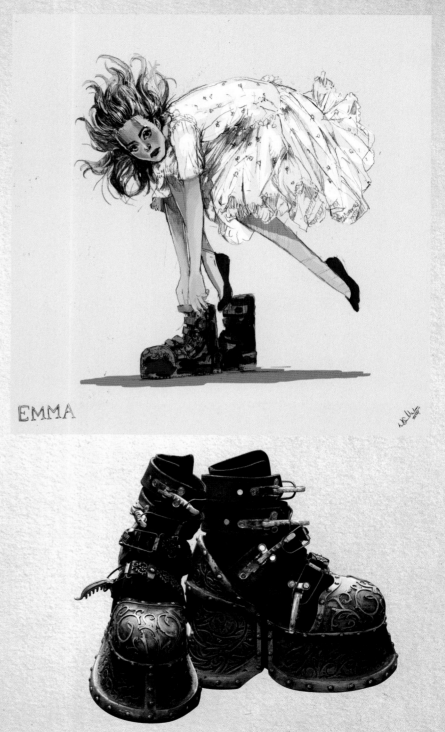

EMMA

TOP: *Atwood's concept for Emma's costume.* ABOVE: *Emma's boots.*

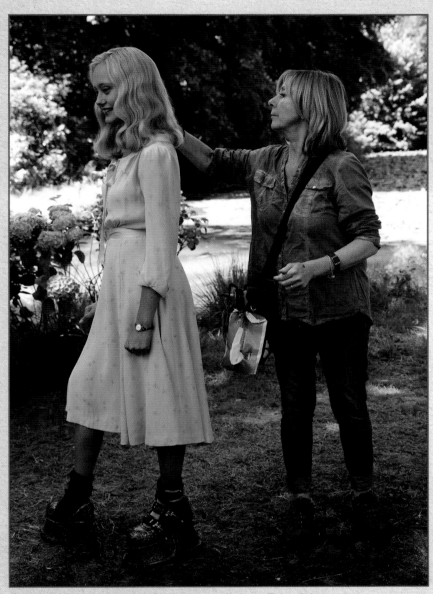

Hair and makeup artist Debbi Salmon arranges Ella Purnell's wig before a scene.

metal details. So we got to the point of the decor and the weight and then we created all kinds of versions for different purposes: lighter-weight ones for Ella to wear on a long day, heavier ones for when they need to sink. At one point, she jumped out of a boat and she was supposed to sink but the shoes floated up. So we had to do a lot of weighting and different versions of the shoes to get them right."

"I had to go in for six boot fittings; it was crazy," Purnell remembers. "And they're so big. In the first set of boots, I was taller than Asa. And he's pretty tall, so those ones were huge. They slowly got shorter and shorter, and more comfortable, too. In the beginning, I had to put plasters on my feet or they would get sore. But midway through shooting I started to get used to the shoes. They really are so cool. If I had been able to keep them, I would've worn them on a night out."

Purnell's hair suffered as much as her feet, at least during casting. Emma was scripted as a brunette, Purnell's natural hair color. However, her hair was dyed blond for her role in another film. Burton called her in for three auditions, which caused Purnell to dye her hair six times in three months. Figgis is still amused by the memory. "Every time Tim brought her in for an audition, she had to dye her hair dark and then blond back the next day. I nearly died when she was made to be blond for this film after all. The poor kid. I don't know how she's got any hair left."

Gooch says that Purnell's hair received a break from chemicals once filming on *Miss P* started. "We toyed with the idea of coloring her own hair and adding extensions to give the 1940s length to it. But that's very labor intensive—you have re-growth every two weeks and our shoot's been the best part of four months. So in the end I opted to give her a wig. I think it works well, and it's a quick fix in the morning, because we just put the wig on top of her own dark hair and, hey ho, she's a blonde."

One particularly fun peculiar to dress was Horace, who is obsessed with clothes and often dreams about them. "Horace is a romantic character," Atwood reckons. "He's like a guy out of an old movie. So I tried to sort of take the idea of the old cinema and an elegant Cary-Grant-as-a-child sort of character. Hayden Keeler-Stone has such an amazing face that it was fun to design costumes for him. We used real period cuts on his clothes. He was

One of the significant features of Emma's appearance are the boots that Burton was initially so focused on. "We did a lot of versions of her shoes," Atwood continues. "I did them higher, I did them lower. I wanted them to look like they were old irons that you pressed clothes with, which somebody modified for her feet a long time ago. That was my starting point. And Tim wanted them quite ornate, not just plain and industrial, but with lots of

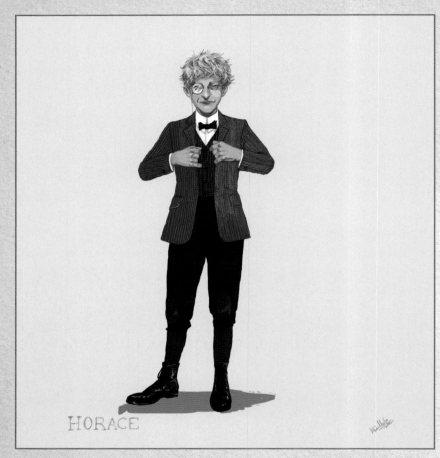

HORACE

very cute in the fittings, because he would always get a tickle from it, and it was great to watch him go over and look at himself and pose in the costume."

Horace owns an eyepiece that projects his dreams. Balfour says he was inspired by a pair of vintage German magnifying surgical jeweler's glasses. "We manufactured Horace's monocle to give it a Victorian scientific feel and also made one version with a light source built in."

Ironically, one of the unusual aspects of having children on set is that the hair and makeup team has to mold dentures for them. As children grow up, they lose their baby teeth—but of course that wouldn't happen to a peculiar living the same day again and again. "A lot of our cast is very young," Gooch points out. "The youngest is six, and the oldest is eighteen. And between those age groups, all sorts of things change. The biggest deal on this film is their teeth, because all the kids are losing their baby teeth on a weekly basis. So at the beginning of the film, I had our dentist, Chris Lyons [whose company Fangs FX does specialized character teeth for films], take casts of all of their teeth and make the vacuum forms [the molds that are used as clear braces these days]. So if anybody's tooth had dropped out, we'd just paint inside the actor's vac form with a color that matches their other teeth, and it's as if the missing tooth is still there."

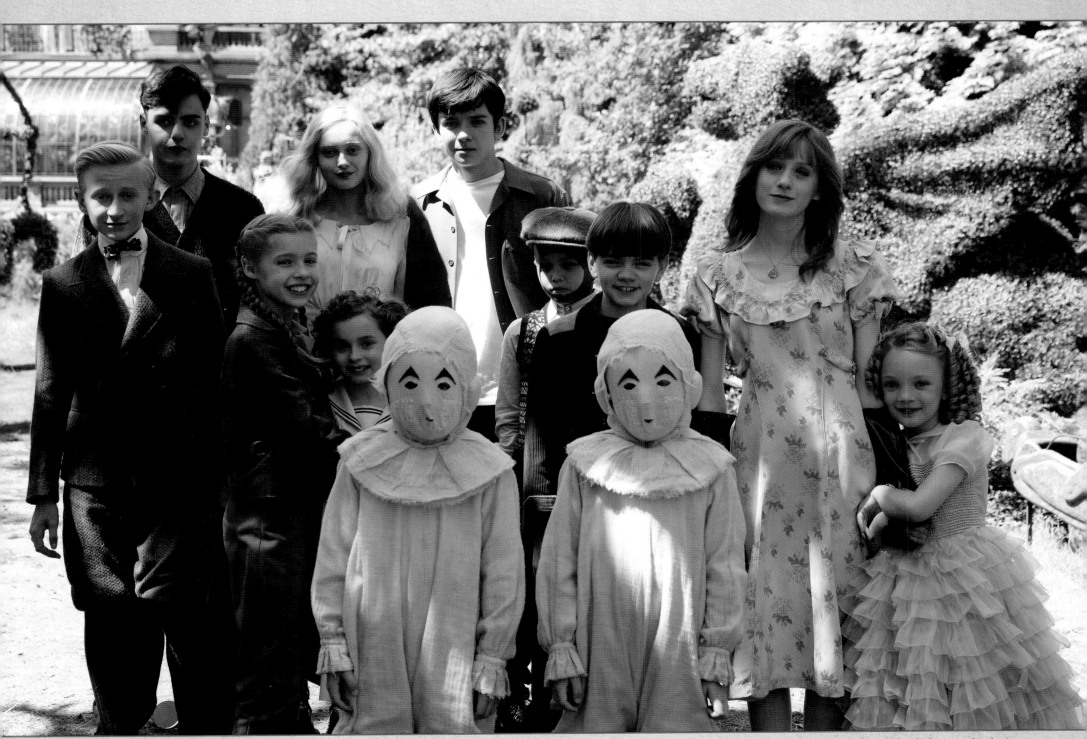

OPPOSITE TOP: *Atwood's concept of Horace's costume.* OPPOSITE BOTTOM LEFT: *Horace wears the eyepiece that projects his dreams.* OPPOSITE BOTTOM RIGHT: *A mold of Pixie Davies's missing front teeth, which were replaced using a painted vacuum form.* ABOVE: *The children pose for a group shot in the gardens of Torenhof.*

5

Map of Days

A TOUR OF FILMING

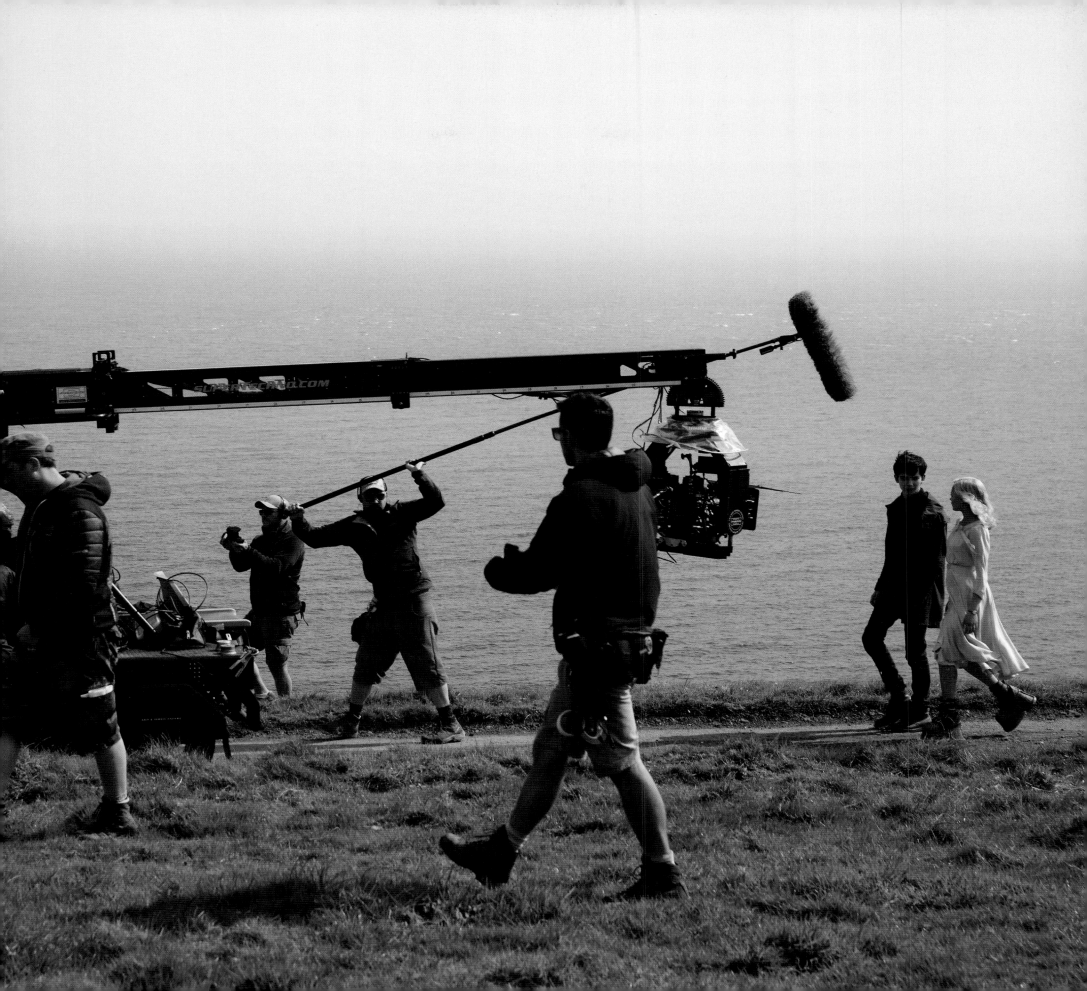

Filming of *Miss Peregrine's Home for Peculiar Children* commenced on February 24, 2015, in St. Petersburg, Florida. "It was interesting to go to Florida first because you don't often shoot in continuity," production designer Gavin Bocquet remarks. "It was nice to start the film with that atmosphere. I think Tim wanted to understand who Jake and his parents were, before embarking on the characters' more exciting travels."

Director of photography Bruno Delbonnel, who likens cinematography to music, described the Florida scenes as forming the debut of a "light melody." To achieve the appropriate tone, he conferred with Burton about the director's wishes. "He knows what he's looking for," Delbonnel says, "but he tries to keep a door open for suggestions from the actors or from me. He is quick to understand what he can do with an idea. It's like a seed you give him, and sometimes he transforms it into something which is pure Tim Burton."

Though Delbonnel and other department heads travel to each location with Burton, production hires local crew members to fill

supporting positions as an economically viable way to move a production company from one place to the next. For Burton, Florida reunited him with some of his team from *Big Fish* and *Edward Scissorhands*, along with cast member O-Lan Jones, who played the evangelical Esmerelda in the *Scissorhands* suburbia of Lutz, near Tampa. Her performance in *Miss P*, as Jake's gun-wielding co-worker,

marks her third appearance in a Burton flick (she also appeared as Sue Ann Norris in *Mars Attacks!*). Working with some of the same people in similar environments was nostalgic for Burton, who scouted Lutz when looking for the grandfather's house. "It was surreal to be back in that development," Burton recollects. "All of the trees had grown so much taller in the past 25 years, it was hardly recognizable."

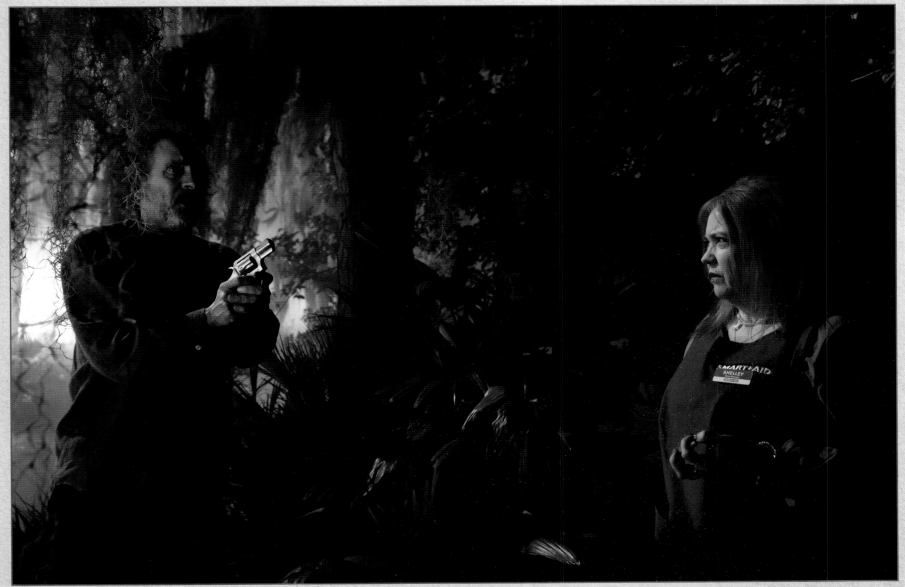

PREVIOUS SPREAD: *The film crew walks backwards to track a crane shot of Purnell and Butterfield.* OPPOSITE TOP: *Opening shot of the film.* OPPOSITE BOTTOM: *Burton's illustration of how he wanted* Miss Peregrine's Home for Peculiar Children *to begin.* ABOVE: *Burton directs Jones on how to enter the scene.*

ABOVE: *Delbonnel and Burton discuss the lighting of the trees behind Abe's house.* RIGHT: *The grips ready the crane for a shot.*

> ## "I liked the idea of the characters all having their own photo, much as they do in the novel. The photos are part of what makes the book so great, so they had to be included."

Ultimately, Burton found Abe's house in a town called Sun City Center. Its name was an irony, since during production's two weeks in the Sunshine State, the skies were uncharacteristically cloudy, with long stretches of fog rolling in. Native Florida crewmembers kept commenting that it was the foggiest weather they had seen in years. Thanks to some skilled rearranging of the schedule by Katterli Frauenfelder, they managed to eke out the sunny shots they needed, even if Delbonnel had to re-create a sunlit effect for the interiors. "The weather wreaked havoc with our schedule," she explains, "but it ended up being fine. We just

had to completely flip how we wanted to shoot. Anywhere you shoot, it's always, 'It hasn't been this way in one hundred years.' It's the law that if you go somewhere to film, then the weather is the exact opposite of what you need. Still, it was the right place to start, because there's nothing in the United Kingdom that looks like Clearwater or St. Petersburg, Florida."

In Jake's home, we catch our first glimpse of the vintage photos of the peculiar children, which are stored in a tin box. In lieu of bedtime stories, Abe Portman regales his young grandson with tales of his childhood friends. Since the vintage photos were so vital to the novel, Burton felt it was important they be represented in the film as well. "I liked the idea of the characters all having their own photo, much as they do in the novel. The photos are part of what makes the book so great, so they had to be included. It's an important story point in the narrative of the film, and it was also a nice connection to the source material."

"We're re-creating the photographs that appear in the original book, but we're doing so with our actors," adds Derek Frey, the executive producer. "When Jake sees these photos in the film, we wanted to preserve the sense of mystery from the novel: Are these images real? Are these children *really* exhibiting these abilities? Or is it just old trick photography? We went to great lengths to re-create the photographs, and to stay true to the feel they have in the book."

After wrapping in Florida, production moved to the United Kingdom, where filming began at Gillette on March 13, 2015. The first scene was dinner with Miss Peregrine and her children. Delbonnel explains that working with children requires a unique way of lighting a set. "You cannot give kids a specific place to be

OPPOSITE: *Executive producers Derek Frey and Katterli Frauenfelder discuss the cloudy skies in Florida with Burton.* ABOVE: *Abe acts out a story for young Jake about his peculiar friends who fight the monstrous hollows.*

ABOVE: *Miss Peregrine and her children at dinner, which occurs promptly at 5:30 pm every evening.* OPPOSITE LEFT: *Davies and Chapman play together.* OPPOSITE RIGHT: *Keeler-Stone blows bubbles between takes.*

in order to get them in your light. In fact, you light the set more than you light the actors. You must give them a lot of freedom to move. This is different from working with adult actors, with whom you can be very specific."

As the director of *Charlie and the Chocolate Factory*, Tim Burton was accustomed to working with young actors—but this film featured an even larger ensemble cast of children. Still, any concerns about inexperience were quickly dispelled. "The kids were all professionals on set," Burton explains. "With some, you would never believe it was their first big film. They definitely bonded off set, which made me happy. The older ones looked after the younger ones. It mirrored the dynamic in the film. They were a good bunch of kids."

"The whole cast of kids is incredibly energetic," observes Lauren McCrostie, who plays Olive. "It's like they have this endless stream of energy and they're just bouncing everywhere and they're so happy. We work long hours, and having that young

brightness jumping around is really nice. It's refreshing to see such young people working so hard and working so well."

McCrostie's cast mate Cameron King, who assumes the role of Millard, agrees. "Between filming, we're often in our trailers or in tutoring," King relates. "When we're in tutoring, it's hard work. But when we're in our trailers, that's when we have the most fun. We just like to muck around, play a bit of football, catch and that. It's basically like being with your best mates and just hanging around. Everyone's a family on set and off set; it's the same."

The combined energy translated well into the stunt training and stunt work scheduled for the actors. The stunt coordinator Rowley Irlam, who has worked on *Game of Thrones*, is acquainted with children from working as a stunt performer on seven *Harry Potter* films. "We've got eleven children, ranging in age from eighteen down to six," he says. "Some of the them were too young and too small to be replaced by adult stunt doubles—particularly Raffi, Pixie, and Milo. So we had to make sure that those cast

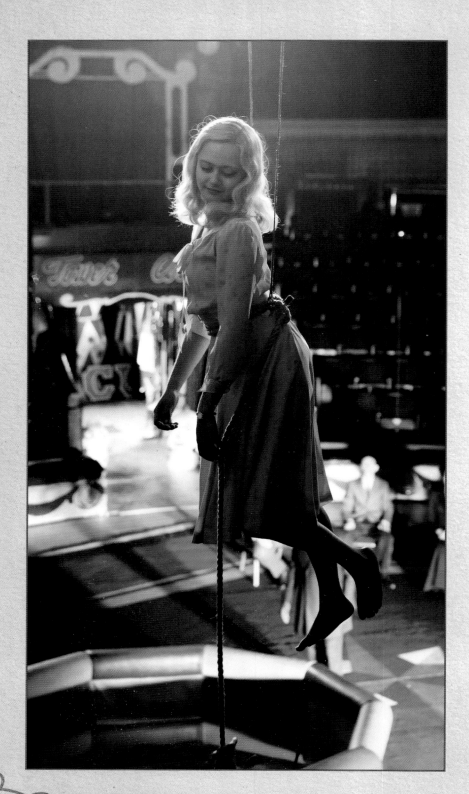

members could do all the action required."

The *Miss P* film is what Irlam calls "wire-heavy," with two especially challenging sequences that take place in the circus and on a roof. To prepare for these scenes, Irlam set up a large rehearsal space at Gillette for the actors to practice. They chose the room with the highest ceiling to accommodate the wirework, but Irlam says the space also happened to be practically derelict. "It was grim. So the company had everything excavated and leveled. It was quite a big deal, but it meant that we were efficient, and in the end it was a pleasant place for the cast to rehearse. You need to start dialing that stuff in long before the film gets going. Once the film starts, you do have some downtime, but you're pretty much on a roller coaster that's not going to stop."

The number of hours the children could legally work also affected their rehearsal schedule, a restriction that Irlam learned to work around. "Most of the kids would rather go to stunt training than study with tutors. They would always ask, 'Do I have something to rehearse? I don't want to go to education.' I think they had a great time, and we built a solid rapport with them."

Another key moment filmed at Gillette featured Miss Peregrine introducing Jake to an ornate and beautifully designed book

> ## "It's basically like being with your **best mates** and just hanging around. Everyone's a **family** on set and off set."

called *A Peculiar History*. As she turns the gilded pages, Jake (and the audience) learn more about peculiars, time loops, and hollows. Carol Kupisz was the graphic designer in charge of making the tome. The cover featured intricately designed 3D typography, and its surface was hand-finished with metal powders, paints, and

polishes. The back and spine were torn from an old Victorian photo album whose aesthetic inspired the volume's interior. "All the innards were remade and the pages were created from hand-made paper with gold-foil embossing and hand-cut windows for the photos," Kupisz explains. "Because of stringent copyright issues, I wrote my own version of the *Peculiar History* loosely based on the book and the script, plus a lot of surreal waffle. The text is tiny and only readable if you pause a DVD, but it was easier than trying to get permission to use someone else's words. Thank-fully, the pages were thick, and I laid out the lettering with a large border to avoid having to write 300 pages of text."

To prevent wear and tear, Balfour's department usually creates multiple versions of a prop. In a departure from normal practice, however, there was only one copy of *A Peculiar History*, which everyone handled with white gloves off camera. Kupisz offers this explanation for why only one book exists: "Because it's magic. But also because it cost a bloody fortune! I did make repeats of the pages, however, in case someone sneezed on it."

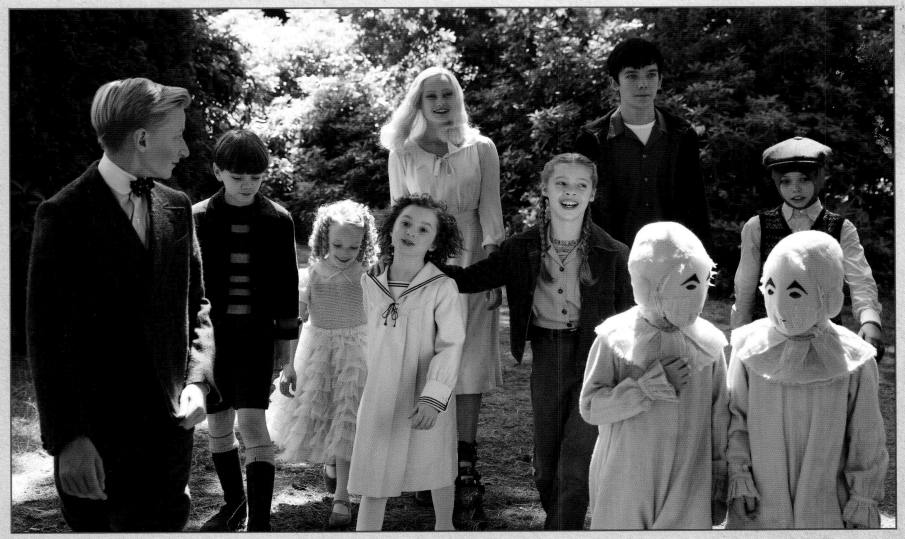

OPPOSITE : *Purnell hangs on wires between takes.* ABOVE: *The children's natural camaraderie comes through during an impromptu marketing shoot.*

ABOVE: *Emma watches as Miss Peregrine shows Jake* A Peculiar History. OPPOSITE: *The cover of the singular* A Peculiar History, *along with two interior pages, one of which is a gallery of the hollows' victims.*

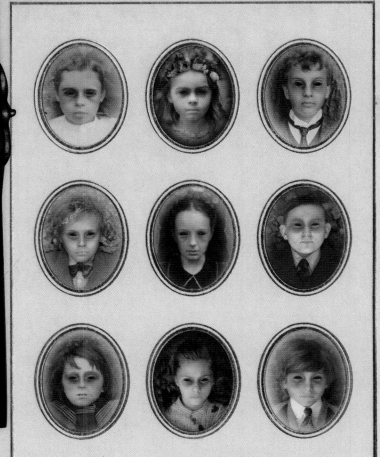

VINDICATORS.

The death toll caused by the Hollogasts was great during the first few years after the experiment. No one really understands how they multiplied, after the initial calamity, but somehow, they have done so. Often times, they form a hunting pack, making them deadlier than ever, but most attach themselves to a Wight, who may have formerly been a brother, close friend or lover who seeks out

In early April production shifted again, this time to Cornwall for a couple weeks to film the Cairnholm scenes. Jake and Frank travel to the Welsh island by ferry, so the actors and crew filmed on a boat in the English Channel along Cornwall's coast. Frauenfelder remembers the day well. "The ferry was small, so most of the crew had to be underneath. The waves were choppy too—a blustery day, which was the weather we needed. Everyone up top—the actors, Tim, Bruno, Des the camera operator—they all did OK. They had fresh air. But the ones below didn't fare as well. There were a lot of green faces. It's one thing to film in bad weather, another entirely to work while being thrown around like that. Not an easy day for the crew."

Once production returned to solid ground, the first major stunt sequence took place at the Priest Hole, the local tavern. This is the scene in which Jake enters the pub in 1943, and the villagers are immediately suspicious of him. Fortunately, the loop children

come to his rescue, and an invisible Millard distracts the angry patrons by throwing glasses and plates.

Naturally, this scene involves many special effects (performed on camera and known as SFX) as well as visual effects (added during the editing process, usually with the assistance of computers, and known as VFX). Hayley Williams, the film's special effects supervisor, has worked in the SFX department on three previous Tim Burton films. "A lot of effects could have been done by VFX, but Tim likes to have in-camera effects as often as he can," she says. "It's important to Tim, and to most of us as well, to have as much happening on set as possible. Anything we can achieve physically, we do." To keep everyone safe from flying tableware and other projectiles, Williams and her team manufactured lightweight and breakaway plates and glasses. "Rowley had a stuntman dressed in blue to stand in for Millard, but the crew decided it was far more fun if they threw the breakaways around the pub themselves."

"A lot of effects could have been done by VFX, but Tim likes to have in-camera effects as often as he can."

OPPOSITE: *Filming on a boat in the English Channel.* ABOVE: *Emma, Olive, and Jake race away from the melee at the Priest Hole.*

Another special effects challenge was depicting Olive's powers of pyrokinesis—the ability to set things on fire, which she uses during the fight in the Priest Hole. "To set things alight, Olive takes a glove off," Williams explains. "In the pub, she starts a fire when she touches the doorframe. So we had to come up with ways of making flames erupt out of nothing. We arranged an exact ignition on the point where she touches the wood, and then spread the fire across the front of the pub. It was great because we could do the scene with the actress. We created our own doorframes, our own pieces of the pub. We used some pyrotechnics, and then we fed in propane gas and rigged all the windows and doors."

At the conclusion of the kerfuffle, Jake hops on a horse-drawn carriage driven by Emma. To prepare for this scene, Irlam sourced a film carriage horse and tells how he conducted driving lessons with actress Ella Purnell. "Carriage driving is all in the voice, because you're not really riding the horse. Ella took to it very well. She's assertive and quite confident. It's more about the tone than the words one uses. We just kept training, every week. We started off with someone seated next to her; she was driving, but someone was always there to take the reins if needed. Soon she was happily driving around on her own, cantering up the lanes. When it came time to shoot, she was totally confident."

In addition to the village, several other locations were clustered nearby so that no disruptive company moves were necessary to film such places as the cliffs or the cave entrance to the loop. Frauenfelder relates how these added both a bit of flexibility and a bit of complexity to the shoot. "Cornwall was split between gray sequences in 2016, and sunny sequences in 1943. On any given day we had to jump from one location to another, challenged by weather and light. Not only do certain scenes require sun, but you need the sun in the correct position for the DP, along with the proper tides. It's a constant puzzle, and I find that fun. Cornwall was an absolutely stunning location in terms of physical beauty. To be able to shoot on a wild beach that we had to sling-load all the equipment down, knowing nobody else is going there—to me that's really special. The scenic quality makes it that much more rewarding."

In Cornwall, there were also several moments for prosthetics, including the use of two full-body doubles: one for the character of Oggie, an 85-year-old man found dead and eyeless at the bot-

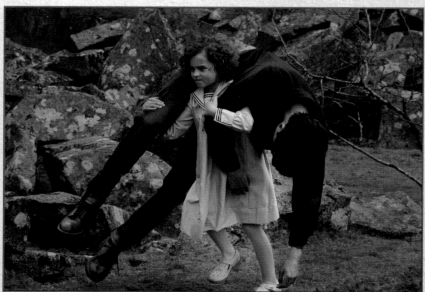

TOP: *Special makeup effects modeler Tom Moore adjusts a prosthetic dead sheep.* ABOVE: *Bronwyn carries Jake to the loop entrance. In reality Davies is carrying a light prosthetic double.* OPPOSITE: *Jake's stunt double, Leigh Maddern, adjusts the body position of a prosthetic Oggie.*

tom of a cliff, and another for an unconscious Jake, who is carried by Bronwyn to the loop entrance. But the biggest challenge, according to special makeup effects designer David White, was creating an entire herd of dead sheep. "We were sculpting heads and legs, armaturing all the different elements. Then we added the horns, making them look totally real. Flocking them, covering them in hair and wool. Adding fake eyes. And then dressing them into the shot. We made sure we had lots of wool that we could scatter around the sheep, giving the impression that something ghastly has happened. We had about ten of those sheep. It was quite a long process—it took about a month and six people from start to finish."

White, who was working with Burton for the first time, found the experience rewarding. "It's a gathering of like-minded people. It's been very exciting, because Tim takes it to the limit. The process can feel almost spontaneous. On some movies, you stop the process of imagination somewhere on page four and you put it to one side, but this process should carry on right to the moment that the camera turns over. Because that's what it's about. And Tim has the ability to do that, which is a very unique and unusual thing nowadays. It's fantastic to be around."

The spontaneity White refers to is part and parcel of how Burton operates, which allows opportunities at every level of filming. "That's why he hates making a concrete decision too early, because he knows that things will change," Frauenfelder asserts. "He knows that throughout the process he might see something in a different light, or a piece of acting will change, or he will find a location last minute, or something will happen which offers a different view into what he wants. That's why he doesn't often use storyboards, because people get too set in concrete; he likes the fluidity of being able to adapt his vision to what's happening at the moment. He hates being locked into something because he

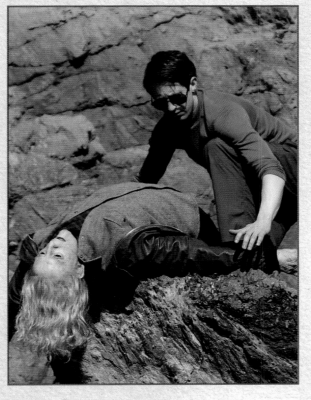

knows that as a story evolves, many aspects evolve with it."

As Burton puts it: "You can make a decision early on, but having so many different elements, mixed with so many great artists, often changes the initial plan. That's part of the beauty of it. The most important principle is to remember the spirit of what you're trying to do."

One example of this improvisation occurred while filming a scene in Cornwall. In the sequence, Miss Peregrine is wielding a crossbow against a hollow—and since the action is taking place in 1943, the crew needed sunny weather. But the skies weren't cooperating. After hours of staring at unchanging clouds, Frauenfelder and Frey began exploring the surrounding area, mostly as a way of killing time. They discovered a hidden beach down a steep slope that would be perfect for another scene—the one in which the children are walking along the coast toward the sunken *Augusta*.

"We were originally going to shoot that scene at Bodmin Moor, where we shot the cave entrance, and add the ocean in CG," she remembers. "But this was such a beautiful beach that I called down Frazer [visual effects supervisor Frazer Churchill] and Bruno [Delbonnel, the director of photography]. Then we all called Tim down, and he loved it, too. Finding the beach was happenstance, and the scene is now stunning because of it."

It's a classic moment: Emma floats high above the backdrop of the ocean while Jake pulls her along on a rope. The extensive "floating" stunts required weeks of training for Purnell. "So much harness and wirework," she comments. "Right from the first week, they put me on wires. But I'd filmed *Maleficent* for three weeks, so I'd already had a lot of training in wires. I worked closely with Rowley, the stunt coordinator, and Fran, the movement coach, on how Emma should look lighter than air."

Stunt coordinator Irlam says that Purnell was a fast learner.

"We put her on wires
all over the country,
since for half the time
you see her,
she's floating
twenty-five feet
above the ground."

Emma acts as a lookout. The scene occurred on a hidden Cornwall beach discovered a few days before filming.

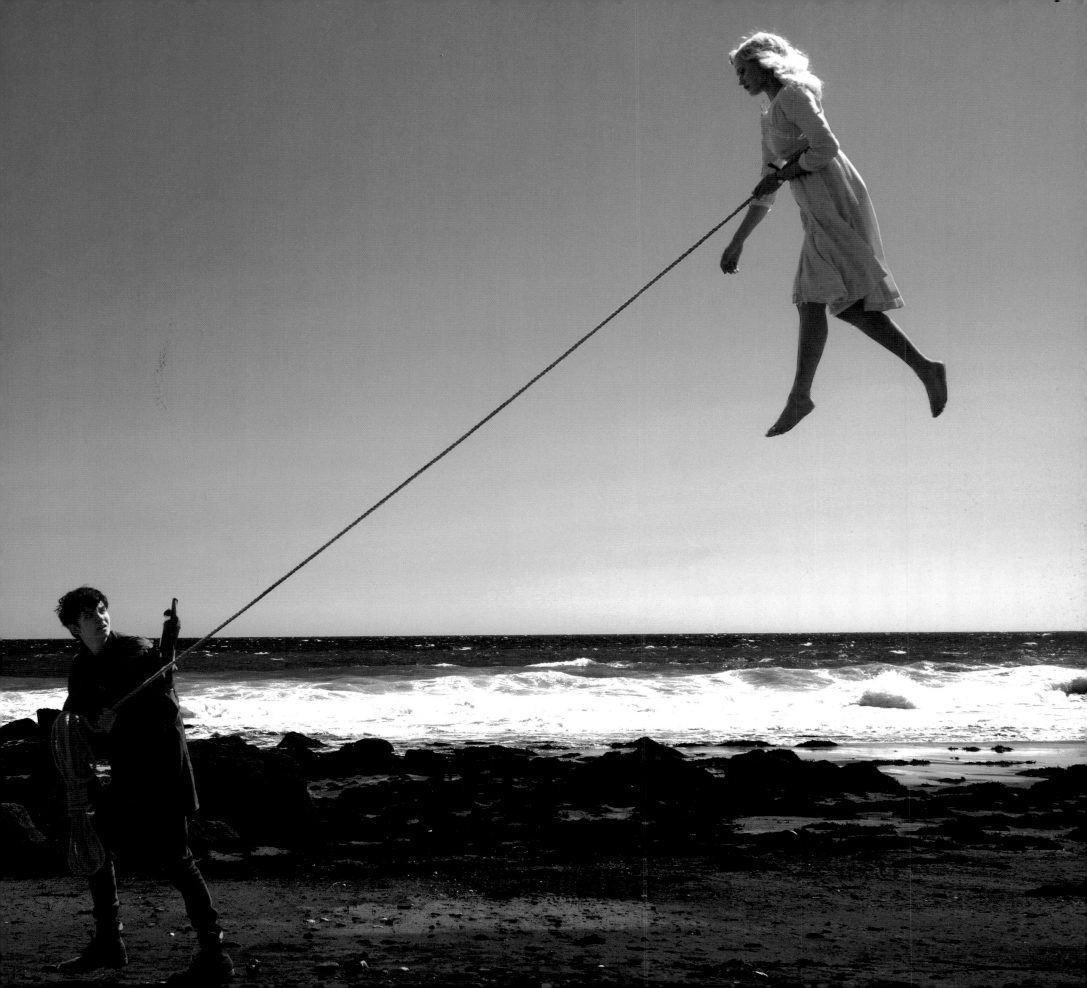

"She had to do a lot of floating. We would use two big high lines, and we had the ability to puppeteer them from side to side to get a little bit of sideways motion. We put her on wires all over the country, since for half the time you see her, she's floating twenty-five feet above the ground. Ella uses a lot of physical performance to make that feel floaty. Some people are more of a deadweight on a wire. She's very light when she's flying around on a harness. That's all her. There's no double. She looks like a balloon, which was the entire goal."

During the last week in April, production moved from Cornwall to Blackpool, where the circus became the staging ground for the penultimate climax of the third act. Because the circus was a historic building, the stunts department was forbidden from putting holes in the ceiling. Instead, Irlam explains, they built an intricate wire structure so that they could hang the harnesses independently of the building. "That was a major rigging job for the stunts team," Irlam notes. "We spent a lot of time and energy in pre-viz [short for pre-visualization, a sort of animated story-boarding process in which the filmmakers can choreograph a scene without live actors]. The kids are in the scene. Barron is set on fire. Bronwyn ends up underneath a frozen pool. Miss Edwards flies around the circus. There's just so much going on."

Setting an actor on fire requires several collaborative elements. The first is the consent of the actors involved. Then it's a matter of the special effects team, in collaboration with the stunts team, safely creating the fire. In the sequence, Olive sneaks up behind Barron, slips off her glove, and touches his shoulder, setting it ablaze. The SFX team designed a rig within Jackson's jacket, then began testing it for safety. After special effects accurately determined the proper amount of flammable solution to use, Irlam's team coordinated with them to test the flame. "We worked out where to position it and we rehearsed it with the stunt double," he says. "Once we were sure the level was right, all we needed to do was protect the wig that both the double and Samuel L. Jackson wear. So immediately before we would set fire to him, we spritzed the wig with water. We also used Zell Jell, a protective substance that you can put on the back of the neck to provide protection for a few seconds. And then, in a highly controlled circumstance, we set fire to Sam. It lasted for about three seconds, and then we'd

put him out straightaway. You plan very carefully how large the flame is, but you also plan for how long someone is alight. You don't set somebody on fire and go, 'Oh, this looks good, and oh, it still looks good' and keep going. Eventually the actor is going to get warm."

One part of the scene was an illusion: the image of Bronwyn trapped in the paddling pool. "Tim specifically wanted to see a shot of her frozen under the ice," Williams remembers. "It's quite

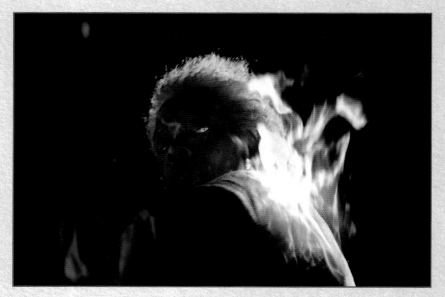

tricky to have a small actress under something. It couldn't be water, obviously, because she's lying static. So we created an effect for Tim that was a sheet of ice. We had a dressing underneath it that she could lie within, stone still and looking through it, creating the effect that she was actually frozen in a block of ice."

Partway through the scene, the kids all pile on top of Barron in an attempt to stop him. This too required choreography and training. "We did running around, falling over, and with Samuel Jackson's stunt double, we all got to punch him," Cameron King recalls. "I didn't punch him hard, but he still fell over. It was good fun."

One of the longer stunt sequences unfolds with Miss Edwards, an ex-hollow who is intent on attacking the children. Her peculiarity is defined by her feet and tail, which were created by White and his team. "The feet were sculpted over the actress's own feet," he explains. "We did a cast up to her knee and then sculpted the entire thing. I chopped the end of the actress's toes off the cast

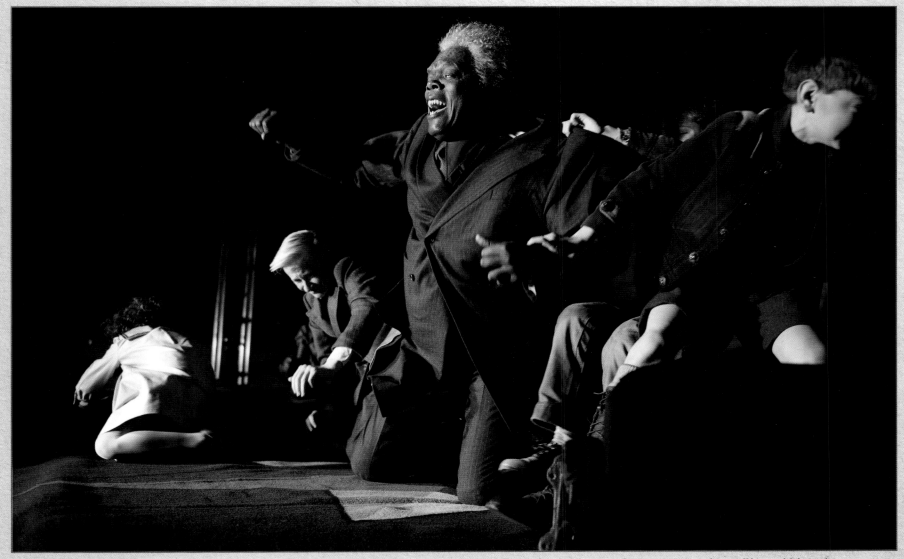

OPPOSITE TOP : *Jackson's jacket erupts in flame.* OPPOSITE BOTTOM: *Davies lies under a sheet of ice to give the illusion that she's frozen inside.* ABOVE: *Barron throws off his youthful attackers.*

"The wire that I'm on doesn't catch me until the very last minute. But it's been exhilarating."

so that it wouldn't look like an extension or a clown's boot. Then we sculpted that in plastilene, molded and cast it in silicon, and lastly punched individual hairs, one by one, into all the areas around the ankles and the foot. We used yak hair with a little bit of mohair mixed in—a very specific color that Tim wanted." Helen Day, who plays Miss Edwards, jokes about her new appendages. "My wonderful feet have been slaved over by prosthetics," she says. "They've created these brilliant kind of monkey-like feet that cause my springing around the circus space. And they're amazing because they look really uncomfortable, but in fact it's like wearing a pair of slippers. Don't tell anyone—they all think I'm suffering."

In the film, Day uses her feet, along with a prehensile tail, to propel herself around the circus. Her training as an aerial performer helped prepare her for the role, but it still took a leap of faith to trust the wires designed to catch her. "The stunts team has been really good at training me and putting me on a wire. They've been incredibly patient, watching me do things again and again and making me feel really safe. I'm jumping from a great height. The first time, it completely freaked me out. The wire that I'm on doesn't catch me until the very last minute. But it's been exhilarating, too; it's a complete adrenaline hit and it's pushed me right out of my comfort zone."

Mr. Gleeson, played by Scott Handy, also had several stunts to perform during what Handy calls his character's "really bad day." First, he's attacked by Hugh's bees, then Fiona throws seeds that grow into vines and entrap him, and then Enoch reanimates an elephant that attacks him. Handy sees the sequence as the stunts version of a long mathematical equation. "You've got to get one number followed by another number, followed by another number. We've just been practicing the numbers. So when we get onto set, Tim can talk to us as actors and we don't have to worry about the math adding up while we do the scene."

Sometimes a particular stunt, combined with where it lands in the day's schedule, can add up to a lot of anxiety for an actor. Handy reflects on one such moment, when his character Mr. Gleeson jumps into the paddling pool to escape a swarm of bees. "There's quite a lot of pressure because you're moving into overtime, it's the last shot of the day. And you're wearing a wig. You've got makeup on. You're fully clothed. This is a one-time shot. If you

OPPOSITE: *With the help of stunt wires, Day jumps around the circus throwing knives.* LEFT: *Assistant costume designer Christine Cantella (middle) and set costumer Perry Goyen (right) adjust Handy's wardrobe, which is trapped in Fiona's vines, while junior hair and makeup artist Daniele Nastasi fixes Handy's wet hair.* RIGHT: *Mr. Gleeson throws Bronwyn into the pool and freezes her there.*

get it wrong, they're going to be nice to you, but everyone's going to be furious inside. But you can't really rehearse it. We practiced the shot with an empty pool, but that means rolling over; and of course when there's water there, it's completely different. So I had to run, screaming, and then jump into the pool, and I did it. I was terrified not that I was going to die. I was terrified of letting people down. But Tim was happy. So, fingers crossed, it worked."

Throughout the film, Emma uses her peculiar abilities to blow forceful gusts of air. Special effects uses wind machines, which are so convincing they sometimes persuade the actors in the scene. As Purnell explains, "If there's a wind machine down here and I'm going 'Whooo,' and the person I'm aiming at has loads of wind in their hair, I feel powerful—like I have that power."

In particular, Purnell cherishes a memory from a circus scene

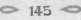

she shared with Jackson. "Every time he does the scene, he'll do it differently. He might chuck in an extra couple of lines. There was this really great moment when I just fell in love with him. It's a scene where I'm blowing air at him, pinning him against a wall, and he shouts at me across the wind machine: 'You could use a mint!' Tim loved it. He was laughing so much, and then Sam walks past me and chucks me a box of mints and I grab it and I'm thinking, 'Oh God, Samuel Jackson just gave me some mints.'"

Another challenge in Blackpool was a scene filmed in front of the Blackpool Tower, where Williams was tasked with creating a winter wonderland in the middle of spring. "The snow on the ground is made of several materials, depending on where you are and what you're working with, whether it's in a studio or on a road. Everyone turned up to the set on a mild spring day, but the snow made it feel very cold for some strange reason."

The town's signature tower wasn't the only landmark featured.

The Blackpool pier is the site of a striking scene in which Miss Peregrine soars above the children in bird form. Production used a real peregrine falcon named Francesca, whose handler, Graham Bessent, describes the day's events. "We were flying her off the end of the pier, so she's going right up in the sky. She had a couple of key points where she had to look directly at the actors. It was quite exciting because the conditions there were so varied. We were getting some ridiculously high speeds coming in."

Bessent is clearly in love with his bird. "Oh my God, just look at her. That's beauty, isn't it?" he asks. "It's those eyes and it's just deep. There's so much to her. It's nice to sort of build up a bond and a relationship with something that goes from you and truly wants to come back. I suppose it's just ingrained in many people over thousands of years. Falconry is an old sport, and it's passed down from generation to generation."

On May 18, 2015, production resumed at Gillette, where the

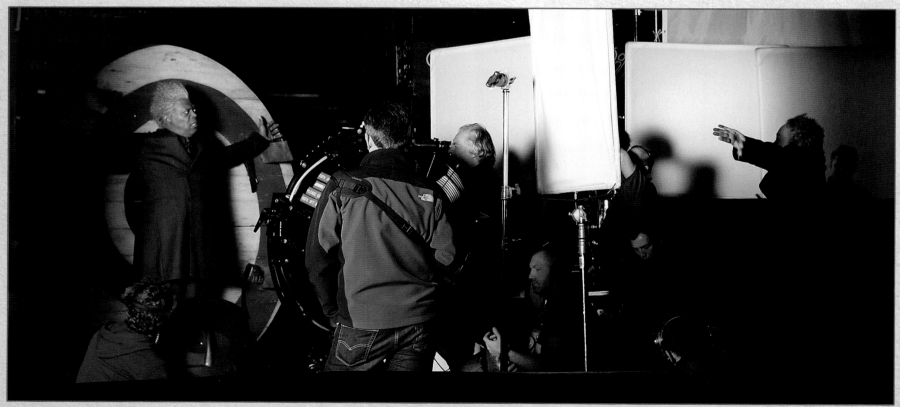

ABOVE: *Burton directs Jackson as he gets blown backwards.* OPPOSITE TOP: *Miss Peregrine soars above Jake and Emma.* OPPOSITE BOTTOM: *Graham Bessent with his peregrine falcon, Francesca.*

crew filmed a scene depicting a group of ymbrynes in bird form. The "cast" included hornbills, ravens, owls, and a seriema. Anthony Bloom, a bird trainer for thirty years, reflects on the scene. "Initially they wanted to have all the different birds in the same cage—the predators and their prey in one enclosure. We had lots of discussions, but ultimately they decided to do each bird individually and then use CGI to put it all together at the end. Each bird had to fly out, but each one had to be on the right perch, fly out at the right moment, and we would shoot a plate [a shot with only one bird at a time] and then do the same scene with another bird and another one and another one [which VFX would overlap in post-production to make it seem as if all the birds are in a single cage]. It was difficult but it went very well."

The flashback scene of Barron's experiment was filmed on the same set, albeit with Victorian decor. Barron and his fellow scientists sit in a ring, wearing helmets wired to a central machine containing a single caged ymbryne. Special effects supervisor Hayley Williams recollects how Burton brainstormed a last-minute embellishment. "Tim came to me the morning before shooting and said, 'Actually, I'd really like for smoke to come pouring out from under their helmets and for sparks to fly around the room. That's all right isn't it?' And I said, 'Yes, Tim, of course, that's fine.' Then I went back to the workshop and said, 'Right guys, thinking caps on. Tim has issued us a challenge!' We were all hands on deck and worked a very late night to create what turned out to be a great-looking shot. It wasn't a massive effect, but it was a good one for having twenty-four hours' notice."

The last major stunt and special effects sequence at Gillette occurs in the parlor. "The hollow is breaking through the house and trying to attack the children, which is great fun because we basically had to dream up a fight that included an invisible being," Williams says. "So, my team and I looked at the room and said, 'Okay, what shall we smash up and how shall we smash it up?' We came up with a good plan, alongside Rowley, and the movement

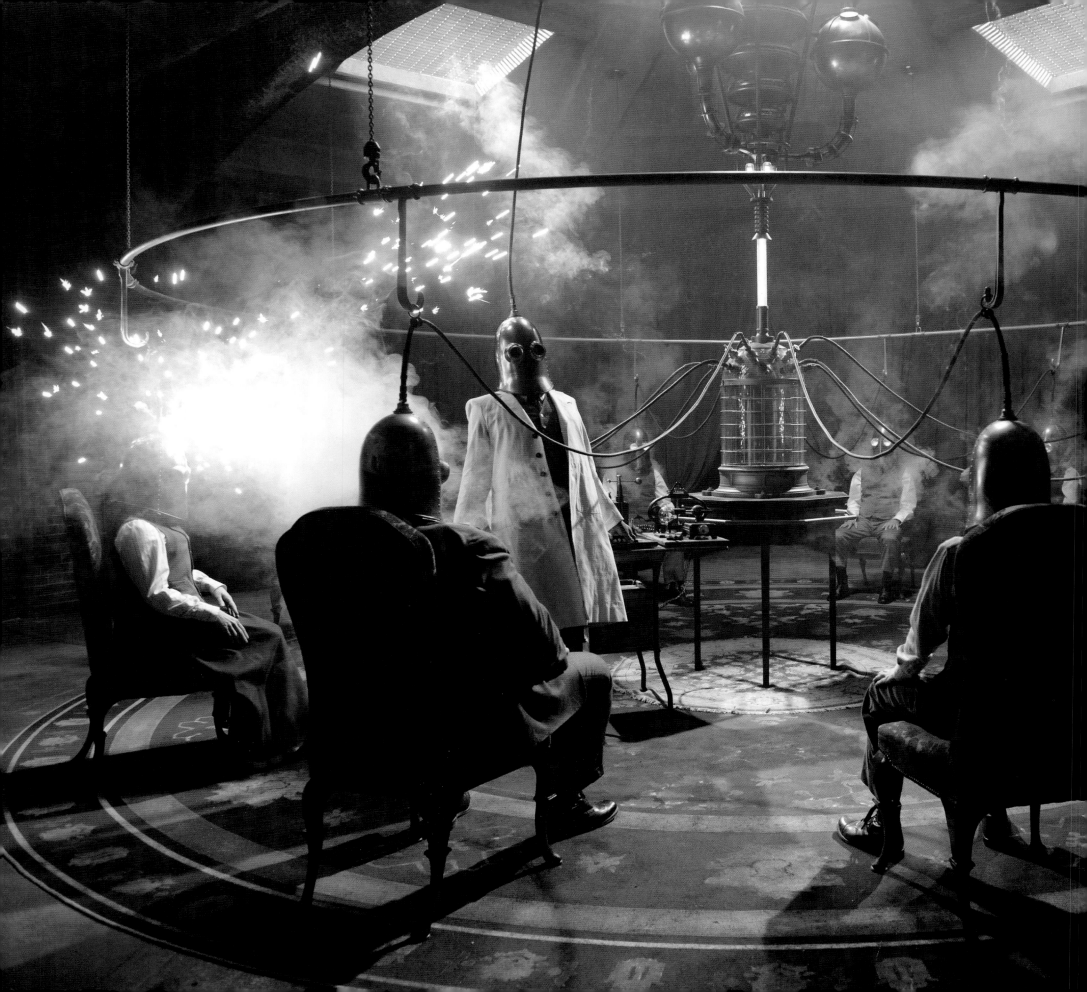

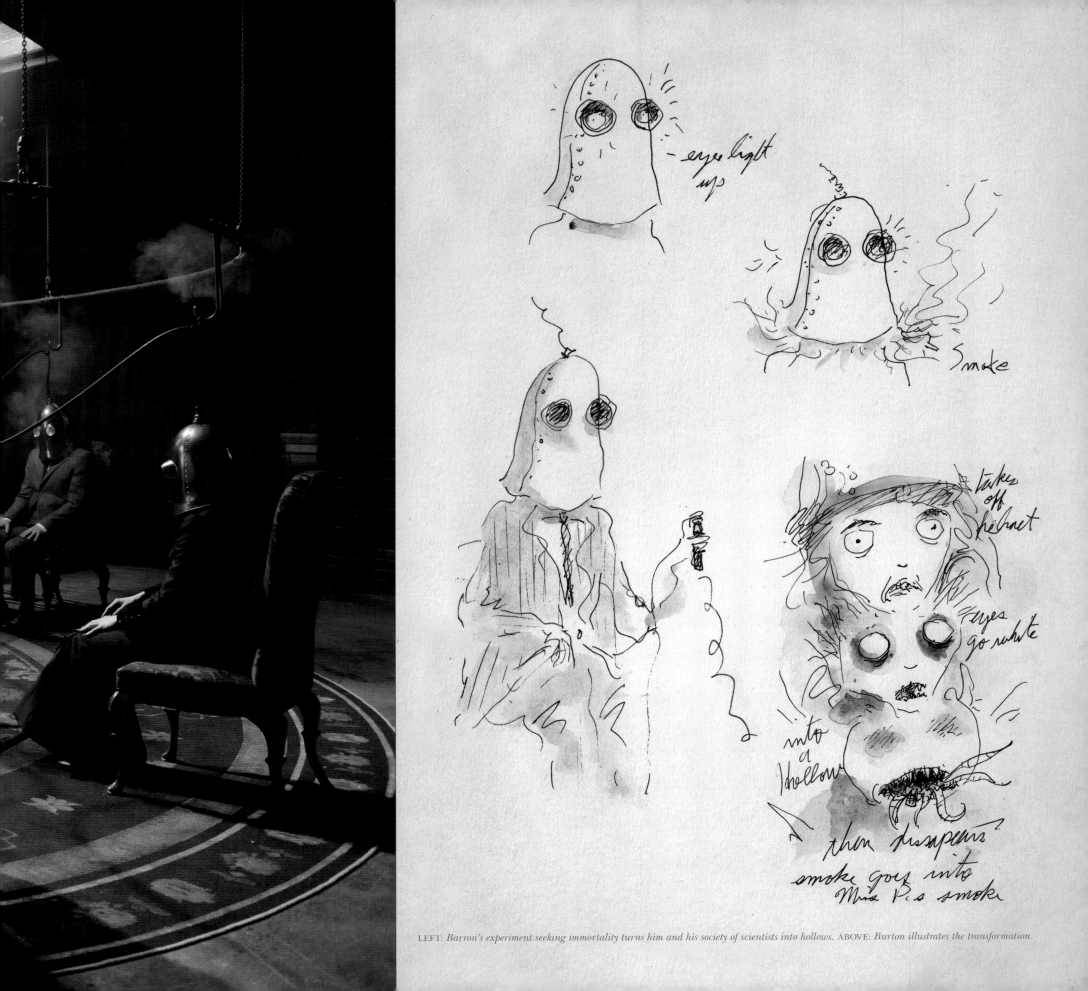

LEFT: *Barron's experiment seeking immortality turns him and his society of scientists into hollows.* ABOVE: *Burton illustrates the transformation.*

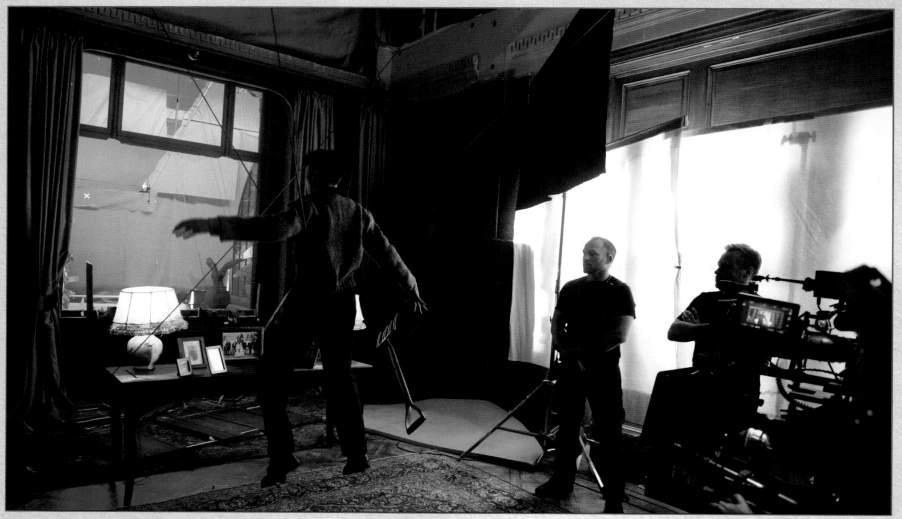

ABOVE: *Finlay MacMillan gets tossed about by stunt wires in a carefully orchestrated sequence.* OPPOSITE: *The children pelt Mr. Clark with snowballs on the pier set.*

for Enoch, who was being attacked. Next we took away the furniture and created breakaway furniture, and then came up with rigs to throw everything around and smash it."

Irlam recalls how Finlay MacMillan bore the brunt of the attack. "The hollow grabs and smashes Enoch all around the parlor set, and Finlay did most of that stunt work himself. We installed a 3D winch system, which is made up of four winches, with pulleys in each corner of the room. They all come down to Finlay in the middle, so we can pick him up and move him anywhere within that space. We smashed him into the mirror above the fireplace. We smashed him through the French doors. Into the sofa, up to

the ceiling, down to the floor, but he loved it. He thought it was great." What teenage boy wouldn't? "I'm smashing through tables and chairs you know? I felt like Spider-Man," MacMillan confesses. "You're just flying about the room!"

After finishing at Gillette, filming switched to Longcross Film Studios for the climax, during which the kids fight the hollows on the set of a reconstructed pier. In the scene, Mr. Clark and his gang of hollows are chasing the children. Jack Brady remembers how he played his character. "It was fun, fun, fun to shoot that scene. It was quite complex but we rehearsed the traveling a lot. Which was good because I couldn't see a thing with

the white 'eyes' and the snow, so I was counting steps and praying that I didn't fall arse over elbow."

Williams explains that the kids climb to the top of a ghost train and pelt Mr. Clark and the hollows with snowballs and candy to see their shapes. "We had piles of real snow that the children made into snowballs, and they had great fun throwing them all around the set. I think the adults had quite a lot of fun as well, to be honest."

"It stung a little to be pelted, but all I could think of was, if I was one of those kids, I'd be throwing stuff at that big bloke so hard," Brady acknowledges. "And yes there was a very low ball thrown, which hurt like hell but also made me laugh, because I

would have done the same thing. It was fun, and for me it had echoes of the old black and white movies which involved a pie in the face. Everyone was having a great time, even though it was a complex scene set within a huge real funfair. I think that helped loads. The fair was real, so you had the noise, the smell, the sounds of an amusement park. The result was that you behaved as you would in real life—and how can anyone be grumpy at a funfair?"

The final major sequence to be filmed at Longcross was the daring escape of the children from the attic of Miss Peregrine's home. "We built a replica of the rooftop in my rehearsal area," relates Irlam. "If you look at the slope on the windows of the

house, it's a steep angle. From down below it looks okay. But take a six-year-old up to the top and ask them to slide out, and it doesn't look quite so safe. For a couple of the cast members, we built up a platform of boxes so we would drop them three feet, six feet, nine feet, and just gently build it up. Then we needed to really do it on the set. So we came in one Saturday to rehearse. There were two windows, and each one of the kids did both of the routes down the house so that when we came to shoot it, Tim could cherry-pick who went where. What all the rehearsal meant was when we actually come to shoot the sequence in the pouring rain, all the children did their own stunts. They all came down the roof, and they were as happy as anything to do it."

"I've done a lot of stunt training," says Hayden Keeler-Stone, who plays Horace. "We tried jumping off this manmade building on a roof, hanging on and jumping, being caught by this guy. But in the movie we're just going to be jumping off, not being caught at all. Just jumping onto a ledge, and it will look quite good."

In late June, production moved to Belgium to film the majority of the exteriors of the house, along with the surrounding gardens and a few interiors. Between the two reconstructed versions of the house (the ruined modern-day version and the functioning 1940s version), plus the real house in Belgium and the many sets constructed in the UK, making the overall structures look and feel consistent was a puzzle. "You have to figure out how to put it together," Frauenfelder explains. "There can be real complications in lighting a sequence because you may be shooting the stage work before you're shooting on location, and you have to match the lighting across all locations. The biggest challenge is making it look like you've shot it all in one place."

"You have to connect real locations with sets built on stage," adds Delbonnel. "In my experience, it's hard to maintain consistency in the light. The quality of light is different at a real location versus on a set. Under these circumstances, it's challenging to keep the look you've

defined with Tim. The other tricky thing is that stages are very dry. As if you were lacking the humidity in the air that you would find on a real location. It's fine if you don't go back and forth from the real location to the stage sets. Otherwise, it's hard to make it believable. Especially because we shot on stage before going on location. We just assumed that, because we were shooting on location in summer, we'd have an 80 percent or more chance to get sun. Therefore, we tried to do a sunlight effect on stage. But sometimes you lose—you might have a rainy summer, and all the shooting you've done doesn't work anymore."

All the daytime outdoor scenes that take place on the grounds of the children's home were filmed in Braaschaat, including all of the outdoor moments when Jake is first introduced to Miss Peregrine and most of the other children. In this scene, he watches Fiona in her vegetable garden as she uses her peculiarity to grow an enormous carrot. Then Bronwyn wrests the giant vegetable from the earth. The prop department designed how the carrot would look and Williams says special effects created a super-light version. "Once we had a carrot to work with, we created a rig that sat under the surface of soil and held the carrot at an angle," Williams explains. "The rig had electric motors that caused the ground to vibrate, giving the illusion of the carrot growing rapidly; it also had sliding plates that created cracks in the earth and a hole for the carrot to pop out of. Then, with a mixture of SFX and VFX shots, the scene was pieced together to show a huge carrot growing out of the earth."

Some of the interior scenes were shot at Torenhof. The kitchen existed only in Belgium. The most dramatic scene shot

in the castle occurs in the lobby, when Barron arrives to kidnap Miss Peregrine. To prevent harm from coming to her children, she willingly flies into the birdcage that Barron has waiting for her. The cage, Balfour says, was handcrafted by the props department. "Tim had an idea of how he wanted the cage to resemble the top of the Blackpool Tower. I work with a great metal fabricator named Barry Butler. He is a genius, a real problem solver. He not only created the cage for Miss P, but he figured out how to make it light enough to be carried easily."

On July 13, 2015, filming returned once again to Gillette, where the art department had turned the 1940s parlor, dining room, and hallway into the modern-day bombed-out shells of their former selves. Bruno Delbonnel's favorite scene to light was when Jake walks through the dilapidated dining room into the rubble-strewn hallway. "I like the transition form the first gray and not so sunny dining room to the strong backlit staircase. I really liked the transition between the two different kinds of light within the same scene."

His lighting received spontaneous compliments from several crew members, who commented that the scene looked like a painting, though this isn't how Delbonnel thinks about it. "Cinematographers are not painters. Cinematographers are storytellers, and I think cinematography is closer to music than painting. It's as if I was asking myself: what is the melody of this movie? I always have the story in my head and I try to develop a certain 'melody,' which would be the 'light melody' of the movie. You need variations in the light you're creating. Sometimes it has to be hard light, sometimes soft light . . . sometimes bright, sometimes very dark. You try to give the

"I think cinematography is closer to music than painting. It's as if I was asking myself: what is the melody of this movie?"

actors and the director an emotional playground, an emotional 'score' they can feel comfortable with. I just try to create a feeling. Fear, happiness, sadness . . . When Jake walks into the derelict house, there are several key story points. This house would be seen later in the movie, therefore I had to light it in a way that the audience would connect it right away with the happy, shiny version of it. On top of that, I wanted the light to be Jake's feeling about what he was experiencing."

The main unit finished filming at Pinewood Studios on Saturday, July 18, 2015, in the underwater tank. Butterfield and Purnell spent several days immersed in water, swimming, to film them entering the sunken *Augusta*. The scenes involving the ship are a bit of a departure from the book, but one that its author was enthusiastic about. "In the book, the shipwreck had been inspired by a diving trip, a night dive I took into a shipwreck where we found all these beautiful bioluminescent fish. Tim and Jane took that image and said, 'Okay, here's the seed of an idea that could be super cool if we just pushed it a little further.' I feel like that's pretty much what they did with a lot of little scenes in the book. They said, 'What if we took this scene and planted it in the fertile soil of Tim's brain and made this crazy other thing?' It's been really exciting to see where those ideas go. It's kind of like playing out the beginning of an idea into its ultimate ideal form."

Jake explores the lobby of the children's wrecked home.

8 17+05

R4_C3_V7. 1_ 160 107

DLL SND Music

PROPERTY OF FOX

6

A Society of
Mad Scientists

POST-PRODUCTION

ost-production begins the day filming has ended, although the artists involved with editing, visual effects, sound, and music usually begin their work much earlier. *Miss Peregrine's Home for Peculiar Children* marks the fourteenth collaboration between Tim Burton and Chris Lebenzon, a veteran editor. Lebenzon says that with most movies, he settles in with the footage while the director is focused on the filming. But when working with Burton, the process differs slightly. "Tim looks at the movie as a whole. I'm editing while we're shooting, as each shot comes into the cutting room. Between setups he'll visit just to make sure

he's getting what he needs. I think maybe it's his animation background, but [he gives me] very conservative and precise coverage. That's why his movies look so original and well-crafted."

At times, the editing directly affects what is filmed, whether from day to day or shot to shot, for Burton uses editing to help him shape a scene. "The biggest challenge on *Miss P* was probably getting that circus scene right. It was long in the script, and Tim's intention was always to cut it down while shooting," Lebenzon reveals. "We're reducing that scene probably by half of what was written, because of limitations of the shooting schedule and budget.

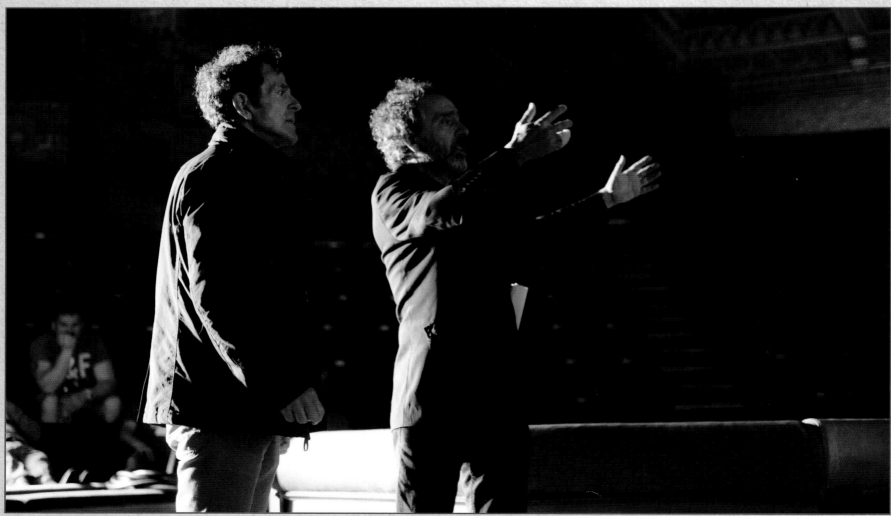

PREVIOUS SPREAD: *A visual effects shot of an eyeless Victor on screen during the scoring sessions.* ABOVE: *Burton explains to editor Chris Lebenzon his idea for the circus scene.*
OPPOSITE TOP: *Jake and Emma on the roof.* OPPOSITE BOTTOM: *The twins escape from the roof window, a scene Lebenzon and Burton shaped through editing as they filmed.*

Rather than doing it before we got there, Tim wanted to see the flow of the scene and how it was working out with Barron and the kids in the circus, with Jake trying to get to the ymbrynes. So in Blackpool, I went down to his trailer three or four times a day with edits, and we continued trying to make it work. Every day we were changing what he was doing and developing the scene."

Lebenzon mentions that the rooftop escape scene also developed while editing. "We started shooting it and then we kept building what we needed, based on the cut. Who's gonna come out the window? How much do we need of each character and what they're doing? When are we going to the hollow chasing them? When do we cut to the planes in the sky? It was a lot of fun and it evolved in an interesting way when we were filming. We continued to revisit shots, and Tim kept adding what he needed."

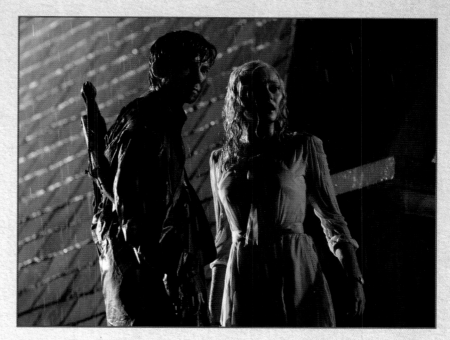

Once post-production begins, Burton continues his close involvement in fine-tuning the edit. Lebenzon says that occasionally, as the edit progresses, Burton decides that inserts are needed. "The scene we're about to spice up with additional photography is the rising of the *Augusta*. Tim is picking up some shots in there that I don't think would have initially occurred to anybody during filming. It's only after seeing the cut that these images kind of accentuate the characters and keep the fun going."

After seeing the edit, Burton felt strongly that he also wanted to further develop a flashback sequence of Miss Peregrine showing Jake the book *A Peculiar History*. Although Burton rarely storyboards during filming, he drew the shots he wanted to include in the edit. "He's the only director who actually draws what he wants," Lebenzon remarks. "Others try to express their ideas in words, but it's great that Tim can show a visual representation to visual effects, to the camera crew, and to me. We put the shots in the movie, and the studio saw them, so it's really helpful."

Executive producer Derek Frey agrees that Burton's working style is both fascinating and effective. "The additional photography has been like watching his drawings come to life," Frey observes. "The shots have been lifted from the pages of his sketchbook. It's impressive to watch."

Editing is a powerful tool in shaping the pacing and narrative of the film, and with Lebenzon at the helm, it's a tool that Burton uses to full effect. "I don't have the luxury of being on the set and

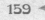

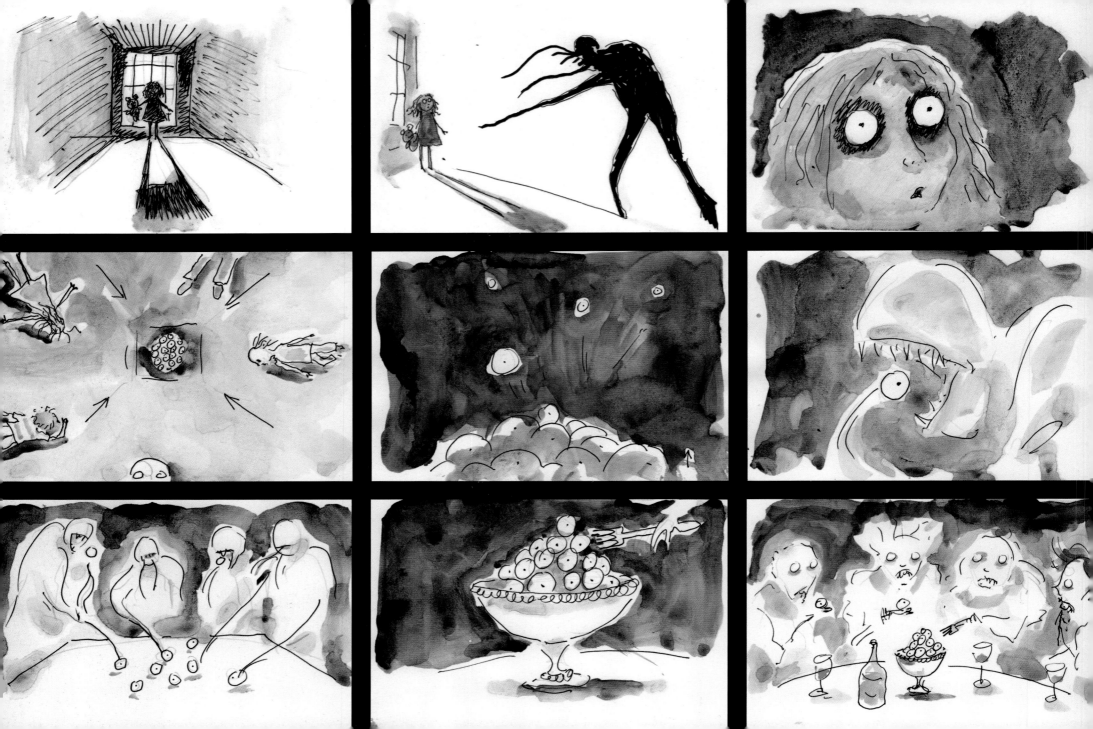

OPPOSITE: *Burton's storyboards for additional photography that extended the flashback revealing how the hollows became ex-hollows.* ABOVE: *The realization of Burton's vision.*

seeing everything live," Lebanzon states. "I get it on a blank slate and everybody has worked so hard just to get what I'm given. Then I have this freedom of putting it together. The possibilities are infinite. Movies are overwritten nowadays, so reductions always have to be made to fit the length into a decent running time. Those are big challenges, so first cuts tend to be long and not very good in terms of an entire movie; but you have the material in there to work with, and that's the job. Working with Tim, however, it's a little easier because he's so much on the cut [edit] with me. Our first cuts are pretty close to the final movie, because Tim is so involved. It's great to have a partner like that."

Visual effects supervisor Frazer Churchill had recently completed work on *The World's End* when he met with Burton. In the apocalyptic comedy, Churchill had used numerous practical effects that were later manipulated digitally. Burton liked this approach, and it became a stepping-off point for how to proceed with *Miss Peregrine's Home for Peculiar Children.* Churchill says that it meant having physical pieces on the sets that the actors could see and interact with. "Even if we're going to get rid of it in the end, I'd like to have that thing for people to look at and touch. It's very important for CG in general to have physical objects on which to base our effects. We've had advances in lighting and rendering so that everything's now photorealistic, but if we can have a physical version of the object to hold it in front of the lights, that's the best in terms of reference. No one has to guess what it looks like. It means that we keep things in the physical realm. David White, the prosthetic and creature designer on the movie, made up some brilliant pieces for us."

White agrees with Churchill's assessment. "A lot of what we did was for visual effects, to aid them in their work," he says. "Which means creating elements that are absolutely lifelike. They need to have the right textures and the right colors, and then we put all those things together and hand them over to those guys to use on set, offering them up to the lighting, to the actors. The special makeup side and the visual effects side are similar but different. Those two worlds marry really well. On this movie more than any other, I've been involved in delivering items and objects that have been used in a big way by those guys. It's been terrific."

Among the myriad items White produced for Churchill were skeletons, a realistic replica of a hollow's head and tentacles, Miss Edward's tail, several silicon versions of characters' faces who have had their eyes removed, and Claire's back mouth. This last elicited a strong response. "It's shocking because Claire opens her second, hidden mouth and you're basically looking into the back of her head," Churchill muses. "She lifts up her beautiful little curls and then you see she's got a gaping shark's maw. We had a physical version made, so we've got a reference on the set of what this mouth looks like in the proper lighting. But ultimately it comes down to the skill of our animators to sell the idea that this opening in her head is a true working mouth and that she's using it to eat a turkey leg."

The visual effects department was involved with several of the other peculiar children's talents, including Fiona's fast-growing plants, Hugh's bees, and Millard's invisibility. "Millard sometimes doesn't wear clothes, and in those moments you can't see him at all," Churchill says. "It's not the 'predator effect,' wherein you see a hazy wobbling when he walks by. He's completely invisible. But when he does wear clothes, the challenge then becomes what can you see of the clothes? You can see inside the sleeves, and you can see behind the collar, the label on the back of the shirt, the inside of the hat."

The character of Millard is played by Cameron King, who wears a blue body stocking over any exposed skin to make it easier for visual effects to identify the parts that need to be removed. The blue cloth is digitally painted out, frame by frame, by artists known as rotoscopers. Churchill elaborates. "I had the special effects guys make a wire frame of Millard based on a digital scan

OPPOSITE: *An eyeless re-creation of Abe's head.* TOP LEFT: *VFX data wrangler Paul Bongiovanni whips around a version of Miss Edward's tail for VFX reference.* TOP RIGHT: *Claire's back mouth prosthetic.*
BOTTOM LEFT: *An SFX explosion destroys the children's home. Both the bomb and the top of the house are added by VFX.* BOTTOM RIGHT: *King next to the wire-frame Millard.*

ABOVE: *Jake views the children's home for the first time. VFX created the house in its dilapidated state.* OPPOSITE: *Jake stares at the water droplets that freeze in place during the time reset.*

of Cameron, so that the frame had the correct volume. We made a duplicate set of clothes for him so we could walk his wire frame onto the set [after a scene that Cameron had performed in] dressed in the correct clothes, in the proper lighting. From that wire frame maquette, we digitally place in the bit of Cameron's clothes that his body is hiding and that we're missing. Our compositors [who combine the elements from different shots into a single image] will have a look and say, 'That works well for one frame, that works because he's standing still, but here he's walking across the room, so we'll have to make a CG version.' Overall, he's basically a walking bunch of clothes."

The children's home was the center of several significant visual effects scenes, including when a bomb blows off its roof. Churchill's team also re-created the destroyed version of the home for when Jake first views it. But the biggest, and most complicated, sequence that takes place at the house is the time loop's reset, which was filmed at Longcross. Because it is scripted at night and involves child actors, it had to be shot on stage. This sequence is one of the few in the film that was shot almost entirely using a blue screen so that backgrounds could be added later in editing. "We want to show that time's running backward, that it's returning to the previous day, so we have a whole time-lapse sequence,

we've got animals bouncing backward," Churchill relates. "We're really trying to sell the idea in a visually arresting way."

Although VFX is known for its work in post-production, Churchill says a lot of his crew's contributions happen in pre-production as well. They mapped out this particular scene in previz, a term that means rendering the sequence with rough animation before filming has started. Churchill scouted the grounds of Torenhof to determine the best location for the reset. "I worked out where the kids might be standing and what might be happening, and then, with Tim's approval, we developed the sequence. We figured out how it would work with the the path of the sun, and all the shifting shadows within that movement, and what was happening to the rest of the environment while the sun was moving across the sky. In a real time-lapse film, all the trees would be jittering frantically and the environment would be shaking, but that wasn't the aesthetic we wanted. We wanted smooth movement from the environment, and we wanted smooth movement from the sun and the moon, and we wanted real-time movement from the kids. We wanted the rain to fall in real time, then in slow motion, and then to freeze and go backward. It was a lot of elements to think about, and it was difficult to conceptualize."

The time loop reset presented Delbonnel with his most technologically complicated lighting setup of the film. Miss Peregrine resets the loop every night at 9:07 p.m. When she winds back her watch, time winds back, too. This means that in reverse, time (and associated daylight) shifts from night, through daytime, and into the night again until stopping again at 9:07 p.m. the night before. Delbonnel calculated ten hours of daylight and had to re-create this period of reverse time in twenty seconds, somehow with lights. "In this case, we had to solve a problem which comes from the fact that you cannot shoot a real time lapse with actors, unless they stand still for ten hours. The question then becomes: how can we reproduce a ten-hour sun path in twenty seconds, with a light that can cast a single hard shadow and cover a large space in which seven or eight actors are standing full figure? It meant using a big source which would be our sun. But to travel a big source on a 180-degree circular move in 20 seconds requires a rig which would probably move at a speed of 40 miles an hour. Quite a complicated rig which, on top of the speed problem, would have to

support a heavy weight since big light sources are not lightweight."

John "Biggles" Higgins, the electrical gaffer and a film industry veteran, helped Delbonnel solve this problem. "It took a lot of discussion and experimentation with prototypes to get the look right," he says, "since we wanted a moving shadow without multiple shadows. We had to imagine how it would work, whereas some more traditional scenes have a natural lighting position. This was, in effect, supernatural."

Delbonnel says they settled on the solution of multiple abutting lights set on a circular rig. "The only solution in our budget was what we call a 'chase.' Basically, to alleviate the shadow problem we rigged around fifteen 20-kilowatt fresnel lights as close to one another as possible. The principle is quite simple: you bring the light up from the first one and then dim it when you light the second one, and so on until the last one is lit." *Voilà*, Delbonnel and Higgins had created a day's worth of sun in twenty seconds.

"In fact, the physics of it don't really add up," Churchill points out. "That's often the case with visual effects. It's all dressed to make the shot look the best it can be—the light shifting on them, the shadows moving—it all seems to work in harmony to make it feel like that's what's really happening."

Churchill says that the majority of the environment was computer generated, mapped out in advance off stills and scans that he had taken while on a scout of the house. "After that, it was just a case of

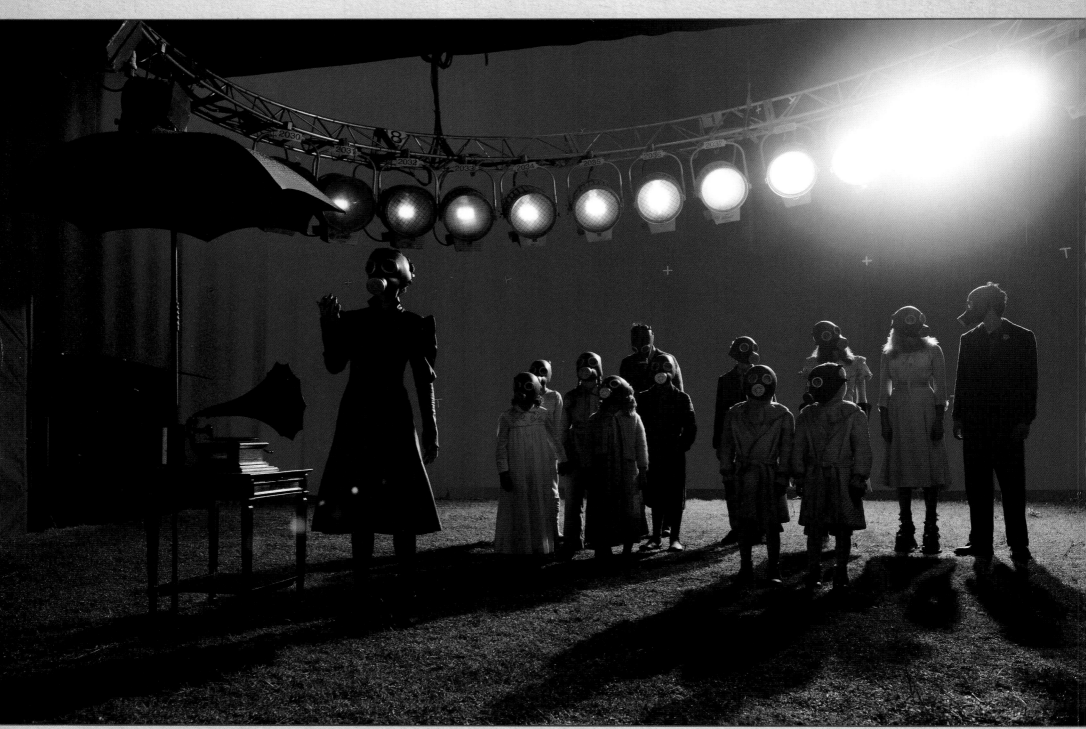

ABOVE: *The sun's movement during the time reset was re-created with a series of lights rigged in a ring.* OPPOSITE: *Post VFX work completed: the time reset.*

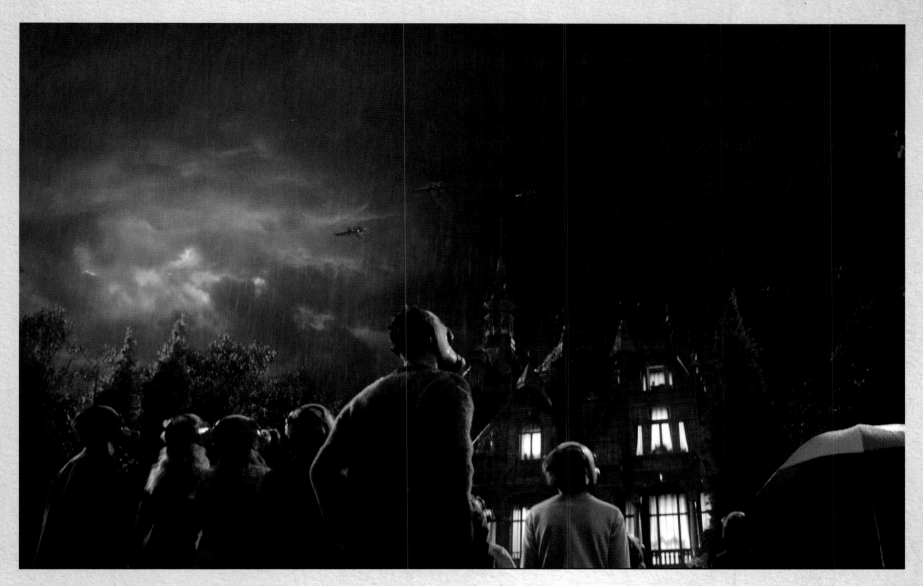

shooting the various pieces in the right order with the right sequence of lights. Andy Lockley and his team at Double Negative came to Torenhof over and over to shoot time lapses running through the night, so we could see exactly what happened when the sun traveled its 24-hour cycle. We got some great stuff, but even then it wasn't enough. Some of their team went down to the south coast of England and shot more time lapses to get the kind of clouds we wanted."

Churchill also had to figure out the rain, deciding it wouldn't be practical to have it pouring down on the actors for the length

of the shoot. "In the end we hardly wet them at all—we just lightly spritzed their clothes and gas masks with water. Everything combined was quite tricky. Anything to do with time travel and time running backwards becomes difficult to think about. You wouldn't want to figure it out with a hangover."

A second major visual effects sequence occurs on the RMS *Augusta*, when Jake and Emma swim underwater into its cocktail lounge. Emma uses her peculiarity to surround Jake's head in a bubble so he can breathe. Then she blows all the water out of the

lounge so that they effectively have a room under the sea filled with breathable air.

Churchill began preparing for the scene by mapping it out in previz. Then he had to convince production to get the actors in the water. "From very early stages, I didn't want to cheat it with a 'dry for wet' look. I have never seen that work; it doesn't look real. I think the keystone for all the effects in this movie is that we were basing them in a realistic world, and not doing magical effects. So it was, 'OK, we've gotta get them in the water, and how are we going to do that?'"

To prepare for the water work, Asa Butterfield and Ella Purnell underwent diving medicals and breathing apparatus training. "We had an induction period to get them used to breathing underwater through their apparatus," the stunt coordinator Rowley Irlam remembers. "They loved the process. They took to it like ducks to water."

"It's the first time Asa and I had ever done anything in a tank," Purnell confesses. "It was a new experience for both of us. The first time I did it, *phew*, terrifying. There's something about being that deep under the water without air, without goggles. It's only for three or four seconds, and you know you're safe. There's people everywhere. But suddenly you do feel very nervous. It's easy to get disorientated when your eyes are shut and you're underwater and suddenly you open them up and you're facing downwards; you don't even know which way you are because you can hardly feel the gravity. It takes a while to get used to the sensation and to feel safe. But once you're comfortable swimming along and breathing through your equipment, it's very therapeutic."

Churchill is satisfied that all the work involved in having the actors in the water pays off onscreen. "The key is that you see them, they're clearly under the water, their hair is floating everywhere, there's no way of faking that. The way light diffuses through water and the way it looks on their faces, the bubbles coming out of their faces, the way they move."

Another challenge for VFX was the air bubble that Emma blows over Jake's head. In the film, the bubble works as a sort of diving bell, allowing Jacob to breathe as he descends to the bottom of the ocean. Although the bubble would be digitally created, VFX was still left with a tricky problem. "We knew Asa

would be under real water and his head would be exposed," Churchill says. "So we had to treat his hair to look like it's not being affected by the water."

Churchill enlisted the help of hair and makeup designer Paul Gooch to devise a solution that would sell the idea. "The people from viz effects asked me if I could come up with a way to keep his hair from moving," Gooch recalls. "It had to give the illusion that while he has the air bubble on, he's in a dry space even though he's underwater. So we developed a product, with the help of David Stoneman, who's a chemist and makeup artist, that would keep Asa's hair completely stiff underwater."

The final challenge, Churchill says, was the moment that the water exits the room and passes over the actors. "We needed them to look like they're immersed, and then we needed that moment where the wall of water passes over them, like that shot in *The Abyss* years ago, and then they're damp and everything's back in the right place. They're not obviously lying down, they're not obviously being manipulated. So it was a case of working with Hayley Williams and finding a mechanical rig that would rotate them out of the water."

The rig is attached to the wall of the cocktail lounge. Its starting position is horizontal, so that it acts as a floor on which the actors lie flat under the water. The rig also has the camera affixed, rotating with it to help hide the movement. Churchill elaborates on the process: "The actors were lifted toward the surface, which would represent the wall of water in the cocktail lounge heading toward them. And then through that moment they surfaced, the rig would rotate, but that rotation would be hidden by the environment and we wouldn't see it on camera. We rotated them through the surface of the water, and then they'd be standing up, and all the water would be dripping off them and their hair would be hanging in the right direction, accounting for gravity." The result is a flawless scene in which the rotation can't be seen, and it's easy for viewers to believe that Emma really harnesses the ability to manipulate air.

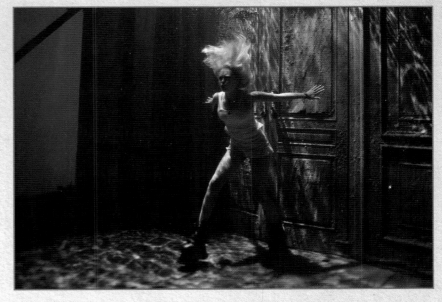

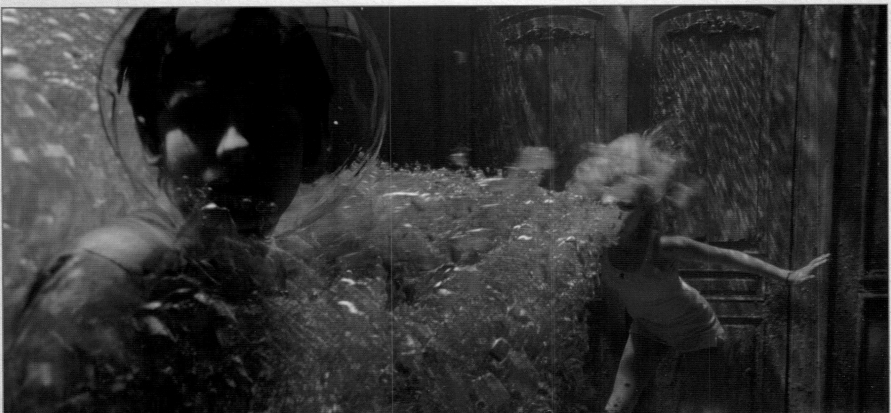

OPPOSITE: *A rig that rotates the actors out of the water.* TOP: *Before VFX: Purnell in the underwater tank at Pinewood.* ABOVE: *After VFX: Emma blows water out of the cocktail lounge.*

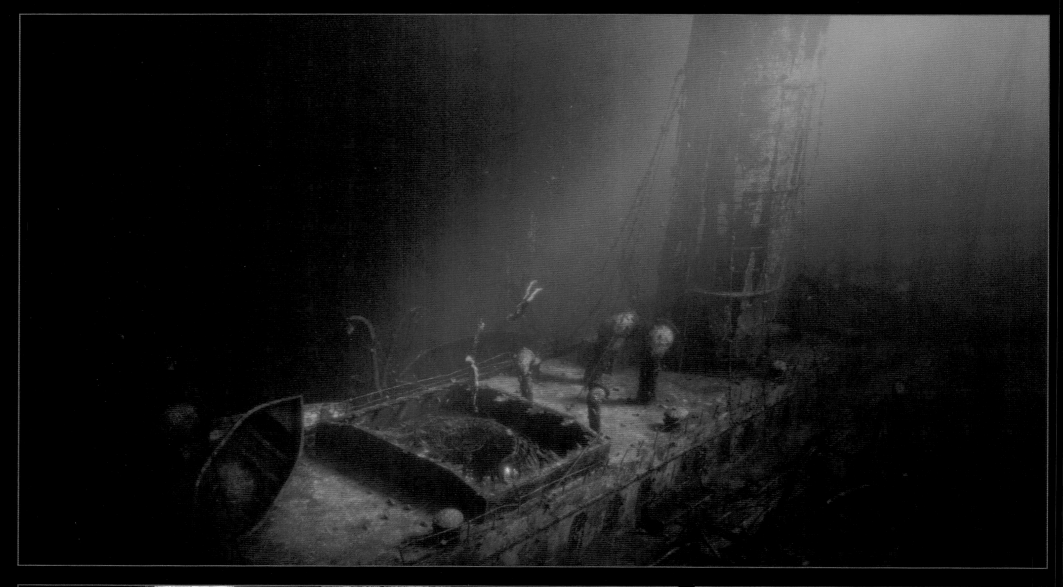

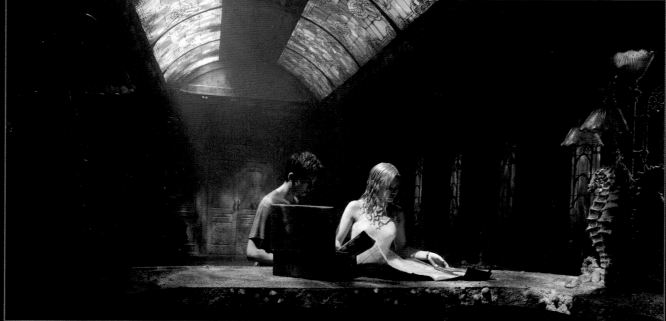

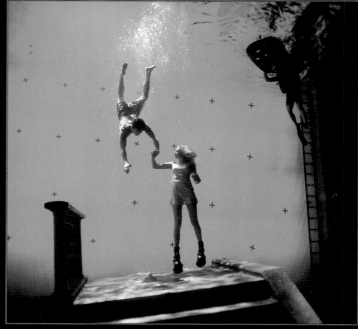

TOP: *A finished VFX still of Emma and Jake entering the sunken ship.* ABOVE LEFT: *Jake and Emma in the cocktail lounge after Emma has expelled all the water.*
ABOVE RIGHT: *Before VFX: Butterfield and Purnell in the underwater tank.* OPPOSITE: *After VFX: Emma and Jake swim in the sunken cruiseliner.*

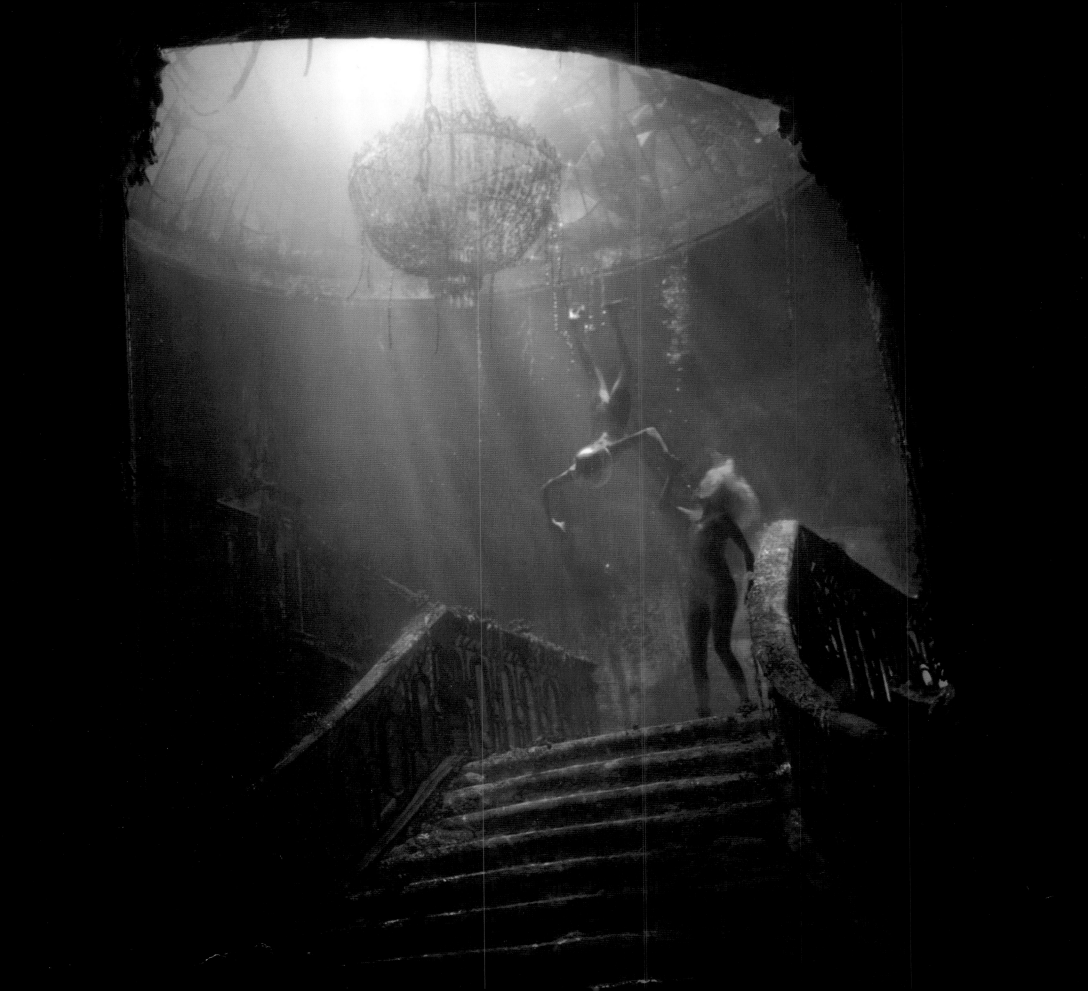

During the film, Jake and his friends are chased by the monstrous hollows. Though Barron is the voice of evil, it is the hollows who truly take its shape, looming menacingly tall and thin, the stuff of nightmares. The hollows' form morphed through several design phases and designers, ultimately resembling one of Dermot Power's concepts. "Because I had some sketches from Tim to work with, they started out very differently from what we see onscreen," he says. "The earlier versions were very much B-movie monsters, with dagger hands and eyes on stalks—darkly funny. Tim was keen to have them be an 'easy read,' which those early designs certainly are—all strong silhouettes and discernible limbs and features."

"We went from what was basically a monster, which wasn't at all humanoid, to a very human-looking figure," Churchill chimes in. "The hollows aren't very far from the humans they once were. They'd just become emaciated; they'd lost their features. They were still wearing some of the clothes they'd had on when they were humans. In the end, the creature became an almost human figure, but with just enough monstrosity to be scary. It ended up with sharp teeth and shallow eyes and unhealthy-looking skin. David White's team built a version of a hollow's head and tentacles that we could hold up on the set, to have the physical representation of the creature when we came to shoot. The model helps actors understand what the hollow looks like. It helps everybody to see and interact with that physical reference, even though it won't be used in the movie. And when we come to the action sequences, we'll have someone dressed in a green or blue suit, depending on the environment. They'll be wearing stilts and they'll look like the creature so that when the actors are fighting it, they're not just pretending and swatting air. It's important to have that basis in physical reality for these kinds of effects."

ABOVE: *The hollow as it appears to Jake.* OPPOSITE LEFT: *Power's later concept of the monster.* OPPOSITE TOP RIGHT: *A prosthetic version of the hollow's head and tentacles.*
OPPOSITE BOTTOM RIGHT: *Power's early concept for Miss Peregrine shooting a hollow.*

In an epic battle, the hollows fight an army of skeletons reanimated by Enoch. Churchill describes these skeletons as "a Tim Burton signature piece" and explains they were more than just your average assembly of bones. "There was some design involved," he says. "Tim loves *Jason and the Argonauts* and the Ray Harryhausen skeletons, and that's basically our reference. I thought, if I go along those lines, I can't really go far wrong. Harryhausen animated his skeletons through stop-motion. He'd move physical skeletons limb by limb, and he'd photograph them frame by frame, which produces a kind of jerky quality. That's been superseded by current-day stop-motion animation. Our skeletons will be computer generated, but there will be a stop-motion quality to give them a classic Harryhausen feel. We made a physical version so that we can hold up the skull and the bones on the set and see exactly what they're supposed to look like in the right lighting."

Irlam also had stunt actors playing the skeletons. "We had three of my guys on stilts playing the hollows," he describes, "and then we had another five of my guys, in motion-capture suits, playing the skeletons. So all of the action, all of the climbing up onto the bumper cars, jumping on the Ferris wheel, all the fighting, all the flying through the air—the beginnings of all that is real. And then VFX will take those characters, make their movements a bit funky, and transform them into skeletons."

Overall, the scene is both original and an homage to beloved films from Burton's childhood. "Tim has dabbled in skeletal themes before," Frey says. "There are skeletons in *Corpse Bride* and *Beetlejuice,* there's Jack Skellington in *The Nightmare before Christmas;* Tim even did a music video with the Killers involving skeletons. They're something he knows well. People associate them with him, but I don't think he's ever had the opportunity to really show them on such a grand scale and have so much fun with them."

Burton's love of stop-motion animation is also on display in a battle scene involving two of Enoch's props. "In this movie, Enoch brings dolls to life," Frey explains, "and it seemed to make sense to depict this power using stop-motion. There's something about

the technique, about using a maquette or a puppet and moving it slightly, frame by frame, multiple movements per second, that goes well with the overall approach of the entire film, in which everything is very tactile and practical. When you watch stop-motion, you feel like you can touch it. On a few occasions, Tim has even used stop-motion within his live-action films, but it's been a while since he's done that, and it will be a fun little segment."

The scene's running time is two minutes five seconds, with fifty-five seconds of stop-motion contained within. Its creation took two and a half months and involved more than a dozen people, all of whom were led by Andy Gent, the supervising puppet modeler. "Tim had a lineup of all of Enoch's dolls and chose a couple that he really liked," Gent remembers. "It was quite fun

for me because I'd done stage fighting and choreographed fights and been the villainous knight at Warwick Castle for seven years, so I offered to choreograph the fight between them, which they allowed me to do. Tim mentioned that what would be really nice would be to have a feel of the Ray Harryhausen homage during the fight. We talked briefly about how they could fight each other. Then we were left to figure something out."

Stop-motion is shot frame by frame with a still camera. There are a couple of phases prior to filming. Gent describes how the first is a "pop," which is shooting key frames of the characters during the action to give a rough map of the scene. The next step are rehearsals, which give a slightly more realized but still clunky sense of how the action will play out. "If everybody's happy with

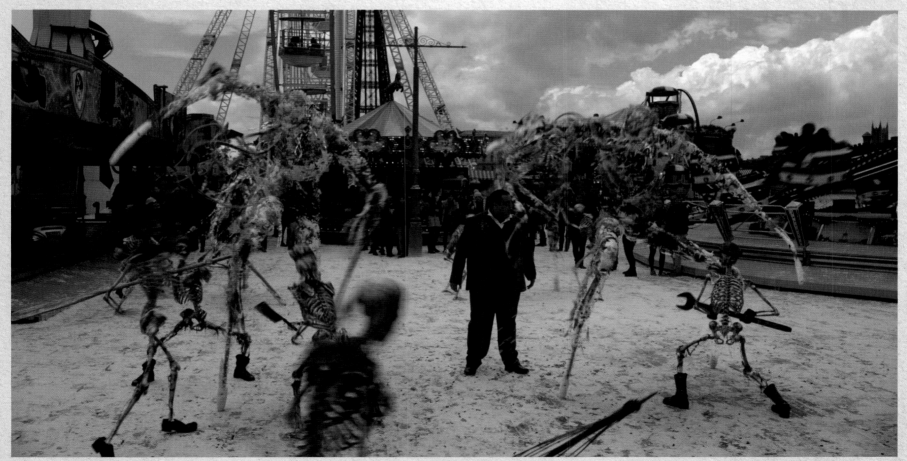

OPPOSITE LEFT: *VFX supervisor Frazer Churchill walks a pair of skeleton legs down the ship's gangplank.* OPPOSITE RIGHT: *Power's skeleton concepts.* ABOVE: *The hollows and skeletons battle on the pier.*

that, we would board it and get ready for a launch and then shoot the animation—with everything worked out, all the rigs, where we can hide things, knowing what we're gonna do, and then shooting the final shot. Tim would see quite a lot of those processes, and at the end of the day we sent off that shot and awaited approval before moving on, in case we needed to tweak or elongate anything. He was extremely involved daily, seeing it all and checking it through."

The "stage" for the battle is a re-created version of Enoch's desk built from reference photos, using real props and taking into account what had already been shot with the actors and where their eyelines were. Gent found the process both similar to and different from working on a full-length animated feature. "The intensity of it was very similar, but the scale was different. The puppets were really big. They had to fit into a live-action world. We normally work on a smaller scale because we're creating whole worlds, but these characters were fitting into a real world. So they were quite big puppets."

Gent says it was a dream come true to work on the project. "It paid homage to greats of the past and all the things that we remember from being children. There's so many other ways that people would do stuff, so to be able to go back and complete something that you'd seen from *Jason and the Argonauts* and *Sinbad*, where you've got things in a real setting, to make something so textural, so beautiful, and so unique, it's a dream come true. You're ticking lots of boxes as a puppet maker to get to do something like that, an insert into a super feature film. It's good that we've got people like Tim who still champion it strongly. I think the future is bright for stop-motion; it just needs to keep rolling with the times. As a medium, it's still evolving; it's nowhere near dead."

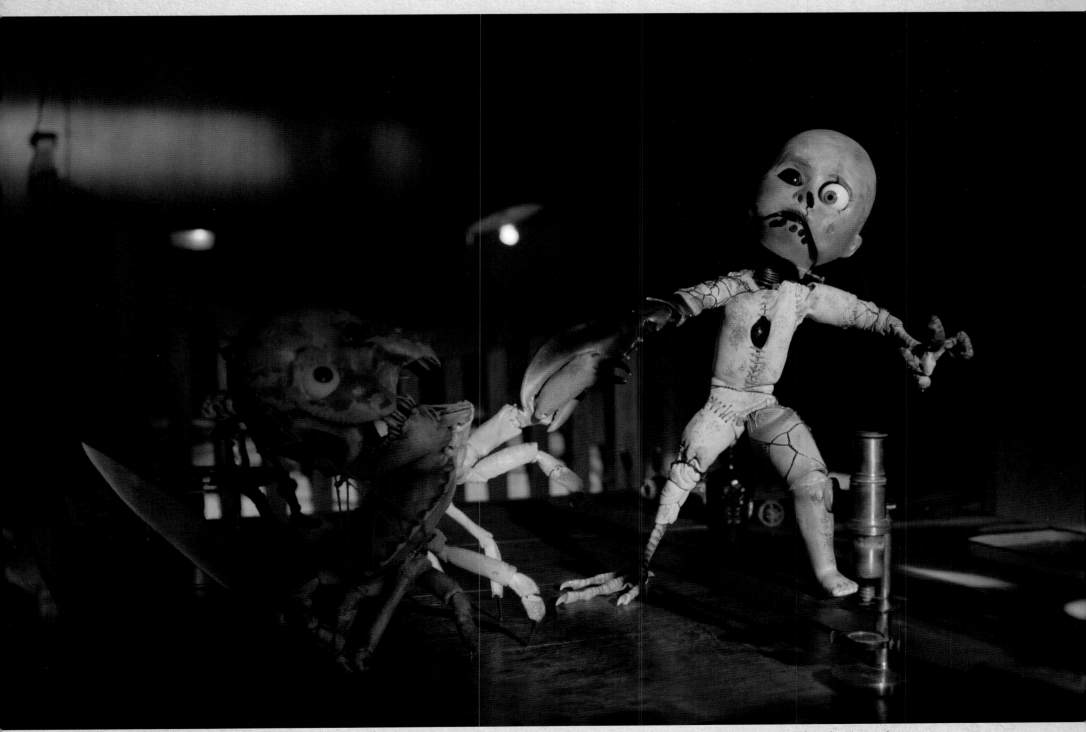

OPPOSITE TOP: *Before VFX: Stuntspeople double as the skeletons.* OPPOSITE BOTTOM: *After VFX: The skeletons burst from the ghost train.* ABOVE: *A stop-motion frame of Enoch's dolls battling one another.*

The final element of any motion picture—but especially in a Tim Burton film—is the score. Longtime Burton collaborator Danny Elfman was already committed to scoring *Alice through the Looking Glass*, so production began on *Miss P* without a composer attached. Midway through filming, Mike Higham was brought onboard, originally as a music supervisor. Higham has collaborated on Burton's films since *Charlie and the Chocolate Factory* in various musical capacities, including music editor, music producer, and music supervisor. On both *Sweeney Todd: The Demon Barber of Fleet Street* and *Big Eyes*, he composed additional music and arrangements. Burton and Higham enjoyed an obvious rapport. In fact, Burton sometimes used Higham's music trailer as a place of respite during filming. "At the beginning, when we were shooting, Tim used to come and see me nine times a day," Higham relates. "He'd come and lie on my couch in the trailer and take a break, saying, 'This is music therapy.'"

Higham was tasked with creating a so-called temp score, which is exactly what it sounds like—a temporary soundtrack, usually composed of music borrowed from other films or sources. In the case of *Miss Peregrine's Home for Peculiar Children*, much of the temp score was original music of Higham's own creation—but he kept this information to himself and tried to help Burton brainstorm ideas for a final composer. "I said to Tim, 'Why don't you meet Matt Margeson?'" Higham reflects. "I'd just worked with him on *Into the Woods*. I'd also worked with him on *Captain Phillips*, which was a difficult project. I knew he was a superb musician, a really talented guy, and I knew he'd get on well with Tim. And Tim said, 'Yeah, let's meet him.'"

So they met with Margeson, and around this same time Burton learned that Higham was responsible for creating most of the temp music. "About six weeks later Tim came up to the editing office to talk to me," Higham recalls. "I remember him spinning around on my chair going, 'You know, Mike, I think we've got to have some fun, and I'd really like you and Matt to do the score, as a duo.' I just remember feeling a whole wave of emotions, thinking, 'Oh my God, can we do this?' Tim just wanted to know if we'd work well together. And I said, 'Well, we've done it before, twice, so I know that would all be good.' Also, it's normally a really lonely business. I love collaborating with other people."

Margeson (*This Is the End; Kingsman: The Secret Service*) was equally excited about collaborating with Higham. "We have a definite shorthand when it comes to talking about music and film. One important thing that Mike and I share is that we both leave our egos at the door. When we're writing, either together or individually, it's nice to have a second brain to bounce ideas off of—even if they're bad ideas. As far as the physical process goes, we pretty much started at the beginning of the film and slowly worked our way forward, splitting up the cues as we saw fit. It was a healthy working collaboration."

OPPOSITE: *Mike Higham (left) and Matt Margeson discuss a cue during scoring.* ABOVE: *Jake enters the children's destroyed home for the first time.*

Though confident in his professional rapport with Higham, Margeson had never worked with Burton before. "I really didn't know what the experience of working with Tim would be like," he says. "I mean, the guy has left such a mark on filmmaking, so I knew I was in for something great. Throughout the whole composition process, Tim seemed to know what he wanted musically (and, just as important, what he didn't want), but I never got the sense that he was forcing us in a direction. We had free rein to try different things, and when we'd play Tim different ideas, it was then that he would steer the ship in a certain direction, and we'd get into discussion about specifics."

"Tim said that this film should feel haunted and poetic," Higham adds. "Those are the exact words he used. Musically, that's very helpful. He definitely wanted a teenage angst feel for the Jake and Emma vibe. And I was like, 'Well, I've got two of the blighters myself, so I can kind of understand that.' He also wanted something simple; he doesn't like busy music. Especially with this film, he seemed to want something quiet. But doing something simple and keeping it interesting is really hard."

The final score is a bit of a hybrid. "One could split the score

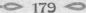

into two types of music," Margeson explains. "For the first half of the film, the music is atmospheric, simple, and a bit weird. But in the second half, as the story unfolds, the amount of big orchestral music increases. Both of these styles were a lot of fun to explore, but also challenging in their own right. Of course, the big underwater set pieces were probably my favorite to record with the orchestra simply because of the epic sound we achieved." Margeson says that early in the film, they worked hard at not

giving away too much through the music. "There was this notion that at the beginning of the film, before Jake starts to add things up, everything is a bit ominous, simple . . . not leading. We didn't want to inject too much thematic material into the music; we didn't want to lead the viewer too much. I think keeping the music as simple as possible, but still harmonically and texturally interesting, was a tough egg to crack."

Because Miss Peregrine is so obsessed with time, Higham reveals that they incorporated a grandfather clock into the rhythm of the children's home. He explains that the idea of Jake being on an adventure also plays heavily into the score. "When I first watched the film, I thought, 'It's all just a big journey for Jake, a discovery. So when we start the movie, there's a sort of ethnic-y, flute vibe when Jake is talking to his grandfather. My thought was that it would be like a calling to the island. And then when Jake gets to the island, it's very surreal and simple, and very synth-y. We've got Jake's chords, which is a sequence that we call his traveling chords, because it's about his journey."

Of course the title character also has her own musical motif, which is connected to some of the main themes. As Higham puts it: "Eva has a tune as well, tied into the film's theme, which you'll hear in the main titles. When they're besting the hollows, we use that. And when Miss Peregrine turns into a bird, there's a big tune, and we'll use that tune in the end as well, when everybody is saying goodbye."

In an example of life imitating art, the villain gave them the most trouble. Barron was the theme they saved for last, and it was Margeson who finally cracked it. "I told Mike that I was just gonna turn the film off, not look at any picture, and just write some 'baddy music.' Three days later, I still hadn't come up with anything. I was eating some poached eggs at a local café when I started thinking about the character in a simple way. Barron never runs, never chases, never really attacks. He is more a villain that comes after you slowly, like an evil machine. He's like a baddy in a nightmare that slowly gets closer and closer even though you're running at top speed. When I had this thought, the musical approach became clearer. The little viola trill motif is the slow-rolling evil machine coming to get you, his tune on cello and low woods is his menacing personality, and we threw in a pipe organ, of course,

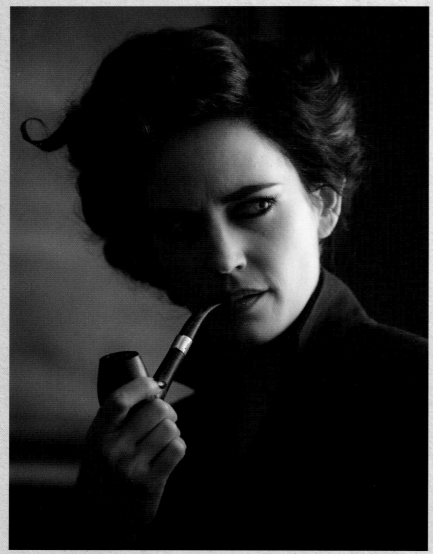

Miss Peregrine and her pipe.

"Barron never runs, never chases, never really attacks. He is more a villain that comes after you slowly, like an evil machine."

because there is an element of mad scientist in the mix."

After twelve years of collaborating with Burton, Higham has learned to read the director, which has helped him navigate his new role as co-composer. "There's always this thing when you play him something. If I've got my back to him, he makes noises, like a sigh or 'mmmm.' He's completely surfing the whole cue with you. You can tell what he's thinking. But he'd never outright say, 'That's terrible.' I remember a few years back, if he didn't like a piece of music—not one that I'd written—I could tell because he'd start putting his fingers in his hair and twirling it around. And I'd be thinking, 'Oh, he doesn't like it,' rather than him saying it aloud. He's quite shy, Tim. You kind of want to finish his sentences for him, when he's talking to you, to make it easier for him."

Higham is aware and respectful of the fanbase for Burton/Elfman scores. "That whole Danny side of things terrifies me because Tim and Danny are like fish and chips, so to be given the chance is ridiculous. I still to this day can't thank Tim enough for trusting us. And hopefully we've done it justice. He seems really happy with the score. The biggest thing for me is that Tim wanted to have fun. Music should be fun. And I hope that comes out in what we've done. That it feels like we've had a good time doing it, because we have. Even though it's been ridiculously challenging for me, my biggest-ever composing gig, it's been amazing."

LEFT: *Barron shifts his hand into an axe.* RIGHT: *The orchestra plays a cue during scoring.*

7

Right on Time

FINAL THOUGHTS

*F*rom pre-production through post-production, the film adaptation of *Miss Peregrine's Home for Peculiar Children* lasted hundreds of days and involved contributions from hundreds of crew members. As with any film, the work often involved long and exhausting hours. But the cast and the crew felt invested. They were working for more than a paycheck; they had become part of a community. There were two main reasons that everyone felt so committed.

First, of course, was Tim Burton. Even though he can't stand to hear people extoling his virtues, Burton nonetheless inspires effusive outpourings of praise and loyalty. There are some people, like Katterli Frauenfelder, who go to great lengths to rearrange their schedules so they can work with him. There are others, like Eva Green, who see Burton as a hero. "I was very excited to get onboard because it's such an unusual and beautiful story," she says. "But above all, it's Tim Burton, and I'm such a big fan. To be able to work with him is a real dream. I could play anything in his movies. I could play a moth, a fly, a tree. I'm playing a bird in this one. He's a delight to work with because he's like a child on set. He's full of passion. He is bursting with ideas all the time, full of energy, always pacing. And it's a happy set, which is very important."

Then there are those, like Samuel Jackson, who have worked with Burton only once but understand why people want to work with him again and again. "His enthusiasm on set is infectious. It makes you want to do well for him, because he's fully committing himself. There's such joy when he laughs at what you've done or he applauds, or you see him skip. And you go, 'Okay, I did it.' It makes you want to give him what he needs to make this world real or embody the reality of what he thought the world was when he conceived it. And hopefully you're enhancing what his concept was, which makes him even more appreciative of what you're doing."

The other main reason for the team's commitment was the message of the film. As with many of Burton's projects, *Miss Peregrine's Home for Peculiar Children* is a celebration of individuality and a reminder that we shouldn't exclude people because they're different. "I've done a few films about people who feel like outsiders," reflects Burton. "It's something I'm interested in and probably always will be. There's something fascinating to me about people who are made to feel like an outsider for something they can or can't do, over which they often have no control. Yet in actuality they are perhaps more relatable and certainly more genuine than those that see them as different. It's one of the reasons I was drawn to this material."

Green feels similarly. "Peculiar children are unlike other children. In the outside world, they would be seen as freaks. They would be persecuted. But on this island, their strangeness is celebrated as something beautiful and special. I think it's refreshing to have a film that says, 'Be yourself, no matter how strange you are. Embrace your uniqueness. Don't be ashamed of it.' I think it's a beautiful message for children as well as for adults."

Finlay MacMillan's assessment of the message is frank. "You can't be a sheep, you know? And that's why I'm so lucky to be in this film, because I'm working with everyone who's doing what they want to do, and expressing how they feel. Even if your peculiarity isn't an art form—if it's being good in math, if you're a geek, whatever—embrace it, because it defines you as a person. Definitely don't hide it away. That'd be silly."

Beyond this message, the final film is a mystery that develops into a spirited adventure with a sprinkling of romance, all wrapped within a world of breathtaking and memorable visuals. "I think it's a very exciting film," says Rupert Everett. "The notion of people trapped in one day is absolutely riveting. This day that always begins and ends with the same event. And it's a very dramatic day. There's a great and exciting interplay between now and the end of the Second World War."

"It's got tons of fantasy and funny, weird, strange characters," Kim Dickens concurs. "It's got everything. Thrills and oddities, peculiar people and magical happenings, scary moments, funny moments, tender moments, and a bunch of misfits."

Burton pours himself completely into his films, so much so that he often goes through a bleak period when he's finished, feeling bereft and adrift until he can reestablish his footing in the "real" world. Despite this total commitment, he doesn't like to overanalyze his films and often is unable to watch them after they're complete. "It's hard to watch them but I still care for them," he says. "They're like my mutated children."

Riggs watched a rough cut of the film on March 15, 2015. It was a difficult moment for Burton. "I felt when I met him that

Ransom was a kindred spirit. He was always very supportive. But it's got to be weird for him to see it, even if he likes it. Showing an adaptation to a writer is almost scarier than showing it to an audience. It's the same feeling when you are a child and going to the principal's office."

Despite Riggs being impressed by the visuals he'd seen on set, and his confidence in Burton as a filmmaker, he still entered the screening room nervous. When he emerged two hours later, he was elated. In an email to executive producer Derek Frey, he wrote the following: "I saw the film and I absolutely loved it.

Watching it was totally overwhelming, a hugely emotional experience—both as an objective viewer and as the author. I can't express how honored I am that my book inspired Tim to make this film. It's so in line with the spirit and the heart of the book, and the changes only serve to make it more powerful and cinematic. As a movie, it feels super original and also like classic Tim in ways that fans are going to love. I know you guys are still tweaking and doing some re-shoots, but what you have is already so powerful, I have no doubt that the final product will blow everyone away. It already feels like a classic."

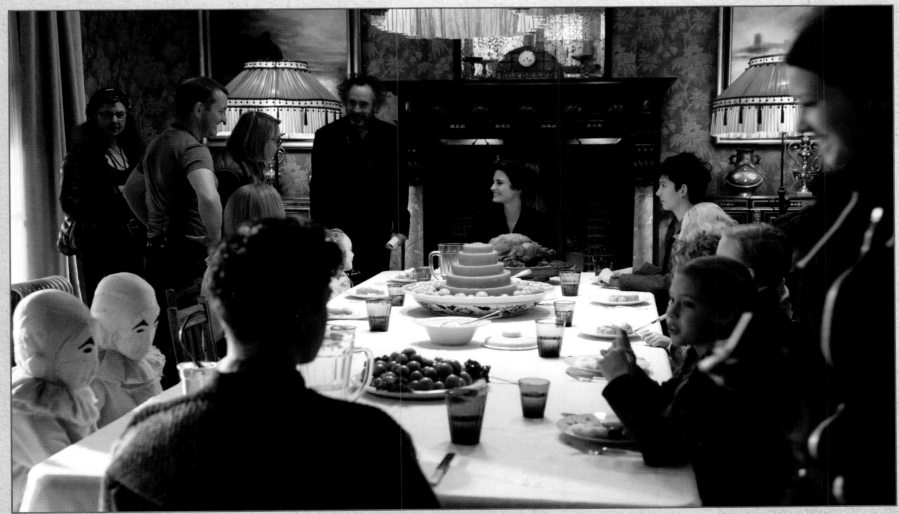

PREVIOUS SPREAD: *Burton reviews his script in the Priest Hole bedroom set.* ABOVE: *The cast and crew share a laugh between takes of the dinner scene.* FOLLOWING SPREADS: *Lighter moments on set.*

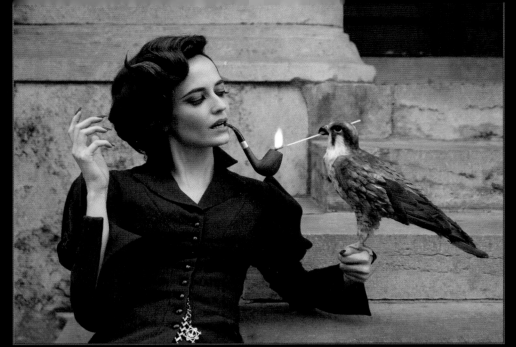

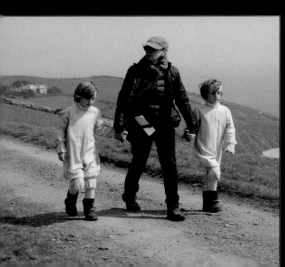

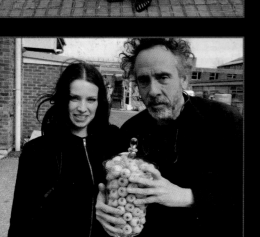

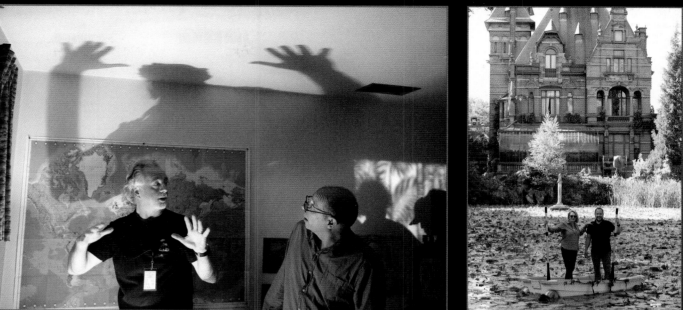

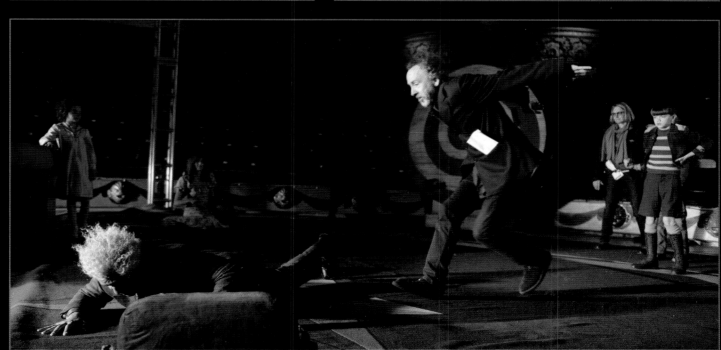

Index

Note: References to illustrations and photographs are **bold**.

Who's Who

4.30 pm
11 JAN 2016

9.07 pm
3RD SEP 1943

9.28 am
13 DEC

5.25 am
17 JUL 1982

1.15 pm
12 SEP 1910

12.04 am
14 JUN 1973

3.15 pm
22 OCT 1952